Photographing Children

LIFE LIBRARY OF PHOTOGRAPHY

Photographing Children

BY THE EDITORS OF TIME-LIFE BOOKS

TIME-LIFE BOOKS, NEW YORK

ON THE COVER: The first sequence pictures ever made of a child walking, these images were exposed by the British photographer Eadweard Muybridge at the University of Pennsylvania in 1887. Muybridge's child model was 21-month-old Godfrey Smith. Making use of a multilens camera, Muybridge took the individual frames at a speed between 1/100 and 1/200 second; the interval between exposures was 85/1000 second. What happened to young Godfrey is not known, but the photographer won fame for his innovative studies of human and animal locomotion.

Contents

TIME-LIFE BOOKS

FOUNDER: Henry R. Luce 1898-1967

Editor-in-Chief: Hedley Donovan
Chairman of the Board: Andrew Heiskell
President: James R. Shepley
Group Vice President: Rhett Austell

Vice Chairman: Roy E. Larsen

MANAGING EDITOR: Jerry Korn
Assistant Managing Editors: Ezra Bowen,
David Maness, Martin Mann, A. B. C. Whipple
Planning Director: Oliver E. Allen
Art Director: Sheldon Cotler
Chief of Research: Beatrice T. Dobie
Director of Photography: Melvin L. Scott
Senior Text Editor: Diana Hirsh
Assistant Art Director: Arnold C. Holeywell
Assistant Chief of Research: Myra Mangan

PUBLISHER: Joan D. Manley
General Manager: John D. McSweeney
Business Manager: Nicholas J. C. Ingleton
Sales Director: Carl G. Jaeger
Promotion Director: Paul R. Stewart
Public Relations Director: Nicholas Benton

LIFE LIBRARY OF PHOTOGRAPHY

SERIES EDITOR: Richard L. Williams
Editorial Staff for *Photographing Children:*
Picture Editor: Kaye Neil
Text Editors: Anne Horan, Robert Tschirky
Designer: Herbert H. Quarmby
Assistant Designer: Angela Sussman
Staff Writers: Bryce S. Walker, John von Hartz
Chief Researcher: Nancy Shuker
Researchers: Sondra Albert, Elizabeth Dagenhardt,
Angela Dews, Frances Gardner, Lee Hassig,
Shirley Miller, Carolyn Stallworth
Art Assistant: Patricia Byrne

Editorial Production
Production Editor: Douglas B. Graham
Assistant Production Editors:
Gennaro C. Esposito, Feliciano Madrid
Quality Director: Robert L. Young
Assistant Quality Director: James J. Cox
Copy Staff: Eleanore W. Karsten (chief),
Barbara Quarmby, Ruth Kelton,
Florence Keith, Pearl Sverdlin
Picture Department: Dolores A. Littles,
Gail Nussbaum
Traffic: Carmen McLellan

Portions of this book were written by Edmund White and Anthony Wolff. Valuable aid was provided by these individuals and departments of Time Inc.: TIME-LIFE Photo Lab, George Karas, Herbert Orth; Editorial Production, Norman Airey; Library, Benjamin Lightman; Picture Collection, Doris O'Neil; TIME-LIFE News Service, Murray J. Gart; Correspondents Margot Hapgood, Brenda Draper and Helena Burke (London), Maria Vincenza Aloisi and Josephine du Brusle (Paris), Elisabeth Kraemer (Bonn), Ann Natanson (Rome), Iradj Baghirzade (Amsterdam), Mary Johnson (Stockholm), Roger Beardwood (Brussels).

We have all been there in our own childhood—stationed in front of the inescapable camera and staring into its inscrutable eye—long before we ever got around in back of it. So the topic of this book should be familiar to us all. And yet familiarity can breed complacency. We grownups take more pictures of children than of anything else; still we manage to miss, all too often, the excitement, the emotion, the infinite diversity that is there for the taking.

The aim of this book is to open the reader's eyes and mind anew to the whole complex and fascinating subject of photographing children. The great cliché pictures are here, sturdy representatives of all the tried-and-true approaches that worked a century ago and frequently work today. The how-to-do-it pictures are here, spelling out the techniques of recording the expanding life and personality of the child, from the brand new baby to the teenager. The creative, innovative pictures are here too, proving that the subject is broad and deep enough to challenge the wit and imagination—and, above all, the heart—of any photographer.

The real authors of the volume are not the editors who wrote the explanatory text, useful as we hope it is, but the scores of photographers whose work with children is represented in the pictures. Many of these photographers are accomplished professionals whose own children have put their parents' skills to the test. The results, and all the funny and sad, dramatic and quiet interactions between child and camera that the pictures on these pages disclose, speak louder than any words.

The Editors

The Inexhaustible Subject 1

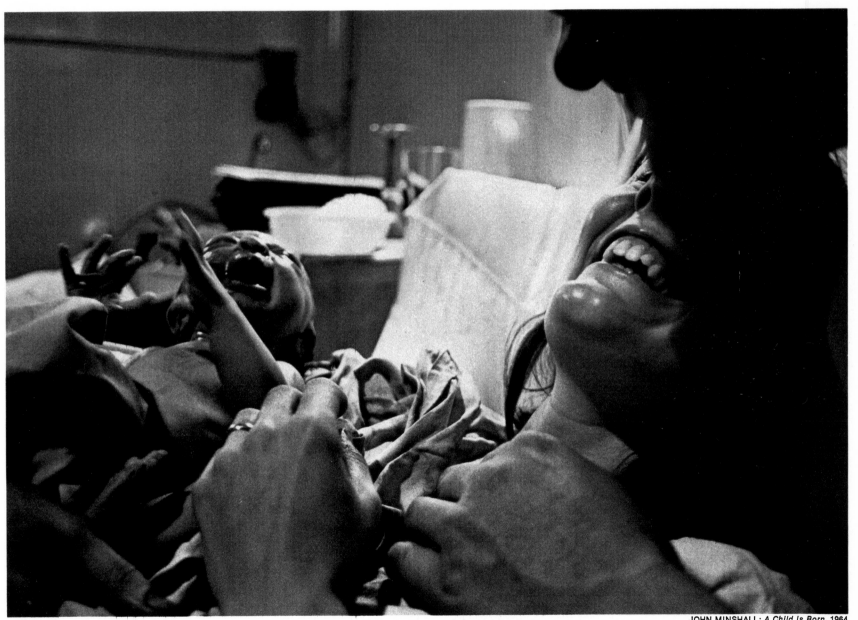

JOHN MINSHALL: *A Child Is Born*, 1964

Getting the Spirit of Childhood onto Film

The child and the camera belong together. Frequently the new father's second purchase, after the cigars, is a roll of film. From then on, through infancy, childhood and into adolescence, the child is forever followed by the camera. Usually he is a willing subject. Often he is too preoccupied to care. Almost always he makes a good picture.

On the next 21 pages are examples of some better-than-good photographs of children—records on film of those moments in a child's life that most parents wish they could somehow preserve. These pictures were taken by professionals who may have brought no more feeling and understanding to the occasion than any parent does, but who have added technical expertise to that feeling. It is a matter of technique to capture on film, for example, that magic moment when an ecstatic mother confronts the yowling, squirming chunk of protoplasm that is of her own flesh and blood *(previous page).* Every parent remembers the moment; it can be preserved in a photograph nearly as memorable as the moment itself.

So can every stage in childhood, every role the growing youngster plays: the tubby toddler and the little terror, the demure young lady and the hesitant explorer, the daydreamer and the warrior. Nowhere is there a subject so versatile, so artless, so beguiling, so ever-changing and so dependable as the child. Children are, as these pictures eloquently demonstrate, the photographer's inexhaustible subject.

And they are his most cooperative ones. Children readily enter into the spirit of photography. They love to pose and posture, and they are tireless subjects—if only because they *are* tireless; the child whose short attention span abruptly ends will almost always provide an even better picture as he dashes off into some other absorbing activity. "When I started a long time ago," says George Krause, whose photographs appear on pages 18 and 210 through 213, "I took nothing but children, like a lot of photographers do—it's such an easy way to start."

Of course, it is not quite so easy as it appears. There are many methods and techniques that are helpful in capturing that free and infectious spirit of childhood. While no one else can look through the viewfinder for you to compose the picture or catch the precise second to snap the shutter, there are guidelines that can lead to successful children's pictures. They have been useful to many of the photographers represented throughout this book, and they may be useful to you. Here are some of them.

1. Let the camera be a natural part of the child's life. The more often you use it, the more easily he will accept it. As for a strange child you want to photograph, approach him as you would a strange cat or dog—i.e., be friendly, not fawning, and wary.

2. Take a relaxed and informal approach to your picture taking, rather

than making the child assume a just-so pose. Candid photographs of preoccupied children, taken unobtrusively, are often among the best.

3. There are times when you will want to stimulate a conscious reaction to the camera. But be sure you know what you want before you begin, as a child's attention span is short.

4. Do not stop a picture session too soon. Blowing out the first birthday candle is a photograph a grandmother will want, but she might equally cherish the picture taken five minutes later, when the child has smeared the cake frosting in his hair.

5. Vary the physical levels at which you photograph the child, as well as the angles. Shooting down on him shows how he looks to you; but if you want the picture to convey his point of view, photograph him at his own eye level, or even from below it.

6. Do not be miserly with film. Children are so busy, their moods and their bodies flashing so rapidly from one point to the next, that you can be equally busy just trying to keep up with them. However, taking a lot of pictures does not necessarily mean that a few are bound to be good. Every exposure should be deliberate.

7. Fashion photographers play music to relax their models; the device also works for many children when you are trying to keep them calm for a portrait.

8. Talk about anything and everything—even about the photographs you are making. Professional photographer Marie Cosindas keeps up a running conversation with children about the pictures she is making; she finds that it gives them a feeling that they share in what is happening.

Most children like to please, and most find fun in being photographed. You yourself are apt to come in for a good deal more than fun. Photographer Wayne Miller devoted four years exclusively to documenting the day-to-day lives of his own four children. "Before my eyes," he wrote when he was done, "courses were being charted that would be with these children to their dying day. Frustration and defeat, success, pleasure, triumph were being carved into their natures." To witness such things with the camera as well as with the human eye is to get out of life something that should not be missed. ☐

From Infant to Adolescent

The pictures in this section record experiences that, as numberless manuals for parents have explained, nearly every human shares during his journey through childhood. Fortunately for both subject and photographer, children do not read child-guidance books; they do not know in advance how they will react to each fresh stage in their lives —which means that they endlessly offer fresh opportunities for pictures. And the observant photographer quickly recognizes that he is photographing an individual in a progression from the helplessness of infancy to the independence of adolescence.

The photographers represented here have captured both the universality of childhood and the individuality of children. The full face of the baby sheltered by his mother's arm *(right)* does not show, yet the picture conveys the contentment and security enjoyed by all loved infants. At the other end of the emotional spectrum is the little boy on page 23. He is doing a chore to help the family; but his smile and his awareness of the admiring young ladies behind him both say a great deal about his attitudes toward work, himself and life.

DOROTHEA LANGE: *Bringing Home the First Born*, 1952

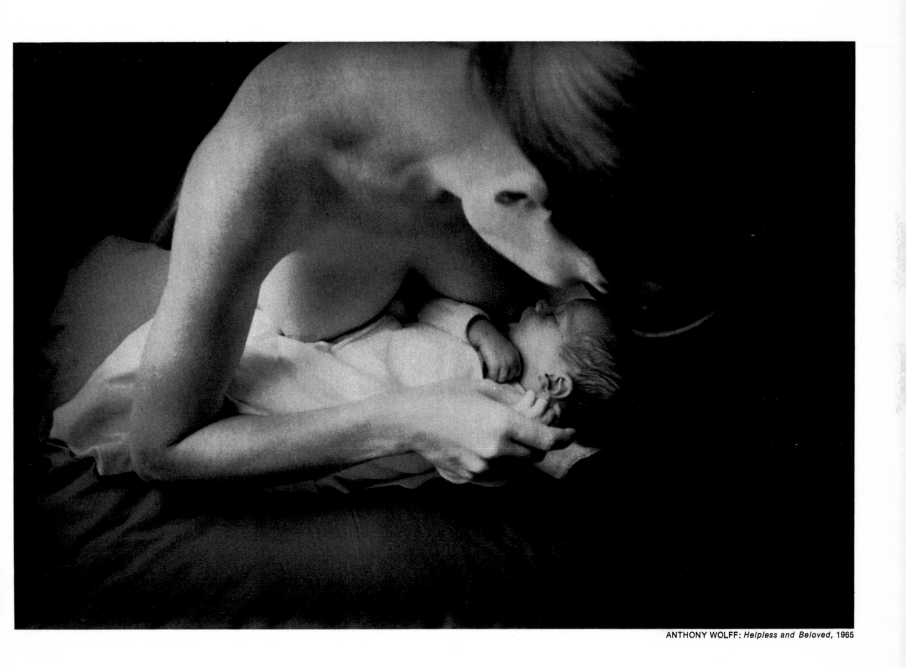

ANTHONY WOLFF: *Helpless and Beloved*, 1965

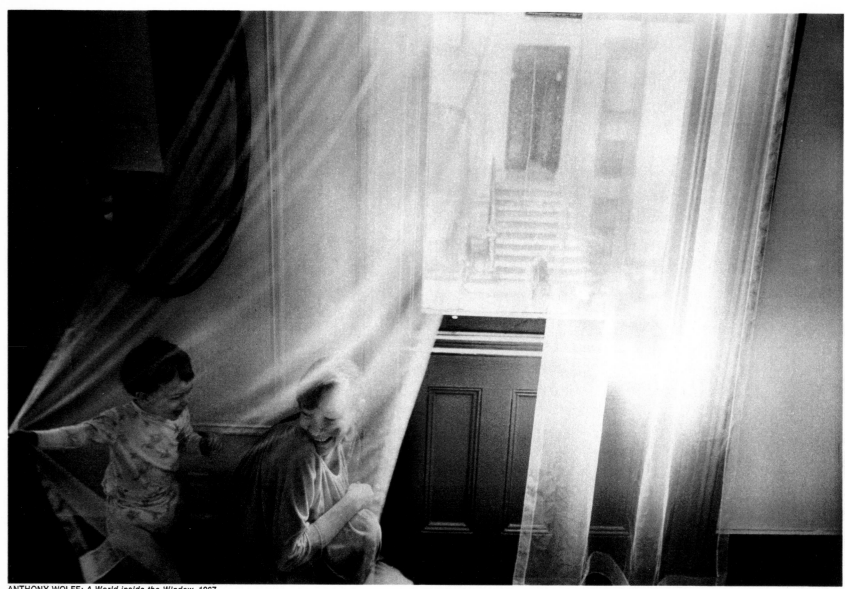

ANTHONY WOLFF: *A World inside the Window,* 1967

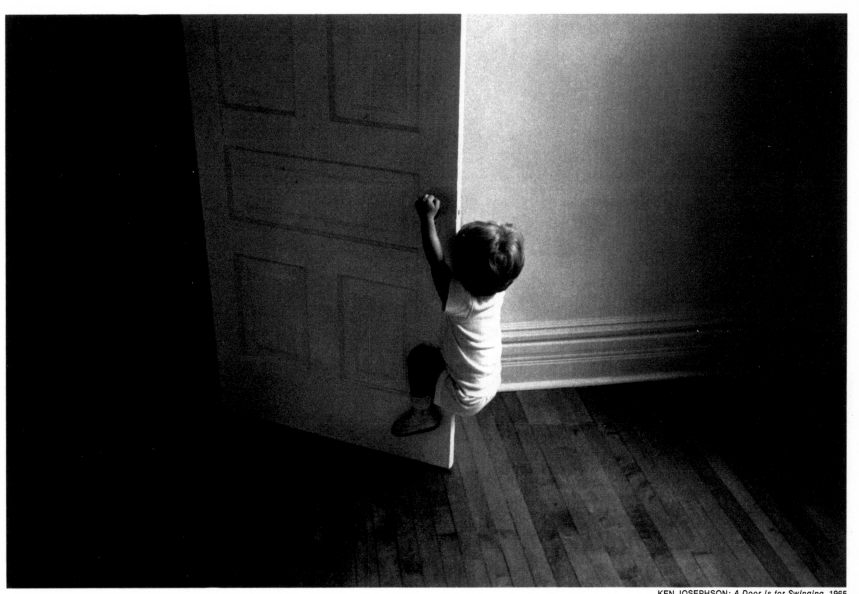

KEN JOSEPHSON: *A Door Is for Swinging*, 1965

17

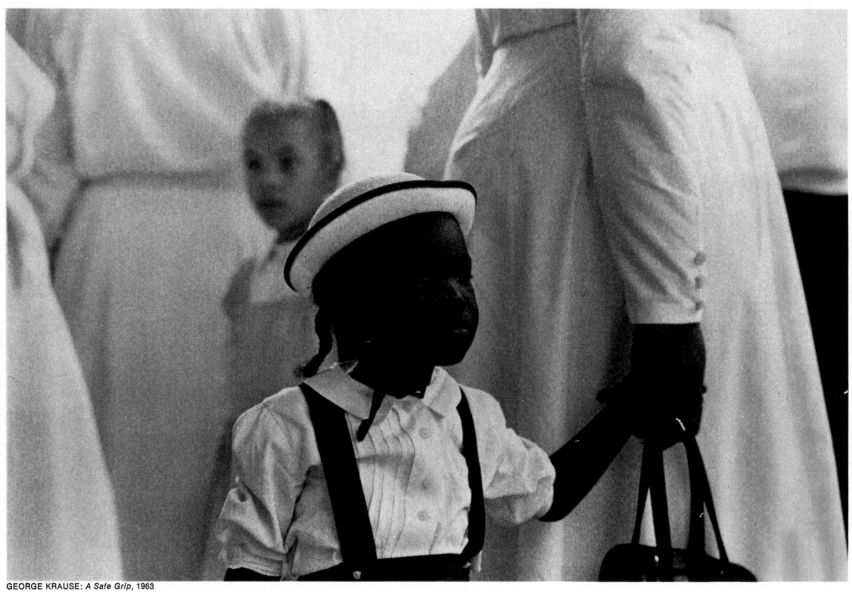

GEORGE KRAUSE: *A Safe Grip,* 1963

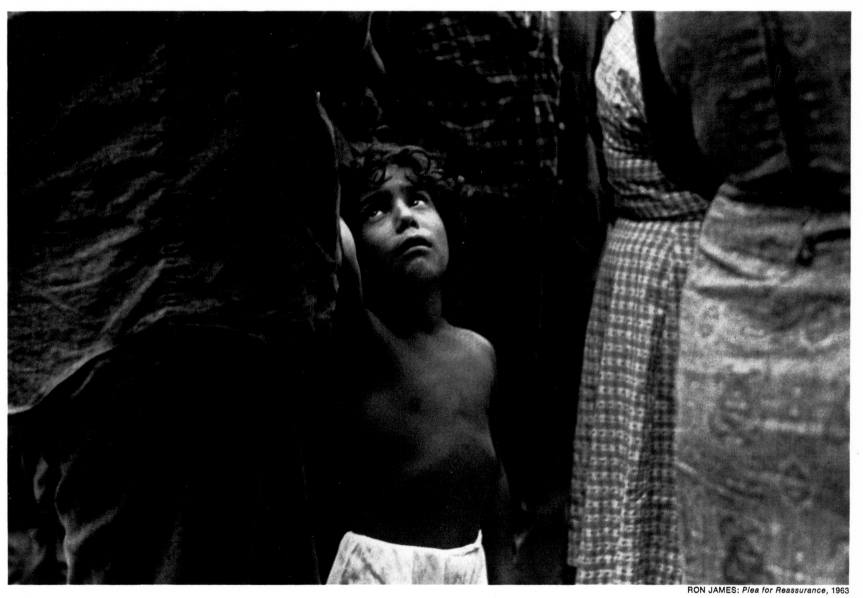

RON JAMES: *Plea for Reassurance*, 1963

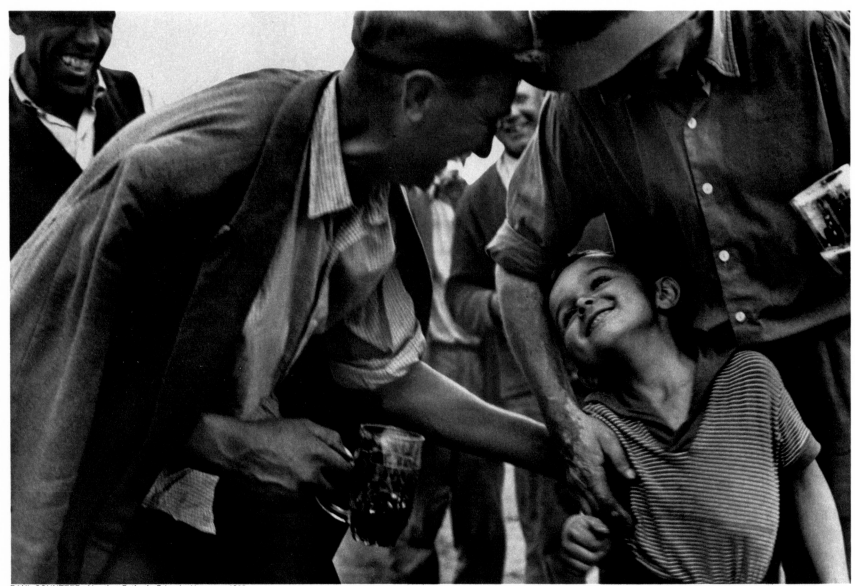

PAUL SCHUTZER: *Meeting Father's Friends*, Hungary, 1963

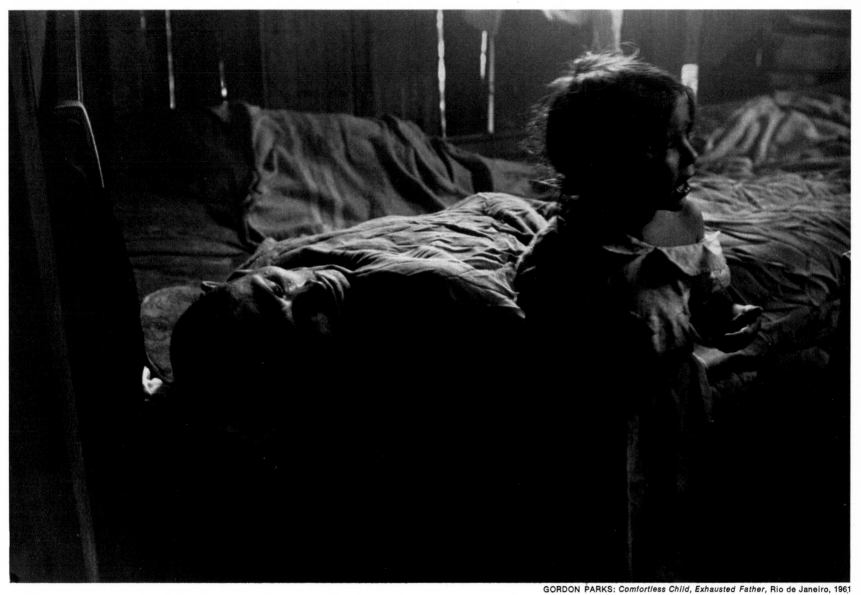

GORDON PARKS: *Comfortless Child, Exhausted Father*, Rio de Janeiro, 1961

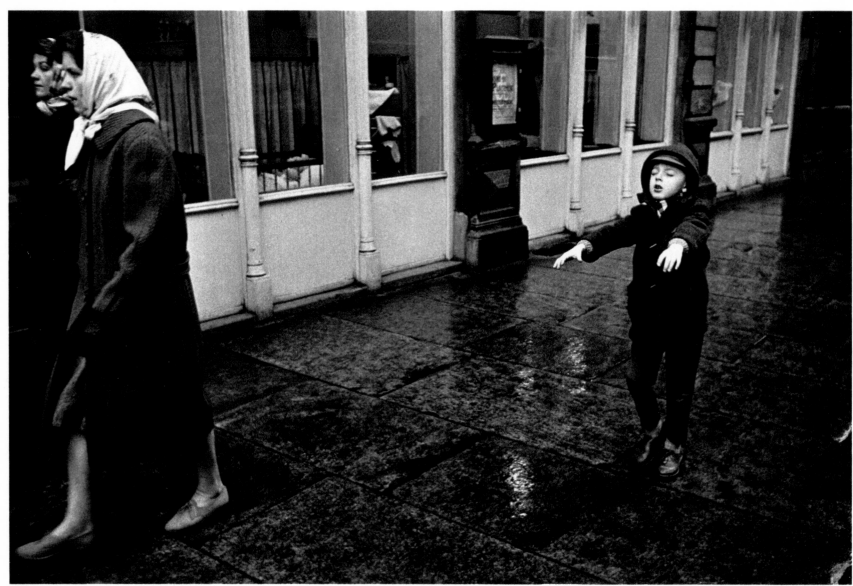

JOHN YANG: *Blindman's Bluff*, Strasbourg, 1960

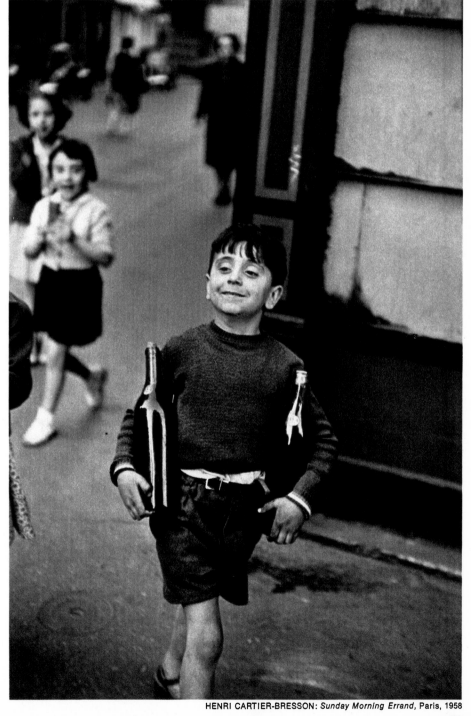

HENRI CARTIER-BRESSON: *Sunday Morning Errand*, Paris, 1958

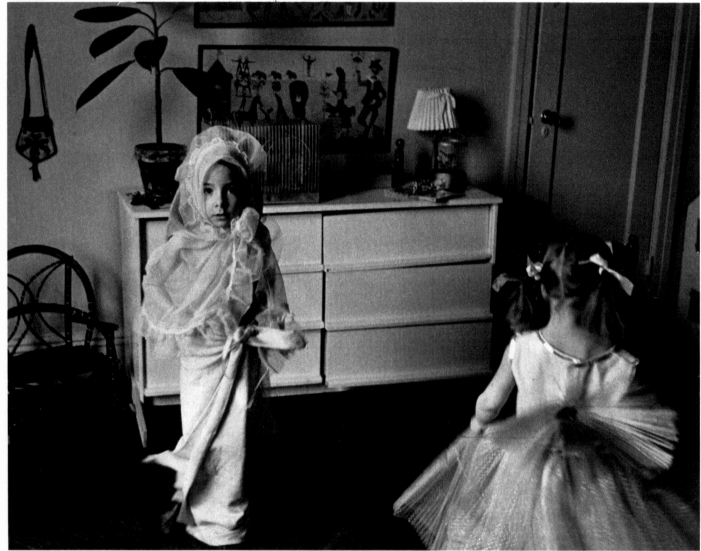

DENA: *Princesses in Borrowed Finery,* 1964

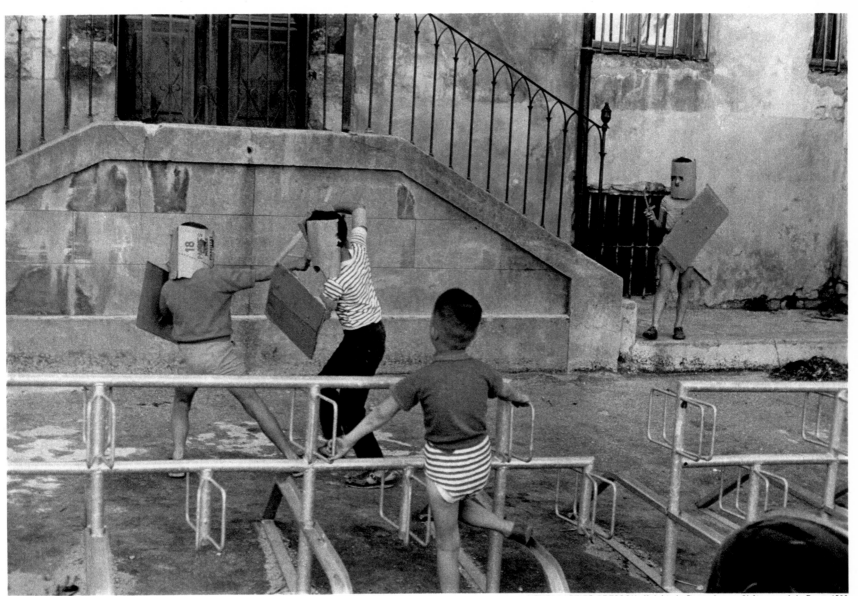

HENRI CARTIER-BRESSON: *Knights in Paper Armor*, Châteauneuf-du-Pape, 1960

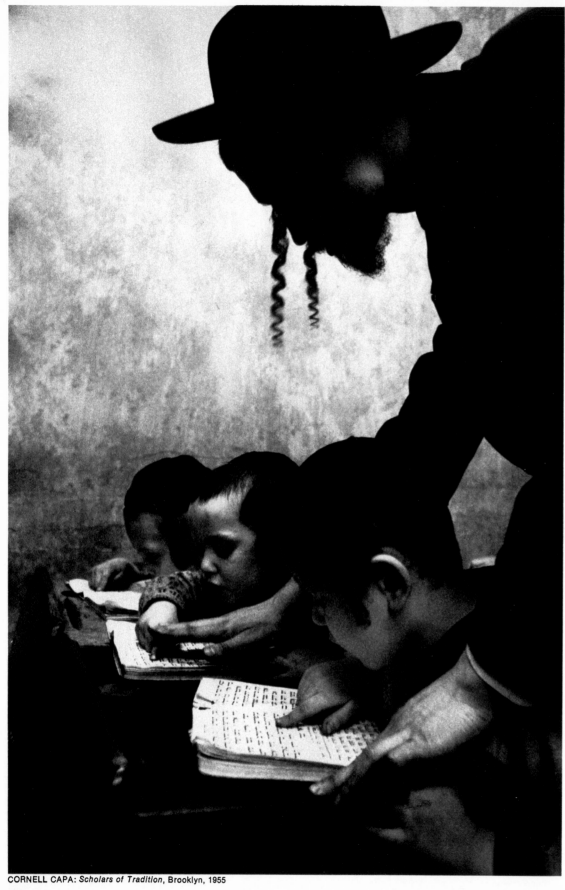

CORNELL CAPA: *Scholars of Tradition*, Brooklyn, 1955

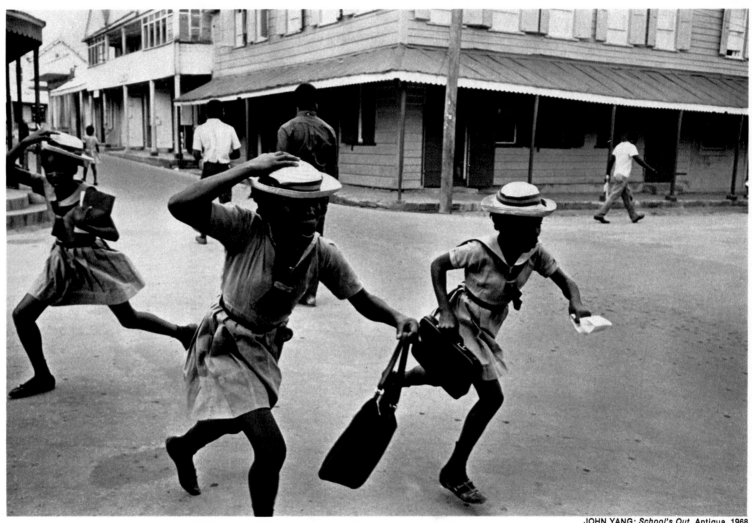

JOHN YANG: *School's Out*, Antigua, 1968

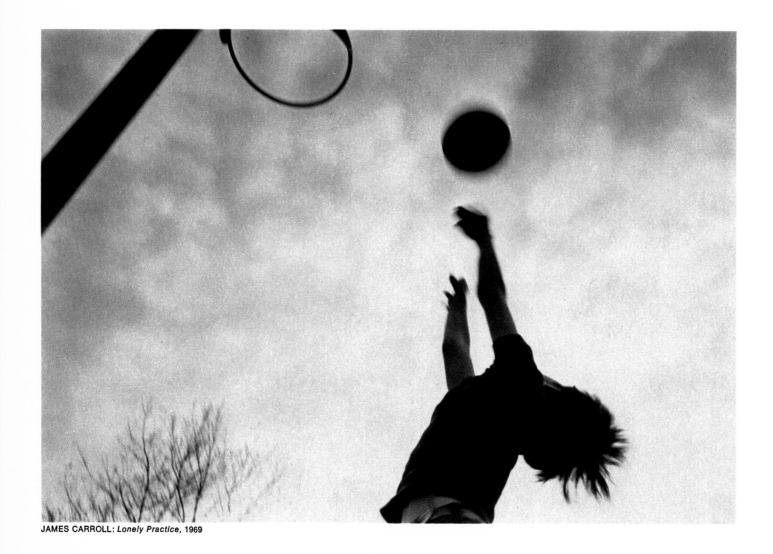

JAMES CARROLL: *Lonely Practice*, 1969

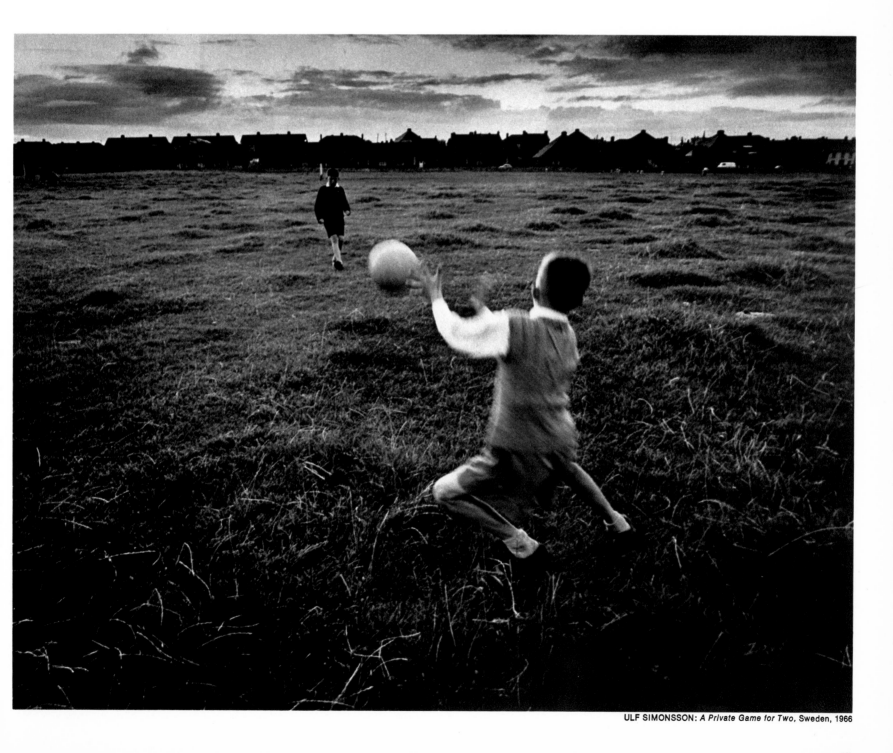

ULF SIMONSSON: *A Private Game for Two*, Sweden, 1966

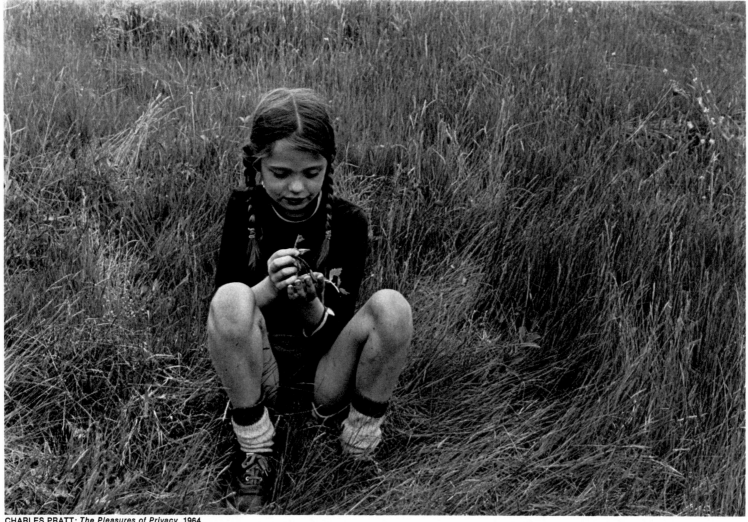

CHARLES PRATT: *The Pleasures of Privacy,* 1964

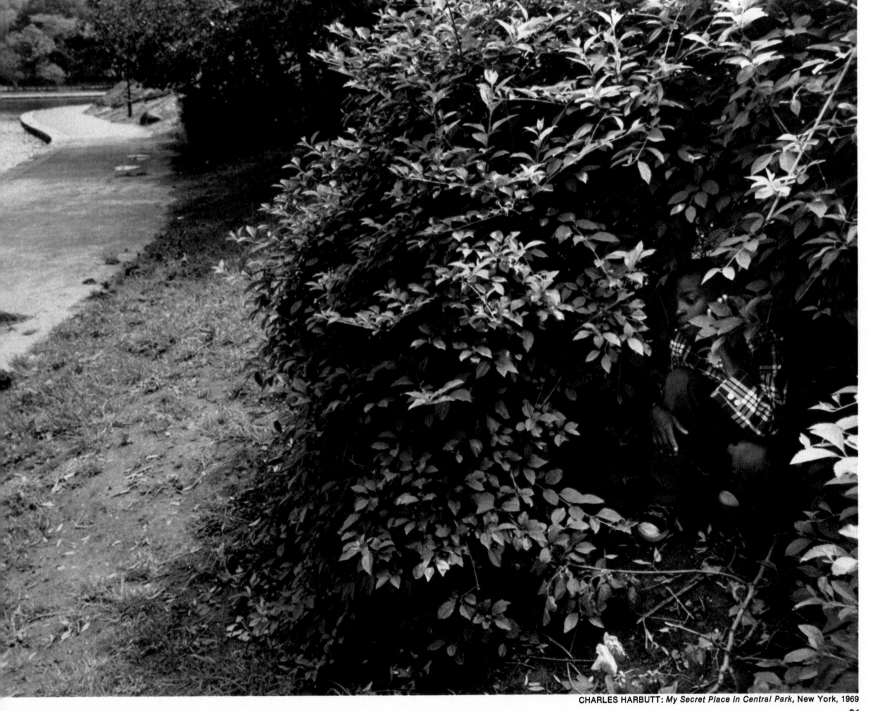

CHARLES HARBUTT: *My Secret Place in Central Park*, New York, 1969

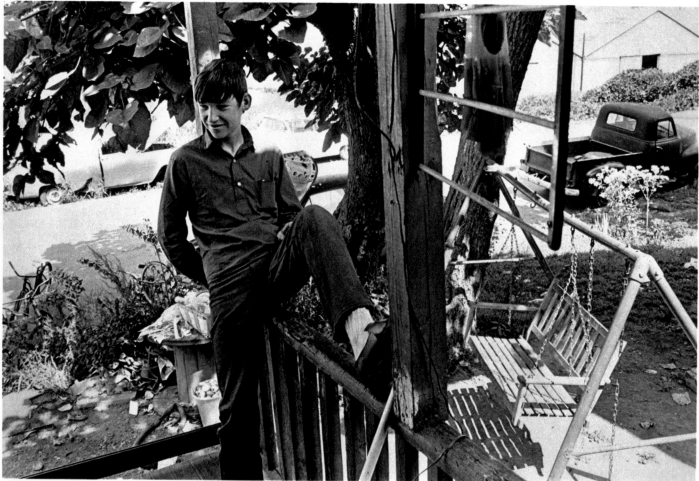

DANNY LYON: *Long Summer Afternoon*, 1967

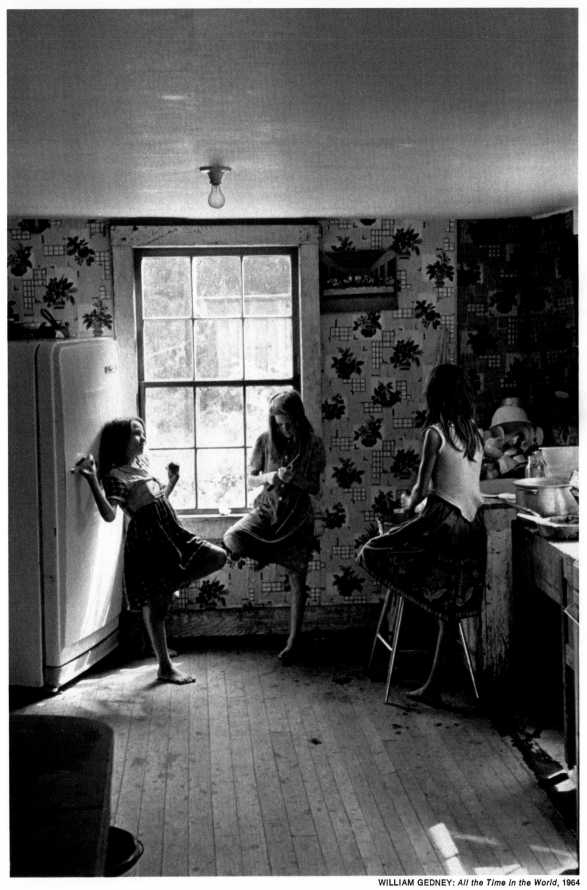

WILLIAM GEDNEY: *All the Time in the World*, 1964

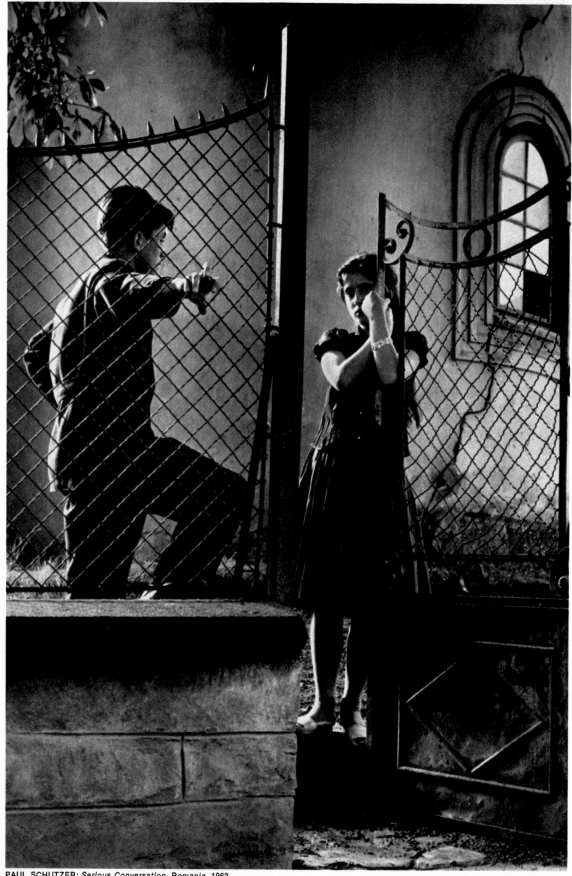

PAUL SCHUTZER: *Serious Conversation*, Romania, 1963

34

The Ideal, the Real—and the Surreal

*In the elaborate tableau vivant at right, the ►
children of Queen Victoria and Prince Albert
entertain their parents on their wedding
anniversary with an allegorical illustration of
James Thomson's poem "The Seasons." From left
they are Princess Alice, whose daughter Alix
became the last Czarina of Russia; Prince Arthur,
Duke of Connaught; "Vicky," the Princess Royal,
who became Empress of Prussia and mother
of Kaiser Wilhelm II; Princess Helena (on the
pedestal) who married Prince Christian of
Schleswig-Holstein; Prince Alfred, who married
the Grand Duchess Marie, daughter of Czar
Alexander II of Russia; Princess Louise; and the
cotton-bearded Albert Edward, Prince of Wales,
who grew up to be England's King Edward VII.*

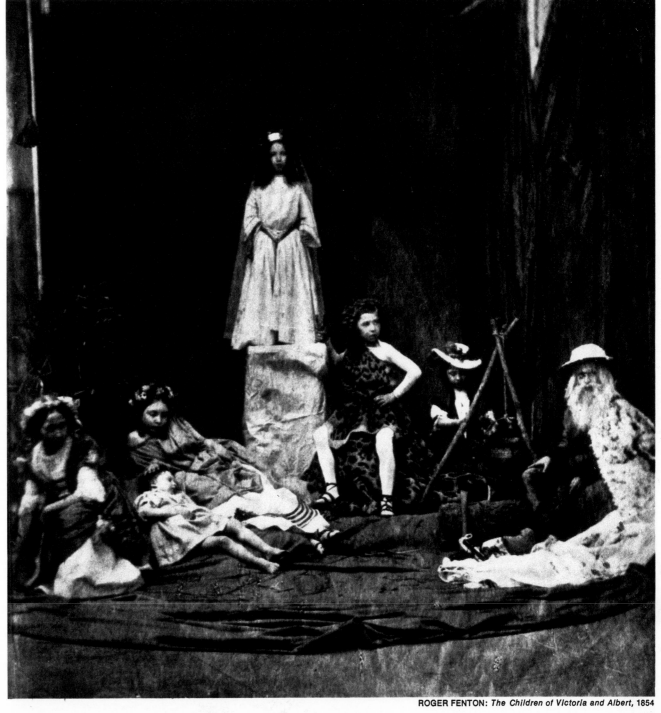

ROGER FENTON: *The Children of Victoria and Albert*, 1854

The Changing Adult View of Children

Grownups see in a child what they want to see—and if they are looking at their own offspring, they generally see something admirable. Most photographs of children accurately reflect this admiration, since the person behind the camera is usually either an obliging professional or a proud parent. Children themselves have little to say about how they are to be photographed. As infants they cannot express their opinion; by the thousands they have submitted to nude poses on bearskin rugs or sat like precious jewels on lace pillows. When they are old enough to know what they think, they are usually shrewd enough to humor adult preconceptions. Like dutiful dolls they peer pensively into a pond or obligingly mount a Shetland pony. But although most photographs of children are thus idealized, they do not always represent the same ideal. The prevailing view of children has varied so much over the years that scholars can speak of "styles of childhood" as readily as they can refer to styles of dress or architecture.

When photography was born in the first half of the last century, the majority of the adults still regarded children as little adults. Miniature grownups, dressed and posed like their parents, impassively peer out at the viewer of early daguerreotypes *(pages 40-41).* By the 1850s and 1860s, however, when photography was in full swing, most Europeans and Americans had come over to the opinion that children were something special. And now that the child no longer was regarded as a little adult, he became a little angel.

The angel-child, as William Wordsworth put it, came "trailing clouds of glory" from heaven, where he had lived until his birth. If he was an angel, his mother was a saint and the family itself was sacred. As for the Victorian father, he was a knight who ventured forth to do battle with the profane world, and then rushed back to the consoling purity of his hearth. Children were not only considered to be angelic; they were also instructed to be so. As Robert Louis Stevenson wrote in 1885 in *A Child's Garden of Verses:*

You must still be bright and quiet,
And content with simple diet;
And remain, through all bewild'ring,
Innocent and honest children.

Long evenings were passed *en famille* in front of the fireplace, reading out loud, performing charades and plays or re-creating scenes from history or art, which were called living pictures, or *tableaux vivants.* On occasion the children of Queen Victoria herself enjoyed posing in such tableaux *(previous page),* but Her Majesty thought such photographs were not suitably dignified as an image of royalty at play, and demanded that the photographer, Roger Fenton, destroy his handiwork (only one print has survived).

The narrow bounds of Victorian ideals so constricted everyday life that children and adults alike found escape in fantasy. Accordingly, when children were not photographed as their own innocent little selves they were pictured as characters from fiction and fairy tales or as children from other lands. Lewis Carroll, the author of *Alice in Wonderland,* photographed upper-class little girls costumed as gypsy beggars, Little Red Riding Hood, Turks, Romans and Chinese, and wrote in his diary that he had taken pictures of young Alexandra Kitchin "with spade and bucket, in bed, and in Greek dress." Such pictures fitted in neatly with the prevailing taste of the day as expressed by the painter Edward Coley Burne-Jones, who sought "a beautiful romantic dream of something that never was, never will be—in a light better than any light that ever shone—in a land no one can define or remember, only desire."

The Victorians, of course, were not alone in romanticizing their children. Every decade has committed its own excesses of photographic fad and fancy: Lewis Carroll's dreaming little maiden became a pseudo-sophisticated sub-debutante in the 1920s, the nation's sweetheart in the 1930s and a posturing little clown in the 1940s and 1950s.

But must pictures of children always embody some adult view? Until children themselves become expert behind the camera, the record will perhaps always be biased; but at least some serious grownups now attempt to assimilate the child's own point of view. These photographers (some of whose work is shown in the latter part of this chapter) have either plumbed memories of their own childhood and re-created them, or have patiently studied and submitted to the reality of their young subjects—often catching them unawares. What distinguishes this work is its fidelity to the pain, curiosity and bewilderment of actual children. At their best such photographers reveal youngsters not as adults would have them be, but as they really are. □

Introducing the Model Child

The image of childhood at its least childlike is recorded in the daguerreotypes taken at the turn of the century. Frozen into position in the studio for agonizing time exposures, often with hidden clamps holding their heads, the young subjects tried to assume adult postures and adult expressions. Brother and sister stared at the camera as gravely as if they were newlyweds. If one judged solely by the evidence of surviving photographs, without any recourse to such observers as Mark Twain, one could only assume that the children of the late 19th Century were a generation of little prigs.

To some extent, and in some parts of the world, they were. At least they were urged to be. British and European children were dressed up in smaller-sized adult clothes. They played adult games and discussed adult topics, and many became prodigies: four-year-olds gave sermons, six-year-olds became Latin scholars and 12-year-olds researched and wrote learned books.

Rousseau had written in 1762 that "Nature wants children to be children before they are adults." But it was more than a century before the natural childishness of children was permitted and encouraged, and an even longer time before photography responded to the changing view. It is almost impossible to imagine any of the children on these two pages climbing a tree in bare feet. No doubt the young gentleman at far right shortly gave his squirming sister a smart smack in the chops. But it would be more than another generation before any photographer would think of considering such a childish display an honest, lifelike and therefore worthwhile picture of children.

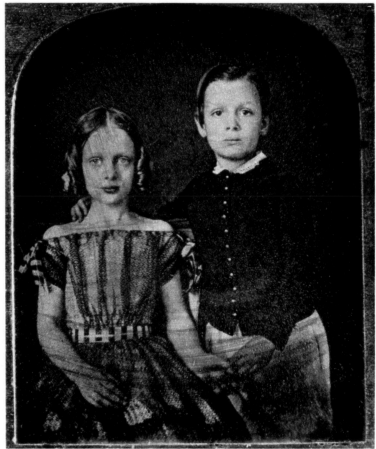

ANONYMOUS DAGUERREOTYPE: *New York Children*, date unknown

Anonymous images from a century past, two sister-and-brother pairs stare with equal impassivity at the camera. The children above held still enough, but in the picture at right the little girl has moved and her fierce expression also indicates that she did her best to escape the restraining arm of her brother. Daguerreotypes were often used by portrait painters as a visual aid, particularly when dealing with models as restless as children.

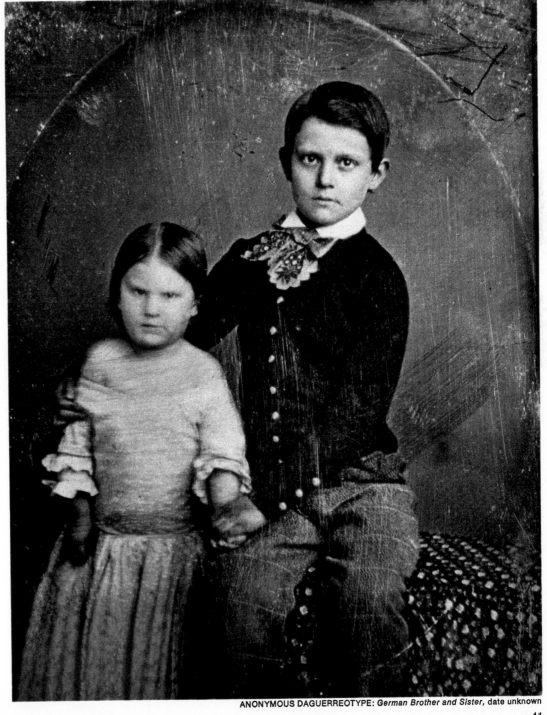

ANONYMOUS DAGUERREOTYPE: *German Brother and Sister,* date unknown

Little Angels, One and All

The cult of sentiment, which might be described as the soft, sweet center of romanticism, led Victorian photographers to pose their young models as heavenly beings, sacred and profane. In such pictures the emphasis is not on the individual child, but upon fervent innocence, as in the picture at near right, or upon an odd mixture of serenity and sensuousness, as in the photograph of Cupid at far right.

Both pictures are the work of the eminent Victorian photographer Mrs. Julia Margaret Cameron. Sitting for the brisk, ambitious Mrs. Cameron could be a trying experience for her little subjects. As her niece, Lady Troubridge, recalled in later life: "To me, I frankly own, Aunt Julia appeared as a terrifying elderly woman, short and squat . . . dressed in dark clothes, stained with chemicals from her photography (and smelling of them, too), with a plump eager face and piercing eyes, and a voice husky and a little harsh, yet in some way compelling and even charming. We were at once pressed into the service of the camera. Our roles were no less than those of two Angels of the Nativity, and to sustain them we were scantily clad and each had a pair of heavy swan wings fastened to her narrow shoulders, while Aunt Julia, with ungentle hand, tousled our hair to get rid of its prim nursery look. No wonder those old photographs of us, leaning over imaginary ramparts of heaven, look anxious and wistful. This is how we felt."

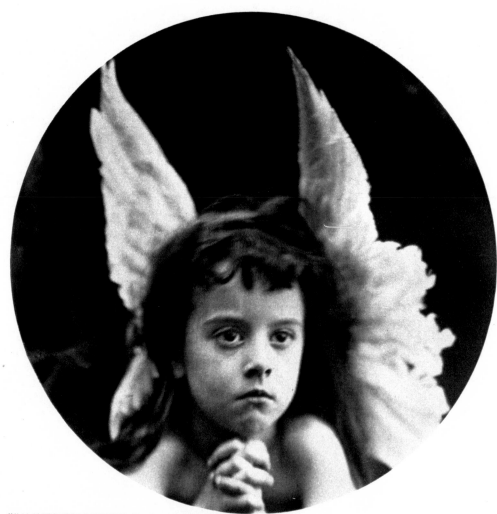

JULIA MARGARET CAMERON: *The Rising of the New Year*, c. 1872

Appearing tired and apprehensive, a young girl thought to be Julia Margaret Cameron's niece (who later became Lady Troubridge) poses as the angelic spirit of the New Year a century ago, with her hands clasped prayerfully and wings strapped onto her shoulders. Mrs. Cameron thought nothing of making her subjects—either children or adults—pose for hours on end until she obtained the photograph that she wanted.

Even though Mrs. Cameron loved to dress her child subjects as inhabitants of her fantasy world, she always managed to catch some realistic quality in them. This young girl is costumed as an ethereal cupid, but her pose, pouting lips and drooping eyelids transmit the languid, worldly sensuality of a real person beyond her years.

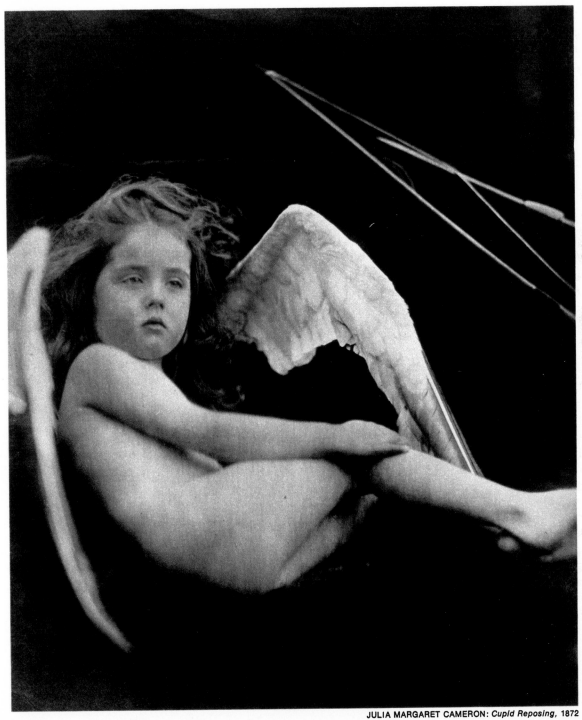

JULIA MARGARET CAMERON: *Cupid Reposing,* 1872

The Parent's Proudest Possession

One adult way of viewing children is as little dependents—as timid, clinging creatures looking to their parents for guidance and for protection against a world full of evils. This attitude was repeatedly exhibited in Victorian photographs during a period when children often had no other playmates than their brothers and sisters and when Father was the autocrat of the breakfast table, and of the lunch and dinner table too.

Queen Victoria, an accomplished autocrat in her own right, once recorded in her journal: "They say no Sovereign was ever more loved than I am (I am bold enough to say) and *this* because of our domestic home, the good example it presents."

The good example was clearly understood in millions of 19th Century homes: in return for parental guidance, protection and love, the child gave unquestioned obedience to every parental wish. The child's duty was to be seen and not heard, not because he was a potential nuisance but because attentive silence helped him absorb the wisdom flowing from parental lips. That is how he was photographed, as his parents' proudest (and, ideally, least troublesome) possession. The picture at right shows that the tradition has been alive in this century as well.

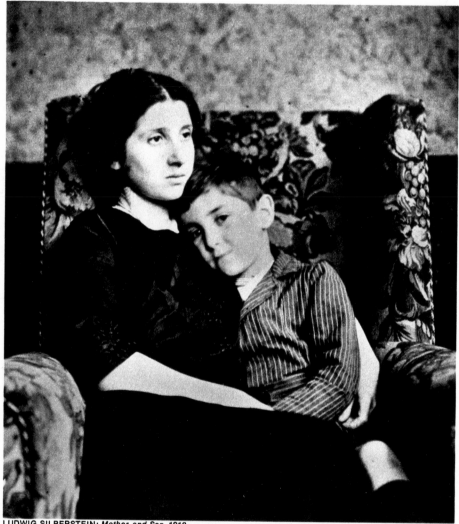

LUDWIG SILBERSTEIN: *Mother and Son*, 1913

The concept of the child as a chattel of the parent did not go out of style—photographically or otherwise—with the Victorians. Although this mother-and-son pair, snuggled together with appropriate affection, faced the camera two generations after the picture at right was made, the air of maternal authority is unmistakable.

One of a pair of identical pictures shot for the ▶ stereoscope, "The Geography Lesson" (right) re-creates an 18th Century painting by Pietro Longhi. In the original the students were women, but to make a point about filial respect the photographer replaced the adults with little girls. (They are not the children of the tutor, but models.)

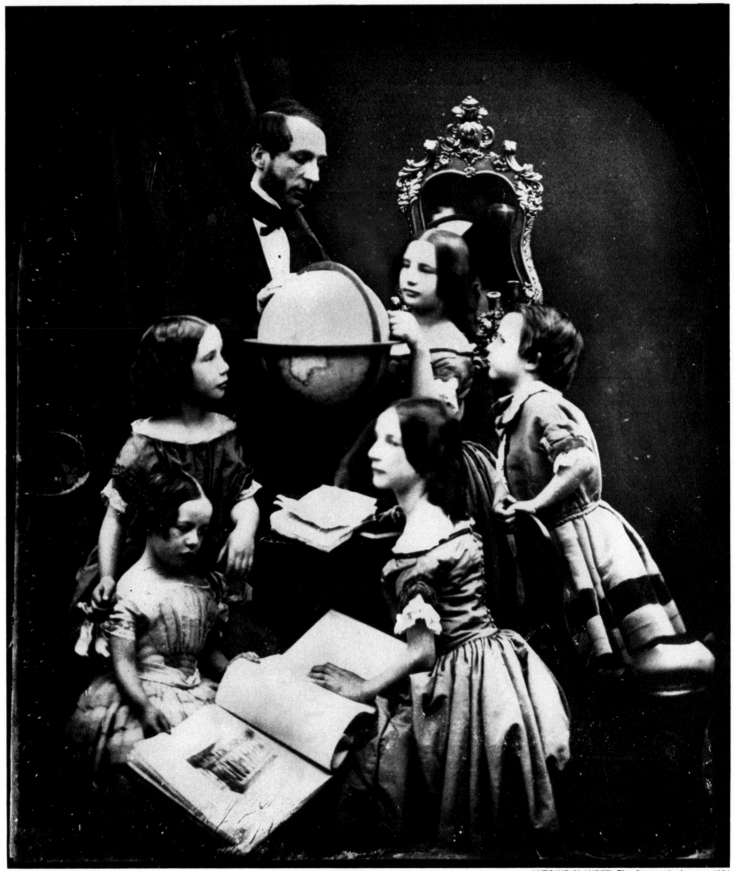

An Object of Adoration

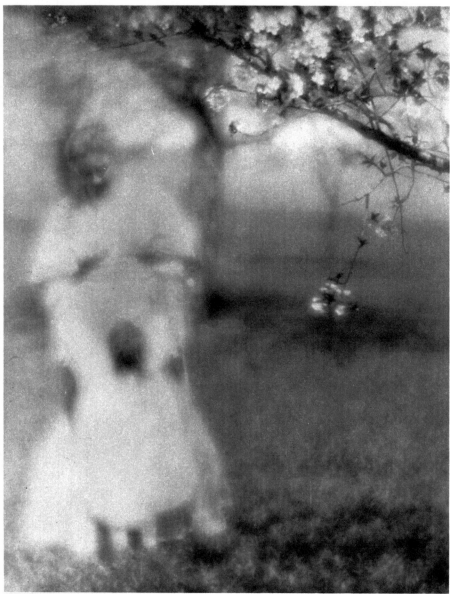

EDWARD STEICHEN: *Mary and Her Mother,* 1905

Steichen's first wife, Clara, plays with her daughter, who grew up to become the distinguished medical doctor Mary Calderone. The picture was taken out of focus and printed by the gum-bichromate process: the paper was coated with gum arabic and potassium bichromate, which varied the amount of light striking it and thus created a variety of moods.

At the turn of the century, when the young photographer Edward Steichen sought to portray the theme of mother and child, he used his own wife and daughter as subjects. His emphasis was not on a particular woman and her baby, however, but on the blur and whiteness of a spring day and on motherhood, idealized and generalized.

At this time Steichen's approach to his subjects was that of a painter. For his ethereal theme he recently had found an equally ethereal photographic treatment. The new gum-bichromate process enabled him to apply sensitized silver salts to a negative and thereby wash away undesired details or distort tones. Whites could be made whiter, shadows could be turned velvety, facial features could be softened.

This jibed with the ruling esthetic principles of the day. Most artists assumed there were only two modes of expression: realism, which depicted things as they were, and idealism, which showed them as they ought to be. A painter or sculptor could suppress distracting details with ease, but a photographer, faced with an ideal theme like motherhood, had to deal with a real woman and child. Steichen's experiments, not only with the gum-bichromate process used for these pictures but also with other colloids, glues and gelatins, freed the photograph from its servitude to the literal and released it into headier realms.

Mrs. Steichen gazes at her daughter in a picture ▶ taken at the same time as the one at left. Again using soft focus and the gum-bichromate process, Steichen re-created the diffused tone of a tenuous painting. Gauzy pictures like these led a critic to rave that they "represent the highest point to which photographic portraiture has yet been brought."

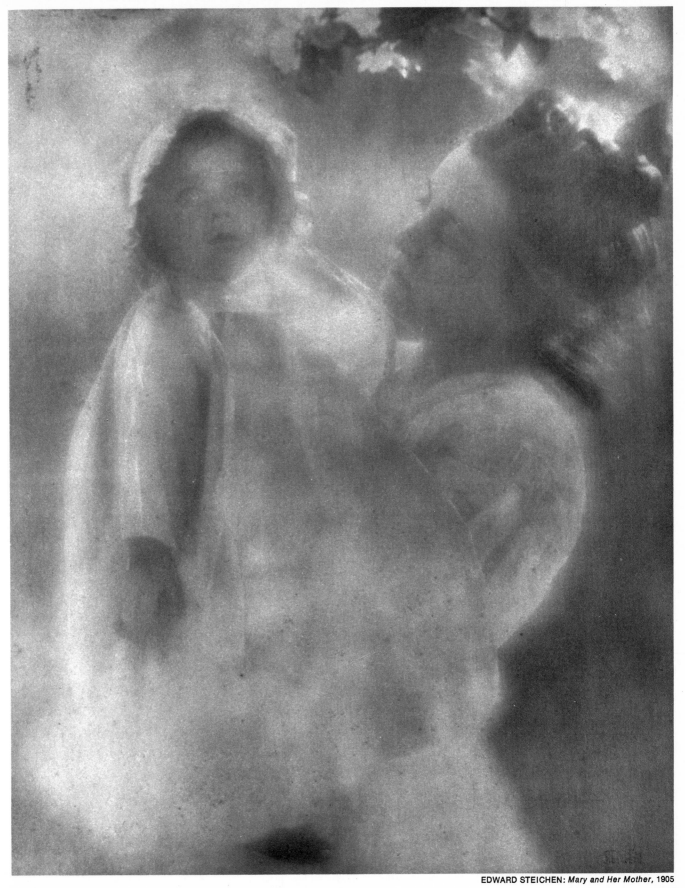

EDWARD STEICHEN: *Mary and Her Mother*, 1905

Innocent Serenity

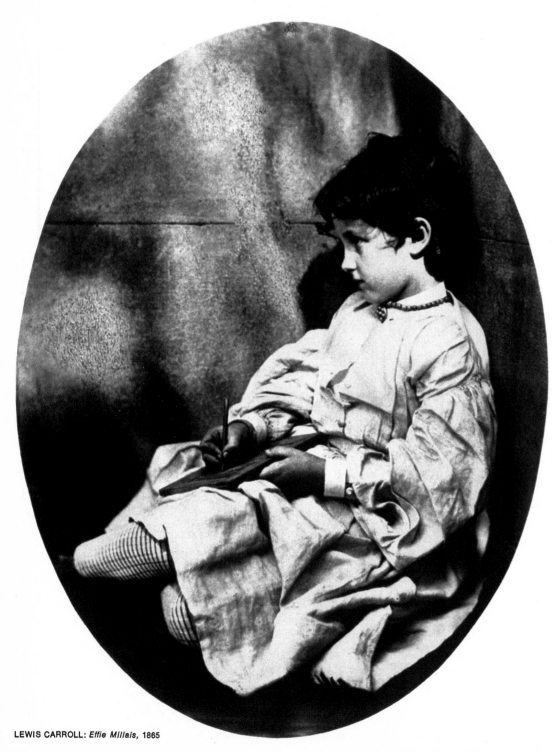

LEWIS CARROLL: *Effie Millais*, 1865

The noisy high-spiritedness that we associate with childhood today was abhorrent to the Victorians. What they found admirable—and often photographed—were calm, reflective children. (To some this ideal never went out of style. Such eminent photographers as Clarence White were still pursuing it *(right)* half a century later.) Little Victorian girls were particularly adept at combining quiet confidence and good manners; if anything as child-like as curiosity overcame them, it took the form of a rational spirit of inquiry.

All of these qualities characterize the favorite heroine of Victorian fiction, Alice; her creator, the Reverend C. L. Dodgson (a mathematics don at Oxford who wrote under the name Lewis Carroll), was also a talented photographer. Dodgson's pictures of well-bred little girls captured the same innocent spirit he immortalized in his fiction.

But the author of *Alice in Wonderland* suffered from the snobbery of his time. He photographed only high-born young ladies. Late in life he inquired after the name of one pretty child, but wrote to her teacher, "I fear I must be content with her *name* only: the social gulf between us is probably too wide for it to be wise to make *friends. . . .*"

Effie Millais looks up from the slate in her lap, an image of self-possessed good manners. Effie was the daughter of Sir John Everett Millais, one of the leading portrait painters of the Victorian era. Her mother, a celebrated beauty of the day, had previously been the wife of John Ruskin.

As serene a figure as Effie is the aristocratic ▶ "Master Tom," standing in a pose reminiscent of the famous 18th Century painting "The Blue Boy" by Thomas Gainsborough. The photographer, Clarence White, was a charter member of Alfred Stieglitz's Photo-Secession group founded early in this century. Much of the group's work was patterned on painting.

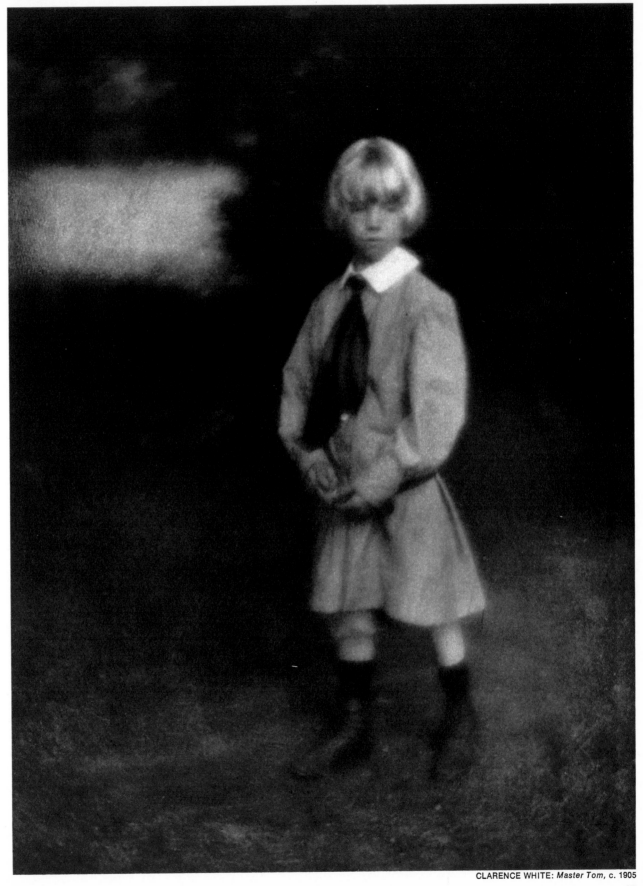

CLARENCE WHITE: *Master Tom, c. 1905*

49

The Saucy Girl, the Puckish Boy

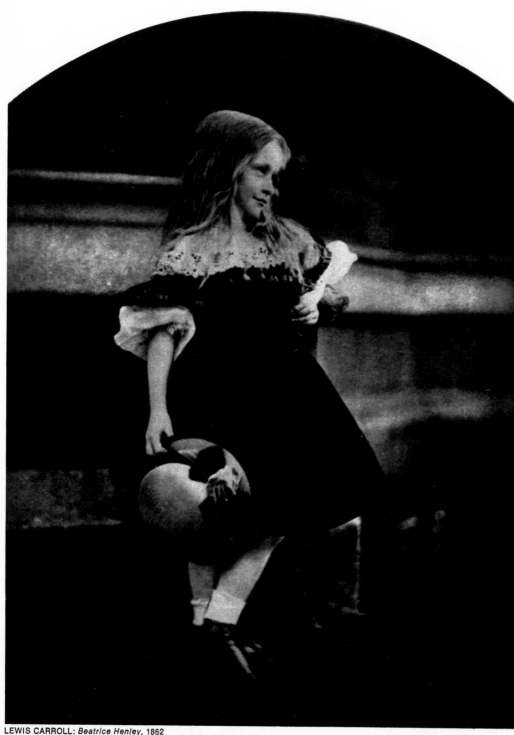

LEWIS CARROLL: *Beatrice Henley, 1862*

Smiling quizzically, Beatrice Henley seems to stare off into a world of fantasy. Beatrice was the daughter of the vicar of Putney; Lewis Carroll met her through his relatives. She almost certainly inspired one of his loveliest poems, "Beatrice."

For all his class-consciousness, Lewis Carroll was too good an observer of children to render them lifeless. Unlike most Victorian photographers of children, who clamped little heads into position against painted backdrops, Carroll avoided stereotyped poses and expressions. He was one of the first artists to see the little devil that lay just below the surface of the little angel.

By present-day standards, his photographs are not really "natural." Even sauciness and puckishness can be idealized. Idealized they were, and such pictures are the progenitors of countless freckled kids on the covers of the *Saturday Evening Post.* Yet Lewis Carroll did capture more on film than earlier photographers. He did it by winning each child's affection. His rooms at Oxford were a paradise of toys—a clockwork bear, a distorting mirror, even a flying bat that the mathematics don had made. His closets contained dozens of costumes for fancy dress pictures. On his shelves were more than a score of music boxes. "But more exciting than being photographed," one of his sitters recalled, "was being allowed to go into the darkroom and watch him develop the large glass plates."

Lewis Carroll preferred girls as his models, announcing once with unintentional humor, "I am fond of children, except boys." But he expertly caught the puckish spirit of this boy —clothes rumpled, hair tousled and clearly concocting some piece of mischief. On one occasion, when asked to teach mathematics to boys, Carroll refused. "To me they are an unattractive race of beings," he announced.

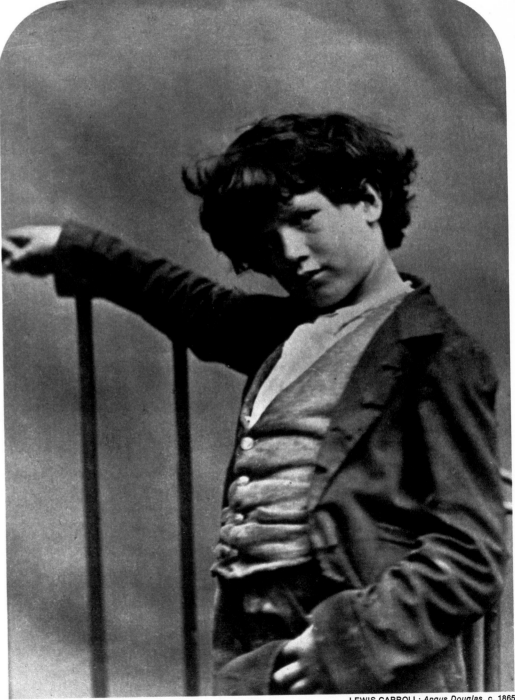

LEWIS CARROLL: *Angus Douglas,* c. 1865

The Famous Clichés

Starting nobody knows how, in the late 19th Century, small-town American photographers ground out thousands of seemingly interchangeable views of bare babies, sprawled on bearskin or sheepskin rugs. The pose became one of the great family-album clichés of all time. Then, 40 or 50 years ago, along came another cliché-maker, the itinerant "pony photographer" whose tiny-tot subjects were posed clinging to the mane of the cameraman's Shetland.

Even in crowded New York City, pony photographers regularly patrolled the sidewalks seeking families out for a stroll. Once a family had been lined up, the photographer gave the child a free pony ride, and then snapped a few pictures with his battered view camera. A few days later the parents received the finished prints, hand-delivered by the photographer himself. Only then would the photographer collect his fee and the family was free to refuse payment if not completely satisfied.

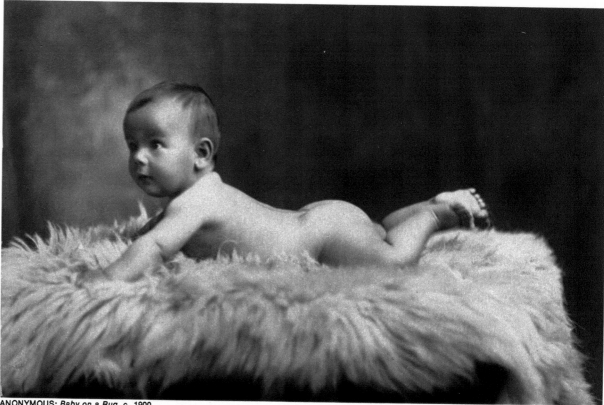

ANONYMOUS: *Baby on a Rug,* c. 1900

Two or three generations ago the baby above reposed on a sheepskin for a photographer who nicely caught the raised head, alert look and curly toes. Today the picture reposes in the archives of Culver Service—and the identity of the small subject is long lost. At right, propped up by the photographer's baggy-pants assistant, plump little Mary McGee sits astride a patient pony. Some itinerant photographers who could not afford ponies posed their subjects in goat carts instead.

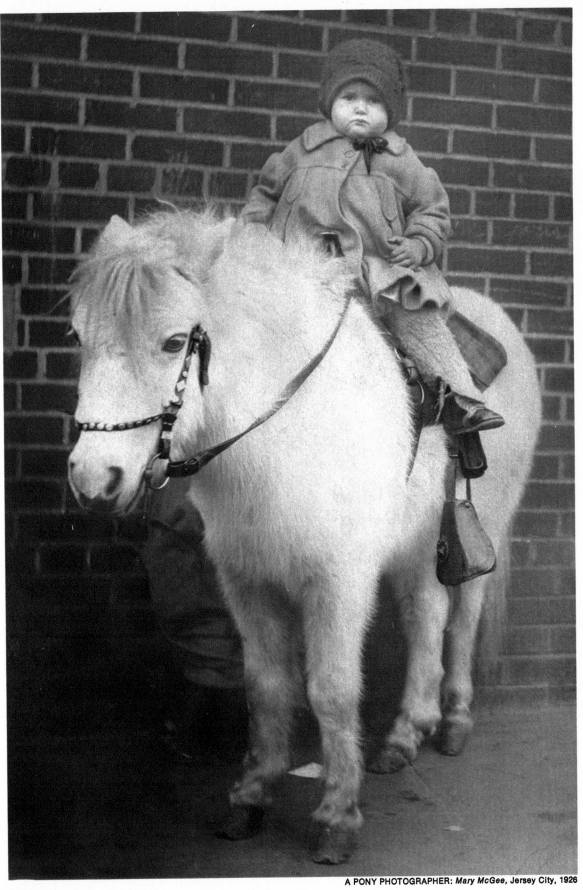

A PONY PHOTOGRAPHER: *Mary McGee, Jersey City, 1926*

A Doll to Dress Up

Parents have thought up many ways of indulging their vanity, and a favorite method is to present their children, particularly little girls, as leaders of fashion. The smart junior miss is admirable in herself; more important, she attracts admiration to her proud parents.

Blatant snob appeal marked many of the photographs of the first three decades of this century in America. Thus the *Vogue* fashion photographer Baron Gayne de Meyer placed the chic young model at right amid expensive, if somewhat eclectic, surroundings.

Professional portrait photographers also conspired with mothers to make little girls look as though they were always about to climb into a limousine and head for a lavish birthday party. Sometimes, as in the portrait at far right, the results were a bit confusing. The girl was only ten years old, but her organdy dress, sausage curls and careful pose make her appear years older. The real cow pasture behind her has been so retouched that it looks like a painted backdrop. The end product, however, was only conforming to the credo of his company, the Bachrach Studios: "People do not want a likeness, they want an idealization that will fill in their inadequacies."

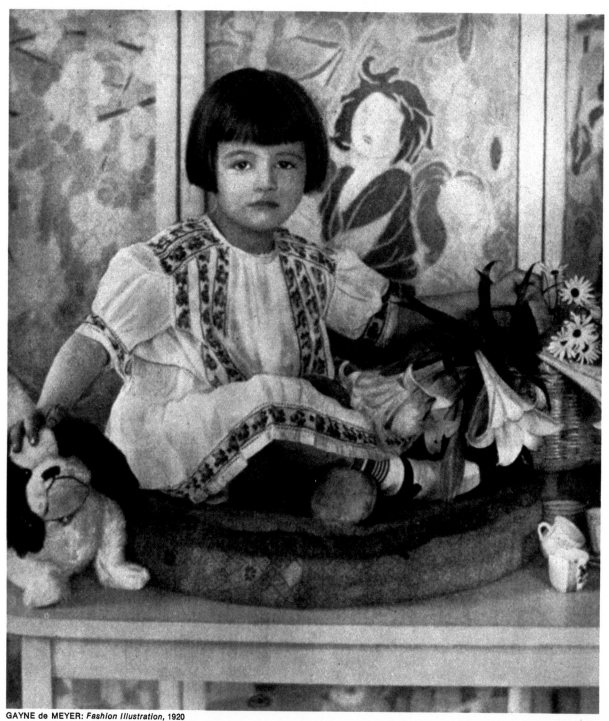

Posed in front of a Japanese lacquered screen, beside daisies and Easter lilies, a little girl displays, as the original Vogue caption put it, "the immaculate charm of a white batiste frock."

GAYNE de MEYER: *Fashion Illustration,* 1920

Assuming a dreamy look, a young lady from Boston poses on her porch for a Bachrach photographer. The Bachrach Studios, founded in 1868, have also photographed American Presidents for more than a hundred years and specialize in making portraits of society weddings, family groups and business executives.

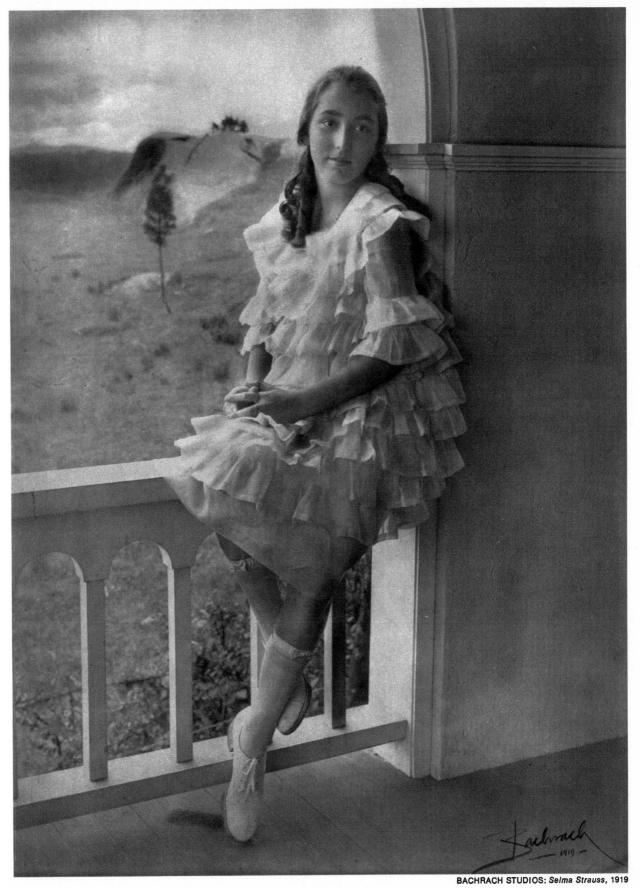

BACHRACH STUDIOS: *Selma Strauss,* 1919

The Lithe and Liberated Spirit

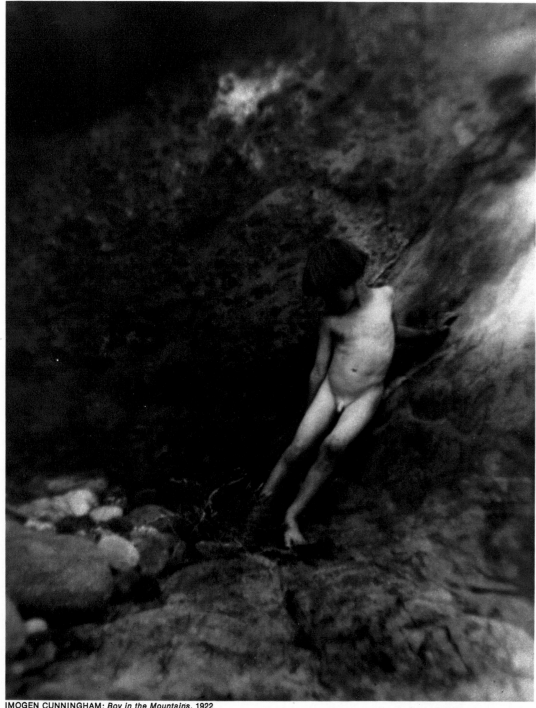

For some grownups, constrained by convention, childhood is nostalgically idealized as the time of freedom, creativity and intimacy with nature. A number of American women artists who worked in various media in the first decades of the 20th Century seized upon this remembrance of unfettered youth. The poet Edna St. Vincent Millay, the dancer Isadora Duncan and the photographers Nell Dorr and Imogen Cunningham all strenuously asserted their personal right to be free and creative; and in the blithe irresponsibility of childhood they found an emblem of the liberty they were struggling for.

Imogen Cunningham expressed this childhood freedom in a practical manner by using her own son as a model *(left)* to produce a sentimentalized result. Nell Dorr's vision of childhood was Greek and pagan *(right)*. Divested of clothes, crowned with a chaplet of leaves, absolved of all puritanical guilt, her lithe young subject celebrated the ancient rhythms of nature.

Nestling against a cliff, Imogen Cunningham's five-year-old son plays in the high Sierra. For years the photographer and her family summered in this secluded region, where the children were free to play as they wished, clothed or in the nude.

A curly-headed blond child perches in the ▶ branches of a tree in the Florida Keys—"faraway, peaceful places," wrote Nell Dorr, "where you can throw off your fears and inhibitions and bathe in the sea and the sun as you please."

IMOGEN CUNNINGHAM: *Boy in the Mountains,* 1922

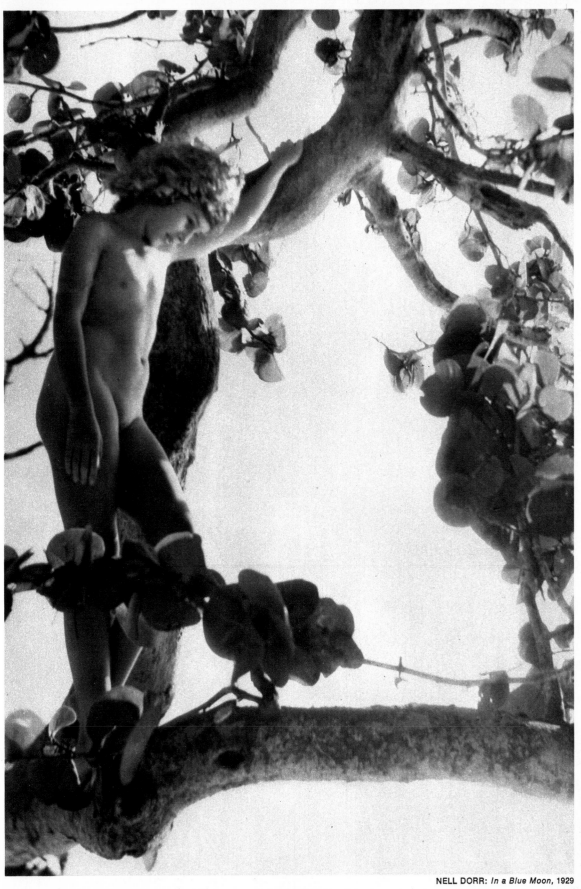

NELL DORR: *In a Blue Moon*, 1929

The Nation's Sweethearts

WILL CONNELL: *Sunkist Baby, 1933*

This was the "Sunkist Baby" of the 1930s, a baby girl photographed in all her chubby-cheeked charm for an orange juice advertisement. To California orange growers and their advertising agency, her wholesome joviality and bright-eyed confidence promised just the right image to help reassure—and sell orange juice to—a nation troubled by the hardships of the depression.

The 1930s was the decade of the winsome child, overflowing with smiles, charm, talent and bright sayings. Advertisers pushed products by linking them with photographs of fat babies; the healthy specimen at left posed for an orange juice advertisement. The movies helped establish the trend, and the symbol and inspiration of all aspiring cuties was the nation's sweetheart, Shirley Temple *(right)*.

Shirley became a star at the age of five in the 1934 film *Stand Up and Cheer.* During the next three years she became America's biggest box-office attraction, made three or four pictures a year and earned an annual salary of about $300,000.

Soon the country was awash in Shirley Temple dolls, doll clothes, soap, books and hair ribbons. Thousands of straight-haired little girls were regularly subjected to permanent waves in order to achieve Shirley's ringleted look, especially if they were to have their pictures taken. Juvenile beauty salons opened and thrived in many towns. Studio photographers also contrived to lend the Temple image of bouncy insouciance to even the dullest, most unpromising girls. It was not always easy, for not all mothers knew how to give directions the way Miss Temple's mother did. She would call out to her daughter just before each shooting session: "Sparkle, Shirley, sparkle!" And Shirley did.

The dimpled smile that brightened the gloom of ▶ the 1930s depression (at least in movie houses) belonged to Shirley Temple, the child star who easily won the affection of America and much of the world. From her ringlets down to her polished tap-dancing shoes, Shirley was the ideal little girl and a photographer's ideal model —bright, pert, precocious and confident.

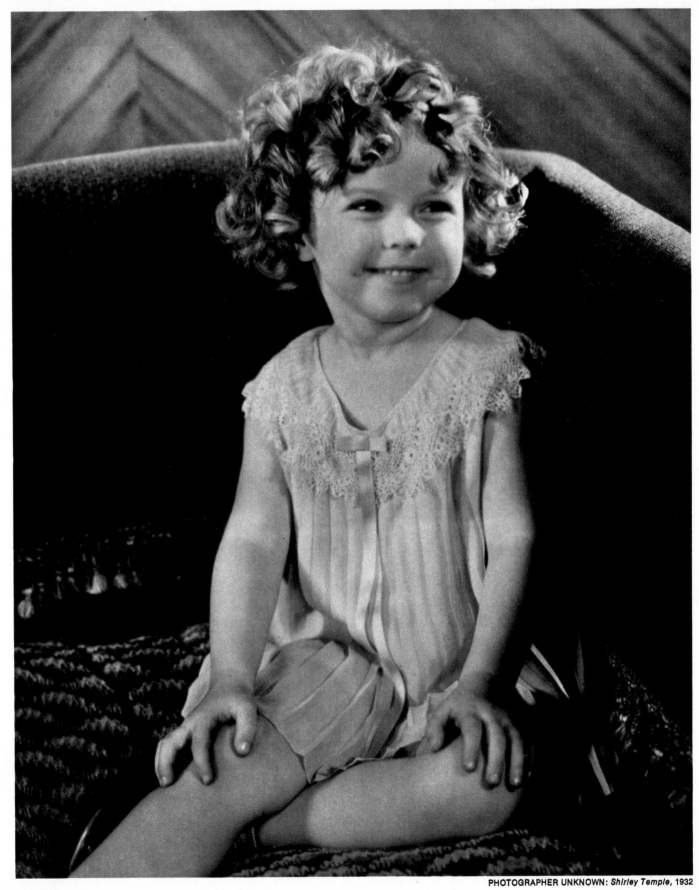

PHOTOGRAPHER UNKNOWN: *Shirley Temple*, 1932

Out of the Mouths of Babes...

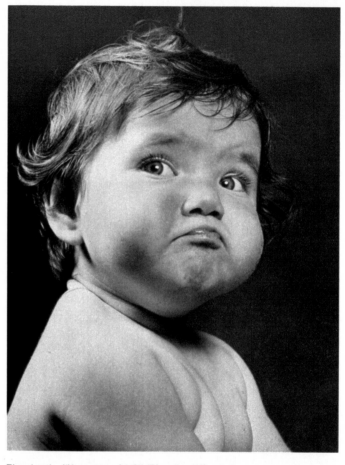

Post-operative braggart: "The doctor said mine was the most outstanding case he'd ever heard of."

The skeptic: "You wanna bet?" (The alternative caption was "That's what you say.")

For a time during the 1940s and 1950s the most widely seen baby pictures in the world were taken by Constance Bannister. A newspaper and magazine photographer from Ashland City, Tennessee, Miss Bannister invented a photographic comic strip in World War II that was syndicated in hundreds of papers. "Baby Banters by Bannister" offered four pictures a day of cute babies simpering, frowning, leering, grin-ning, with captions contrived by Miss Bannister, like the examples here.

After the war the bantering continued, on billboards and box tops, in movies and desk calendars. One collection of "mug" shots called *The Baby* had such droll questions as "What is your opinion of Hedy Lamarr?" (Answer: a drool.) The Bannister fad even had a Cold War side effect. The United States Embassy in Vienna enlarged some of her pictures and put them in a display window, replacing the original captions with such anti-Soviet gibes as "Let's see you try to collectivize the Rumanians." The Viennese were amused, the Soviets were not, the Americans felt they had scored a propaganda point —and Miss Bannister had more assignments than ever. Ultimately her baby pictures even illustrated a prayer book, captioned with pious precocities.

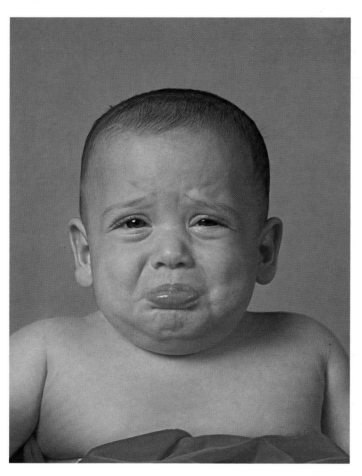

A despondent manufacturer—of tanks, toys, anything: "250,000 . . . and all defective!"

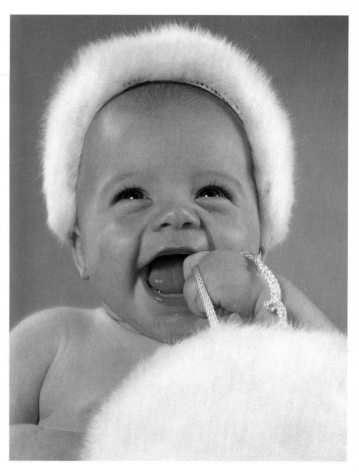

A sweet but cynical young thing: "Sure you can take me home. Where do you live?"

A Remembrance of Things Past

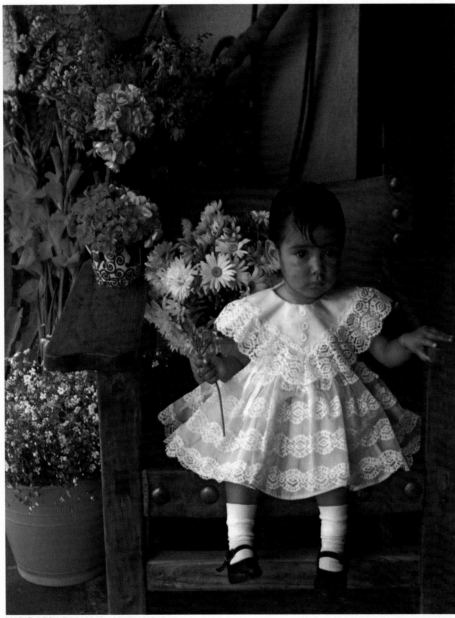

MARIE COSINDAS: *María, Mexico, 1966*

Pictures of children are clearly used to fulfill the fantasies as well as the vanities of adults. During the chaotic 1960s grownups often daydreamed of a more serene past. In the theater, many of the plays that reached Broadway were revivals; fashions alluded to the 1920s and 1930s, and rock groups evoked instant nostalgia in a younger generation by issuing remakes of rock'n'roll songs from the 1950s.

Amidst all this looking backward, children were sometimes turned into little souvenirs when photographed. They evoked not their own past, certainly, and not always their parents' past, but some still-more-remote and golden time gone long before.

In a new party dress a Mexican child rigidly grasps a bouquet. The photographer was originally planning to shoot a still life, but then spied the little girl: "She was petrified and when I asked her to move her head she just sat there like a stone figure. It was a nice accident."

Dwarfed by the handiwork of his great- ▶ grandfather, architect Stanford White, a young subject sits in a sailor suit on the heart-shaped staircase at Rosecliff, a French Renaissance palace in Newport, Rhode Island. White designed the sumptuous Rosecliff for Tessie Oelrichs, a turn-of-the-century mining heiress.

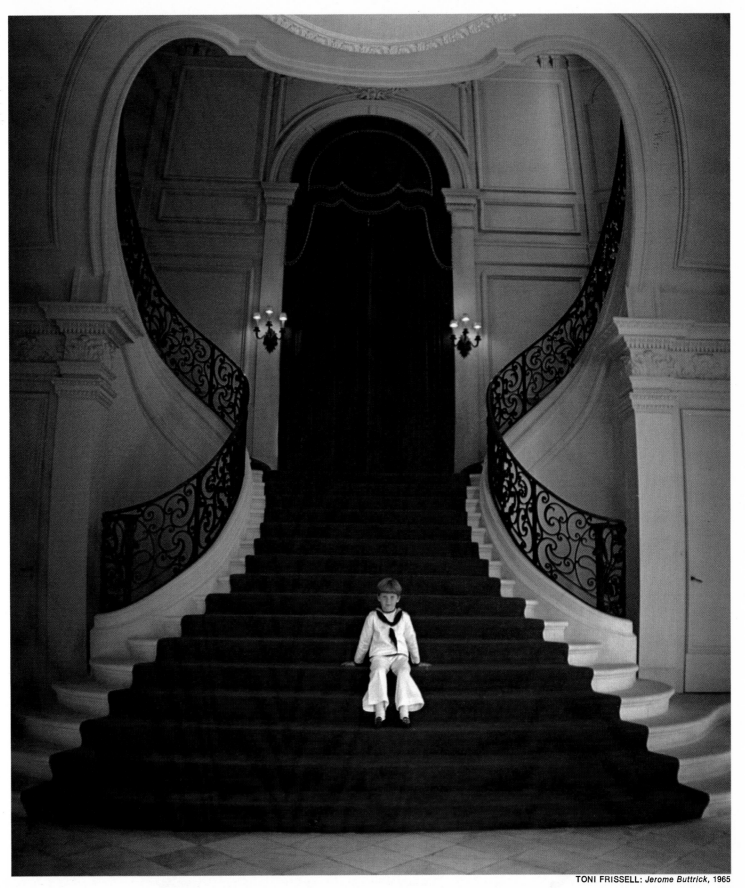

TONI FRISSELL: *Jerome Buttrick*, 1965

A Newer—and More Honest—View

The urge to idealize childhood in pictures persists today and probably will always have its advocates. But child portraiture has gone on into the realms of realism and even surrealism.

The movement toward realism began at the end of the last century as photographers saw the appeal of children at their natural daily pursuits—playing, fighting and discovering the simple pleasures of petting animals, singing in the rain or wearing new shoes. But realistic photography also revealed a lot more. It delved into the private sorrow of family grief, into shocking scenes of forced labor and into the numbing savagery of war. In all these pictures the presence of children adds poignancy to the impact of the scene.

Among the first naturalistic photographers of children was an international group that called itself the Linked Ring. Formed in 1892, this group of men applied their techniques to a large range of other subjects as well. Its members selected as their mentor the brilliant and contentious physician-photographer Peter Henry Emerson, who announced: "Whenever the artist has been true to Nature, art has been good; whenever the artist has neglected Nature and followed his imagination, there has resulted bad art."

Emerson inspired such disciples as Frank Sutcliffe *(pages 66-67 and page 69)* to take pictures of poor children, naked children and children so absorbed in their activities they were oblivious of the camera. These were not pictures to adorn a grand piano; not many parents would have been likely to commission them. Many were actually documents of urban-industrial life of the time, of ragged slum children in pursuit of their homely pleasures.

Soon after the formation of the Linked Ring a solitary French boy, Jacques-Henri Lartigue, began to record his own comfortable, upper-class childhood. He had never heard of the Linked Ring and took no interest in esthetic questions. He simply wanted souvenirs of his day-to-day life. His lively, imaginative photographs *(page 73)* demonstrated that realism need not concentrate on downtrodden subjects.

In America, in contrast to that real but happy view, a number of photographers in the opening decades of this century trained their cameras on children laboring in factories, coal mines and fields. One of the best of these American realists was Lewis W. Hine *(pages 70-71)* who realized that no matter how direct and simple his pictures might be, they inevitably expressed his personal point of view. He confessed his subjectivity by calling his pictures "photo-interpretations." Hine's subjective realism helped set the tone for the many talented photographers who were to follow his lead.

From this concern with realism in the 20th Century there grew, first with artists and then with photographers, a desire to express inner truths that transcended reality. This called for a surrealistic approach; pictures did not have to show either the literal person or the idealized child, but rather could sketch the landscape of the child's experience. By placing emotion, state of mind, attitude and impressions on film, the surrealist photographer found a haunting, sometimes even chilling, way of exploring the mysterious realm of childhood, as shown in the pictures on pages 84 through 88.

If the camera had been placed closer to the ▶ subject, this photograph would have been a formal study of the son of Napoleon III on a pony. But the photographer moved the camera back so that the backdrop, the groom holding the pony and even the Emperor and a pet dog are part of the picture. The change of camera position thus turns the photograph into a realistic view of how the idealized portraits of the time were made.

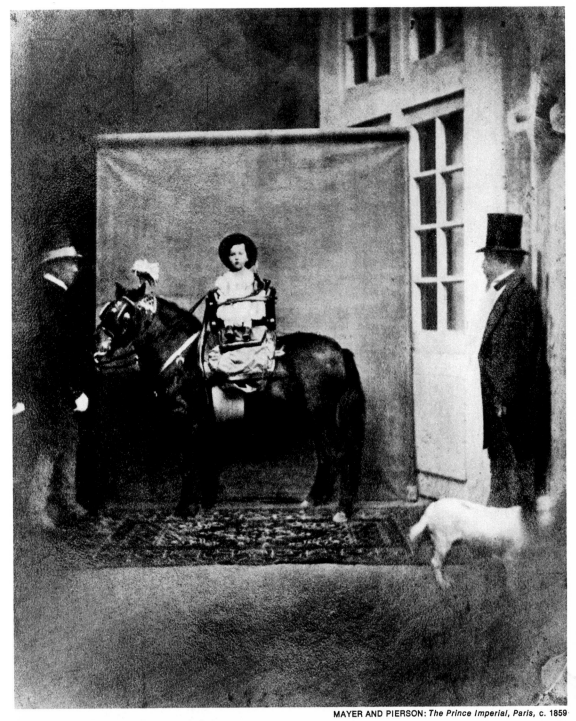

MAYER AND PIERSON: *The Prince Imperial, Paris*, c. 1859

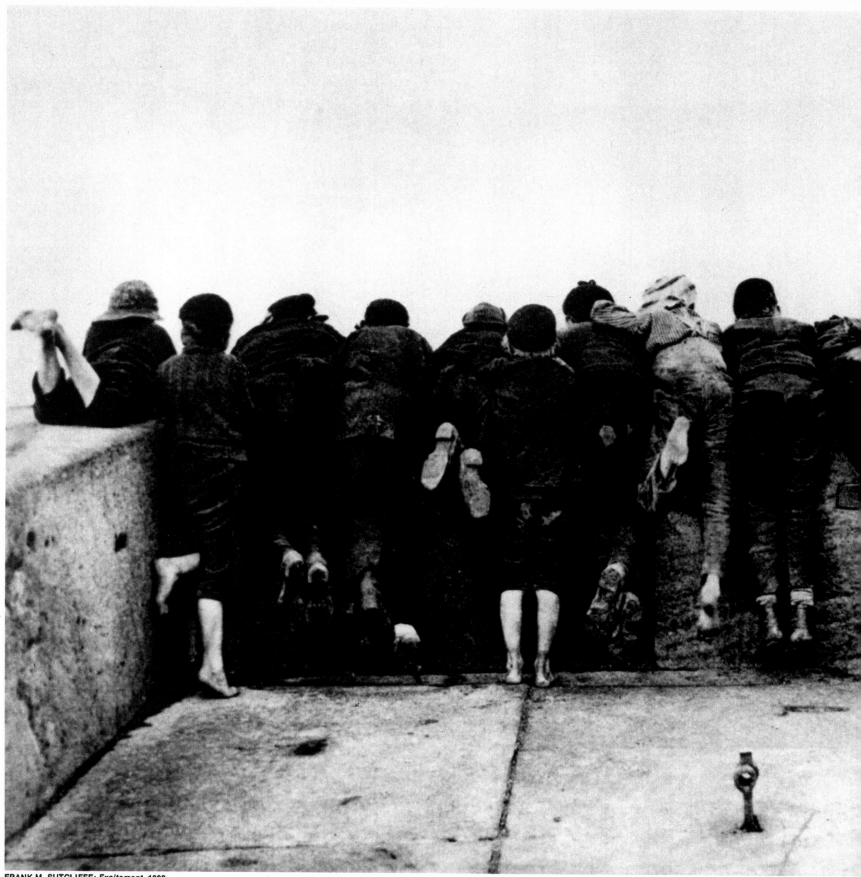

FRANK M. SUTCLIFFE: *Excitement*, 1888

Excited by some event on the other side of a wall, a ragtag band of English boys displays a motley assortment of caps, footwear, bare feet and trouser seats in this humorous picture by 19th Century English photographer Frank M. Sutcliffe. One of the Linked Ring photographic group, Sutcliffe worked to take photography away from the popular, highly stylized views of children and show them as they actually were in daily life.

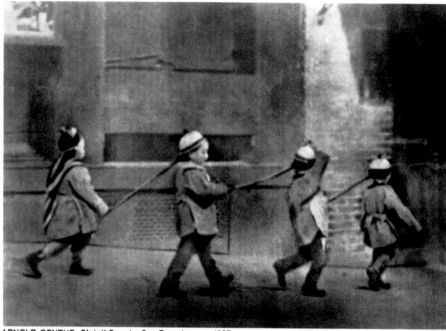

ARNOLD GENTHE: *Pigtail Parade*, San Francisco, c. 1897

Clinging to each others' pigtails, four children wend their way through the streets of San Francisco's Chinatown. At the turn of the century, the neighborhood was a small replica of Canton, complete with paper lanterns, Oriental architecture, opium dens—and pigtails for males, old and young. It was a favorite site for Arnold Genthe, an early exponent of candid photography who later became famous through his pictures of the San Francisco earthquake of 1906.

Transfixed by the spell of an airless summer day, ▶ three boys lounge on a beached fishing boat, their clothes draped on the gunwales. Although Sutcliffe and other members of the Linked Ring thought of themselves as naturalists, they nonetheless sought a poetic quality in their pictures, achieving it through rendering in soft focus everything in the photograph except its subjects—in this case the boys and the boat.

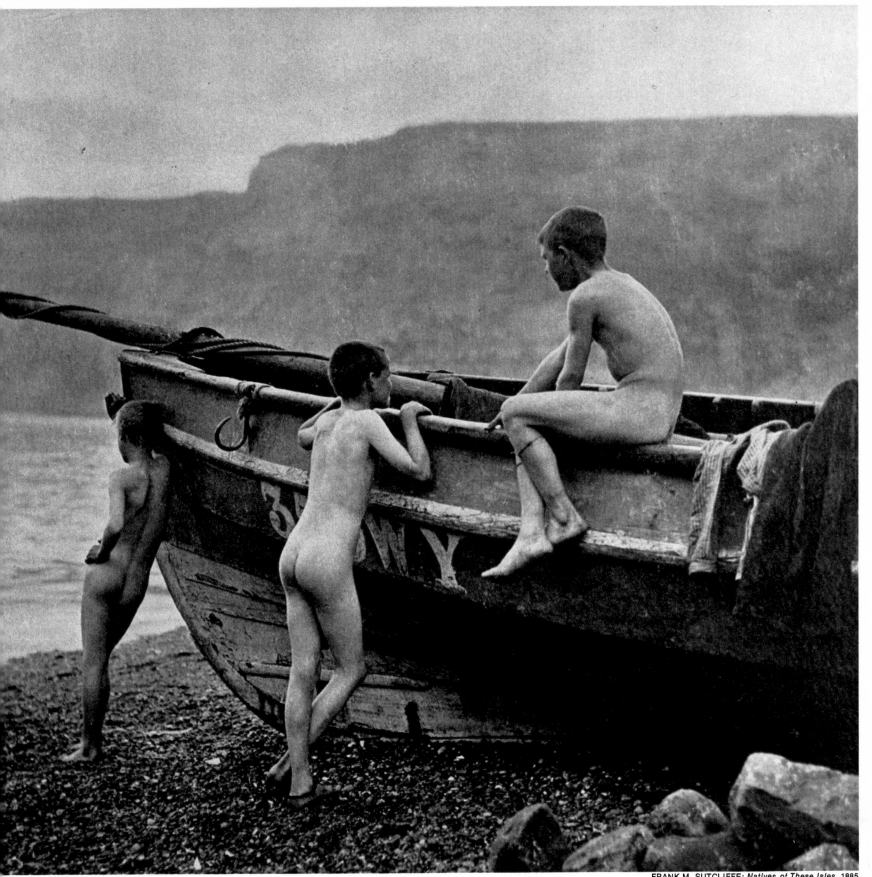

FRANK M. SUTCLIFFE: *Natives of These Isles*, 1885

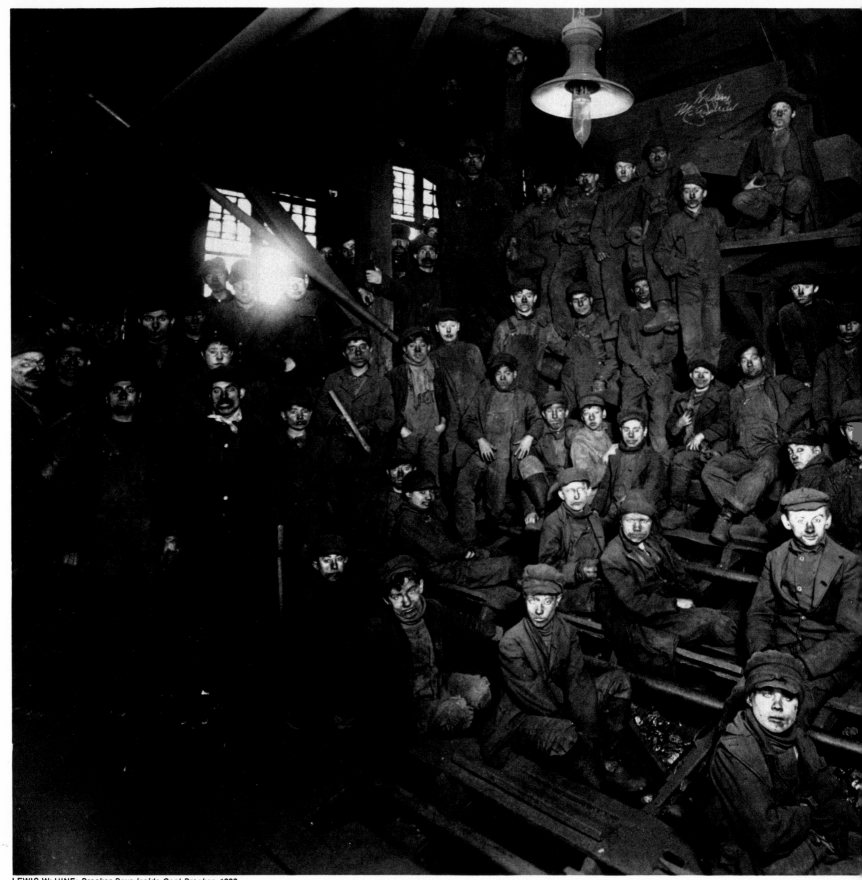

LEWIS W. HINE: *Breaker Boys Inside Coal Breaker*, 1909

70

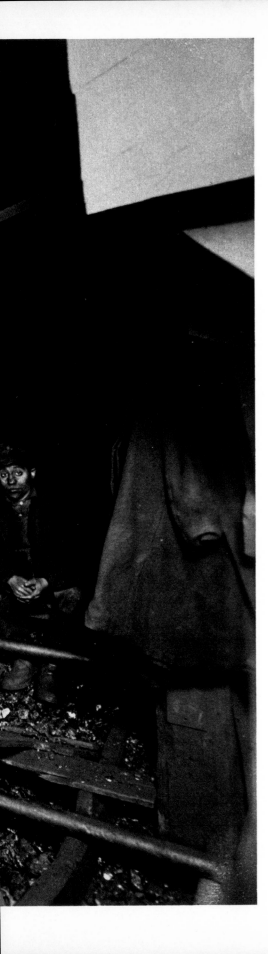

A crew of Pennsylvania breaker boys, who picked the slate out of the coal, stare into the flash of Lewis Hine's camera, their blank faces smudged by their work. Hired by the National Child Labor Committee to document the working conditions of children across the country, Hine pictured young workers in mines, sweatshops and harvest fields. His photographs helped bring about the child labor legislation enacted before 1920. Beyond being documents on which to base social reform, his works caught the spirit of his young subjects, their resignation underscored by quiet courage —even jauntiness—in the face of adversity.

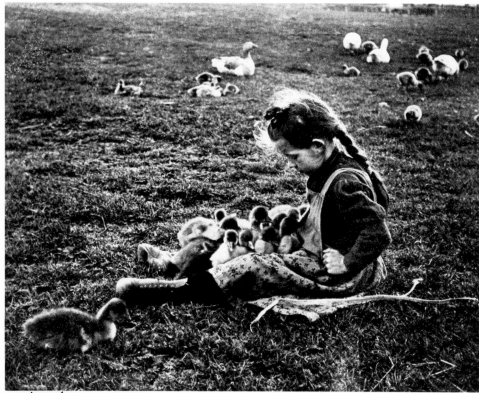

ANDRÉ KERTÉSZ: *Goose Girl*, 1918

A young Hungarian girl cannot hide a trace of apprehensiveness as she studies a lapful of goslings. André Kertész was a soldier in the Austro-Hungarian army during World War I when he saw this unposed scene as his marching column paused for a rest in the countryside.

In her shiny boots and fashionable chapeau, a ► little Parisienne receives a riding lesson along the Avenue des Acacias in the Bois de Boulogne. The photographer, Jacques-Henri Lartigue, was scarcely more than a child himself—he was 16 and evincing a strong interest in women of all ages. Perched on an iron chair similar to those beyond the teacher, he photographed the passing beauties. "Everything about them fascinates me," he confessed, "above all, their hats."

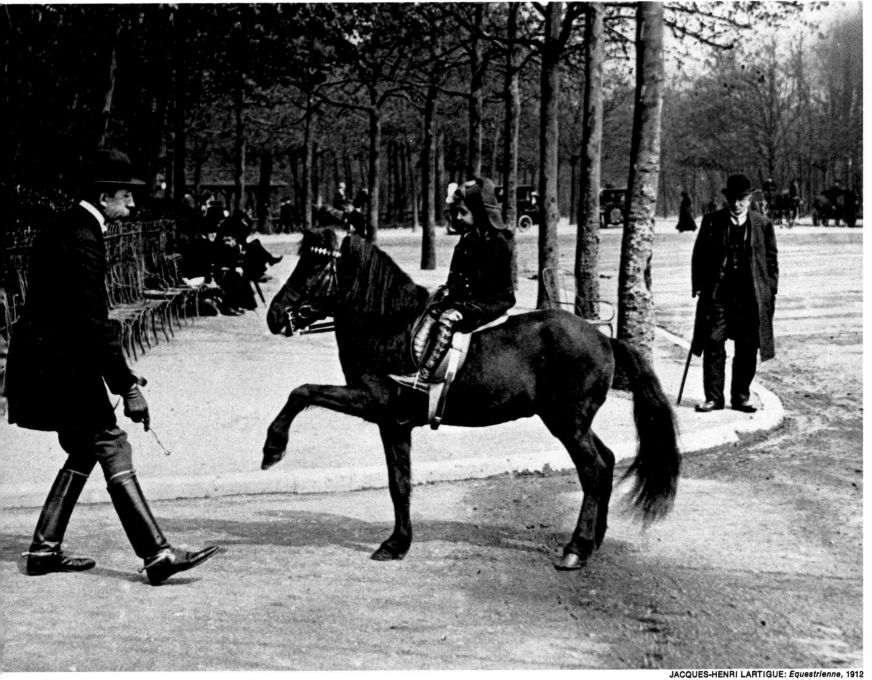

JACQUES-HENRI LARTIGUE: *Equestrienne*, 1912

73

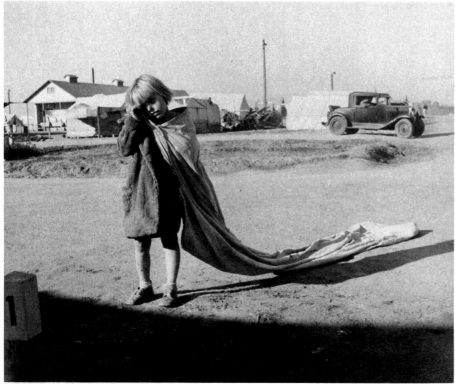

DOROTHEA LANGE: *Kern County, California, 1936*

Still half-asleep, a weary child from Oklahoma drags an empty sack into the cotton fields of California on her way to work at 7 a.m. The girl was one of the thousands of okies who fled the drought, depression and dust storms afflicting their native state in the 1930s. Dorothea Lange, working for the Farm Security Administration, followed them out to California, thereby becoming the first person to document for public inspection the lives of America's migrant working families.

In a famous study in contrast, Spanish slum ▶ children cavort happily amidst the grim ruins of a building in Seville. Even the boy picking his way through the rubble on crutches is grinning, and nearly everyone is laughing and scuffling.

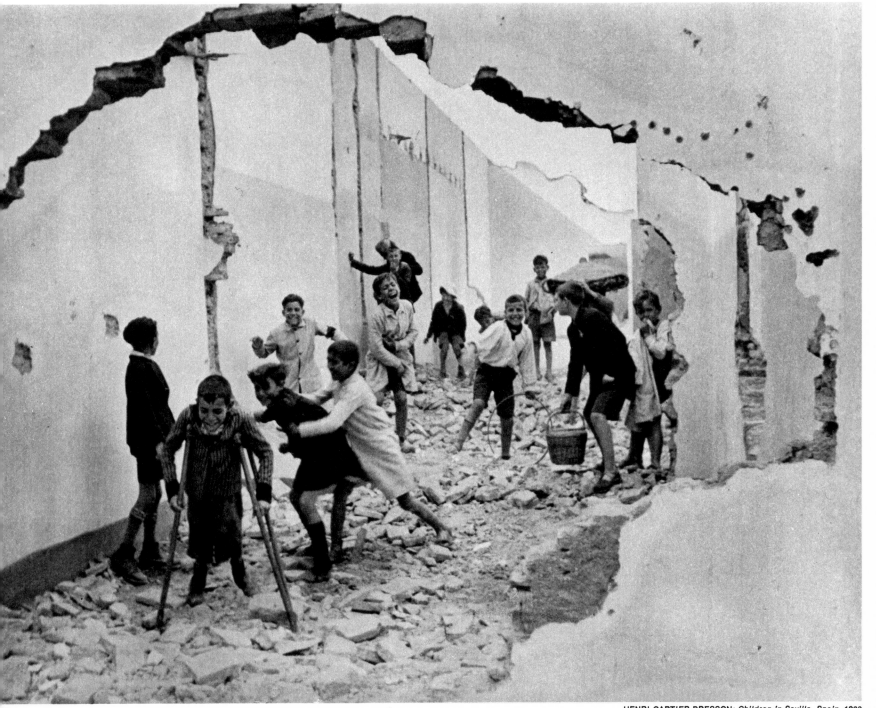

HENRI CARTIER-BRESSON: *Children in Seville, Spain*, 1933

75

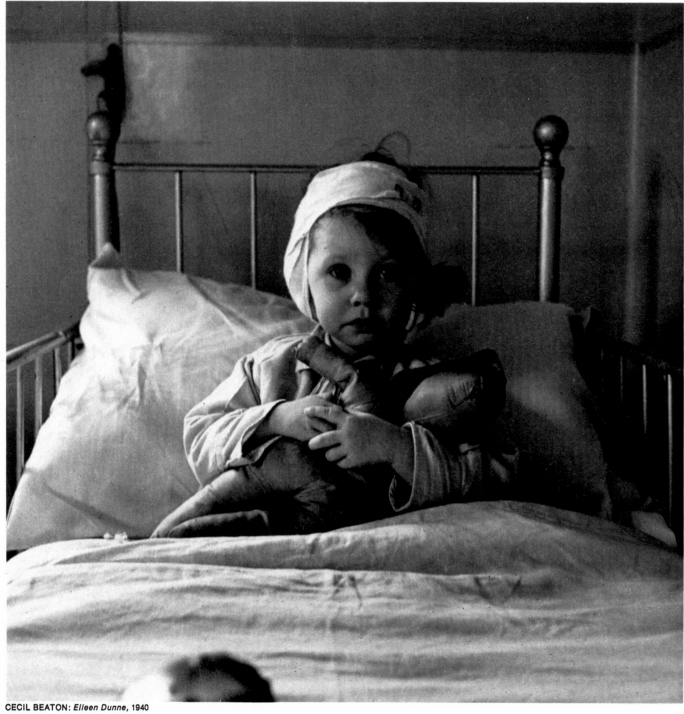

CECIL BEATON: *Eileen Dunne*, 1940

A young English victim of World War II recuperates in a hospital from shrapnel wounds suffered during a German bombing. This picture, which appeared on the cover of LIFE on September 23, 1940, represented an unexpected turn toward simple realism by the English photographer Cecil Beaton. Until the war he had been known primarily for his glossy, fanciful fashion pictures and portraits of beautifully dressed society women. Beaton says of the picture, "When I saw this strange little child, grave-faced, immobile, staring in front of her, I knew that I was about to take the best picture of my life. Would she move? The miracle happened. She remained still; shocked, wide-eyed and utterly memorable. I shall never forget the pathos."

Another World War II victim is this Polish girl who survived the bombing of Warsaw. When asked to draw a picture of her home, she scrawled these chaotic lines on a blackboard. The picture was taken by David Seymour, who had been born in Poland himself and had covered wars on assignments. It was part of a pictorial report commissioned by UNESCO, in which Seymour showed the war's effect on European children.

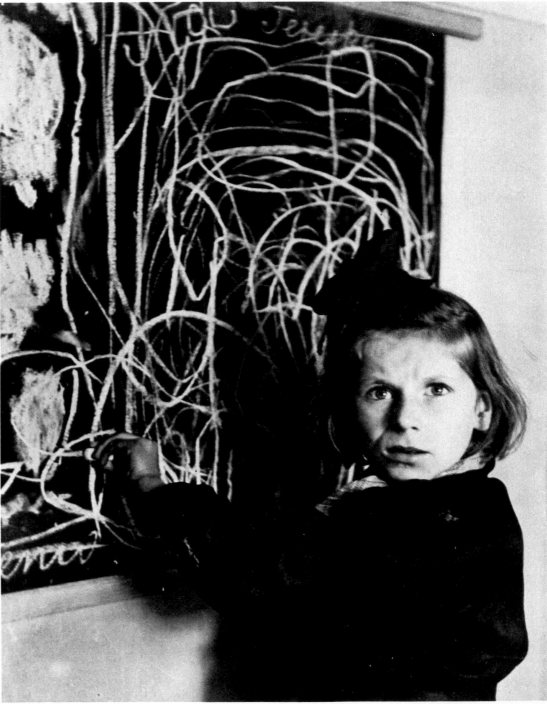

DAVID SEYMOUR: *Polish Girl*, 1948

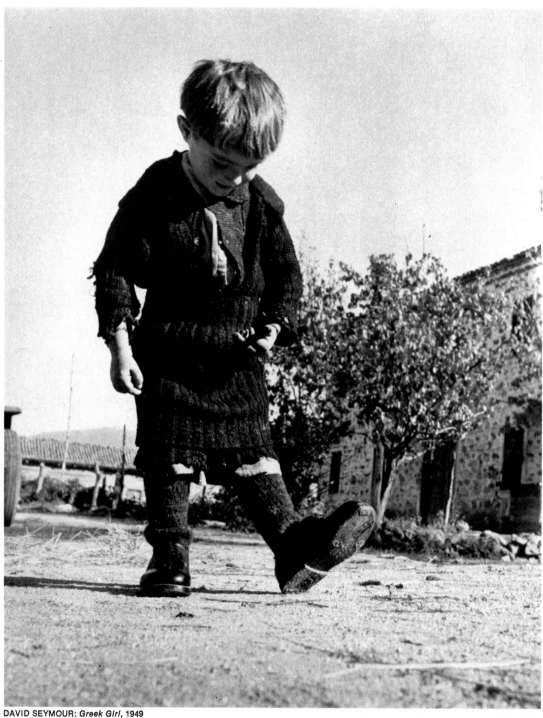

Taking a first step in a new pair of shoes, a Greek girl concentrates on the big, sturdy, unladylike and unfamiliar objects—made even larger by the camera's low angle of vision. David Seymour was a bachelor who befriended children throughout the world, always remembering their birthdays with a card or gift no matter where he was.

Three campers in hats and slickers open their ► mouths to let in the cool raindrops of a summer shower. The photographer made this picture near Lake Placid, New York, for a book about children at camp. Shot over several seasons, the photographs show that children soon overcome their self-consciousness before a camera and carry on with their games and normal activities even when a photographer is always on hand.

DAVID SEYMOUR: *Greek Girl,* 1949

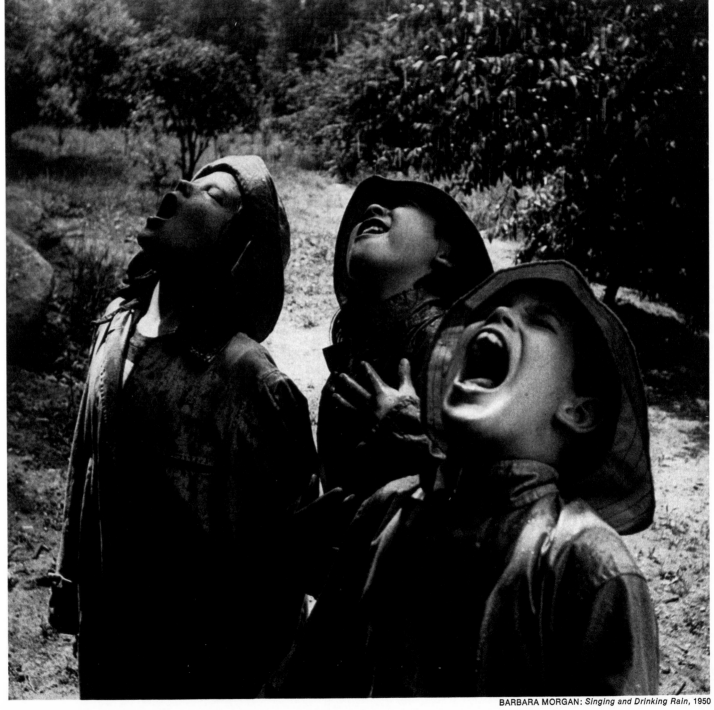

BARBARA MORGAN: *Singing and Drinking Rain*, 1950

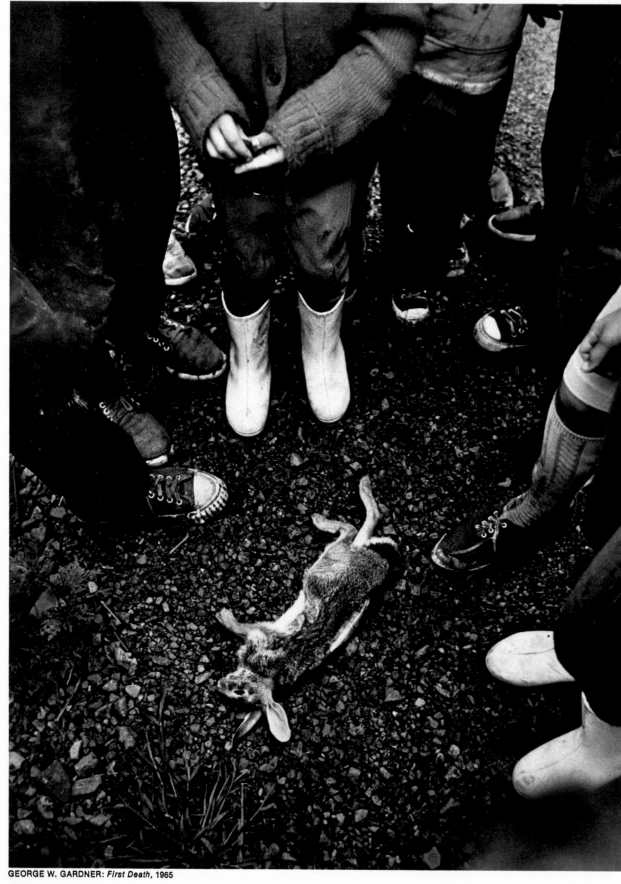

GEORGE W. GARDNER: *First Death,* 1965

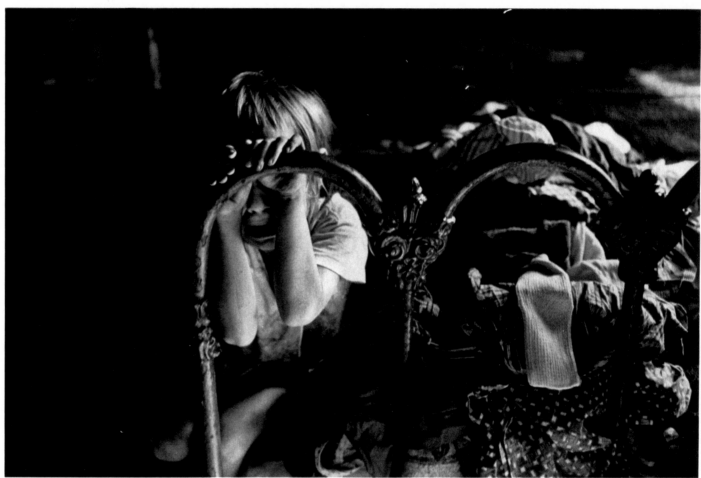

CHARLES HARBUTT: *Girl Crying*, 1964

Oblivious to the stranger in her house, a little girl sits on her mother's bed and sobs her heart out. The photographer was in Kentucky, taking pictures of poverty for the Democratic National Committee, when his car was involved in a minor accident. He was waiting in the house for a tow truck when this little girl came in, sat down and began to cry—exactly why, Harbutt never knew.

◄ *The still feet of children gathered around a dead rabbit eloquently convey the sudden awe and bewilderment they feel as they witness death. The photographer, George W. Gardner, was leading the children on a walking tour in Bucks County, Pennsylvania, when they came across the rabbit, which had been killed by a passing car—and the outing suddenly changed from festive to funereal.*

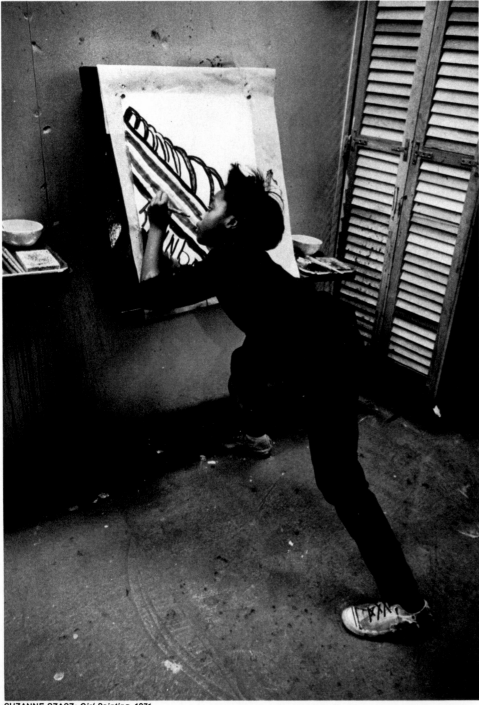

During an art program for Harlem children sponsored by New York's Museum of Modern Art, an action painter in the literal sense leans into her canvas. A wide-angle lens exaggerates the perspective so that the diagonal thrust of the girl's leg emphasizes her intense focus on her creation.

Reaching out to explore the contours of his own ▶ multiple image, a boy at New Jersey's Palisades Amusement Park gropes his way through the corridors of the hall of mirrors. The photographer spent several hours taking pictures here before he caught this moment of awed narcissism.

SUZANNE SZASZ: *Girl Painting,* 1971

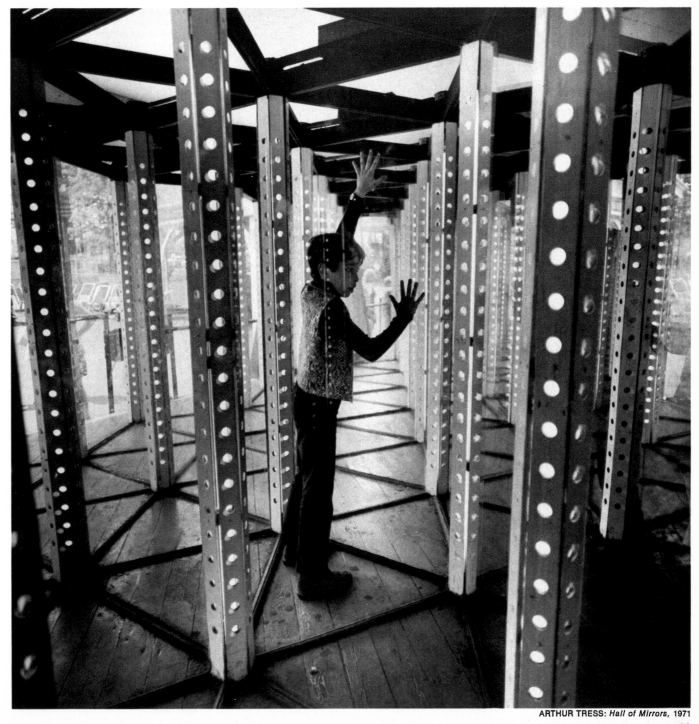

ARTHUR TRESS: *Hall of Mirrors*, 1971

83

Reaching beyond Childhood's Reality

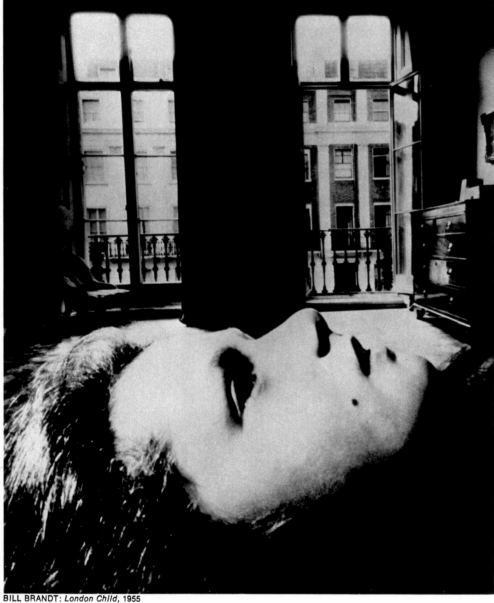

BILL BRANDT: *London Child*, 1955

In moving from realism to surrealism, the photographer leaves behind the naturalistic scenes of youth and enters a realm dominated by moods, emotions, ideas and impressions. English photographer Bill Brandt took the picture at left on a hot summer afternoon when he saw his niece resting in her family's fashionable apartment in London's Eaton Place. The tone of the picture is one of ominous calm, the close-up of the face so relaxed as to resemble a death mask, at a moment when time stopped during a young life.

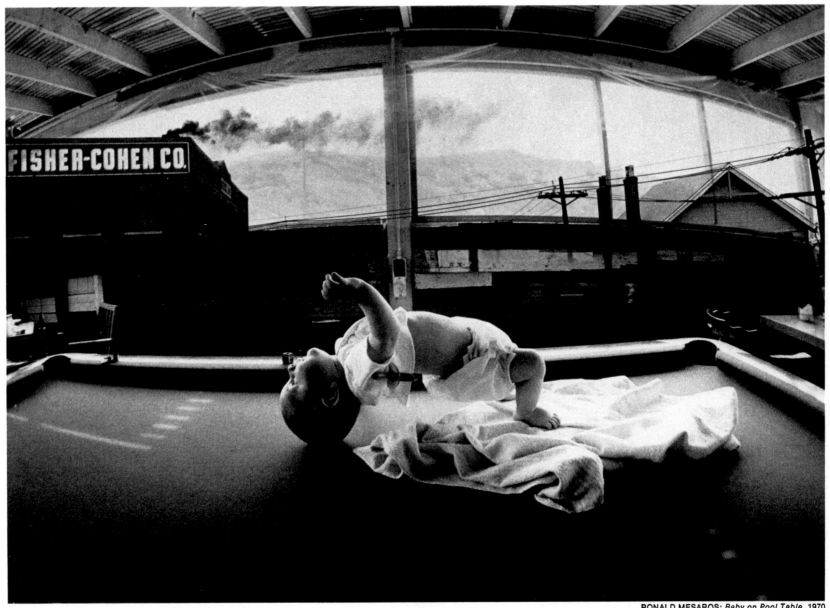

RONALD MESAROS: *Baby on Pool Table*, 1970

Catching the acrobatic back-arching of a baby placed on a pool table, the photographer used an 18mm wide-angle lens to get this effect. He later sandwiched the negative with one shot with a 55mm normal lens in Newark, New Jersey. The result contrasts the innocence of the baby learning to use his body and his eventual harsh confrontation with an industrialized environment.

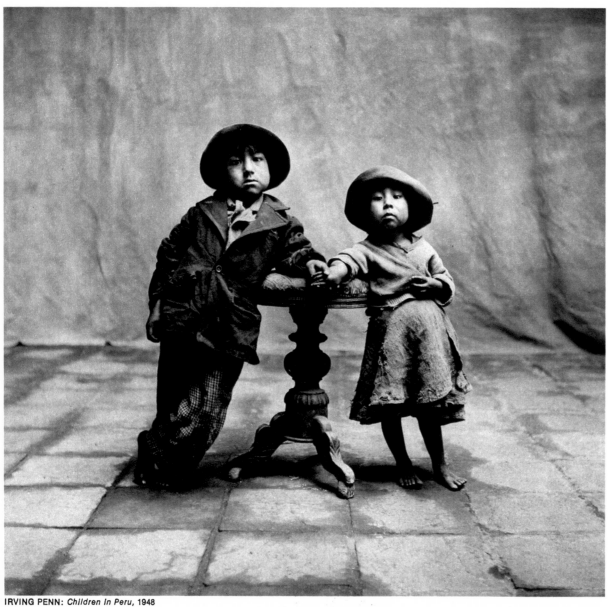

IRVING PENN: *Children In Peru*, 1948

The grave-faced pair at left, solemn as any grownup, are not dwarfs or midgets but children posed with a piano stool by photographer Irving Penn, in a studio he rented in Cuzco, Peru. Their mature faces, careworn expressions, adult-style clothes and the affectionate way in which their hands are joined all cast a surreal tone over them, making them appear old beyond their years.

A boy who had hoped to scoop up fish from the ▶ Passaic River with a colander sits instead before the hovering gas fumes, oil-slicked water and murky sky of industrial New Jersey. Since fish cannot live in this water he puts the useless colander on his head and holds an oily duck decoy he found floating in the river—a symbol of vanished wildlife. Arthur Tress took the picture during a two-year project of photographing environmental conditions around New York.

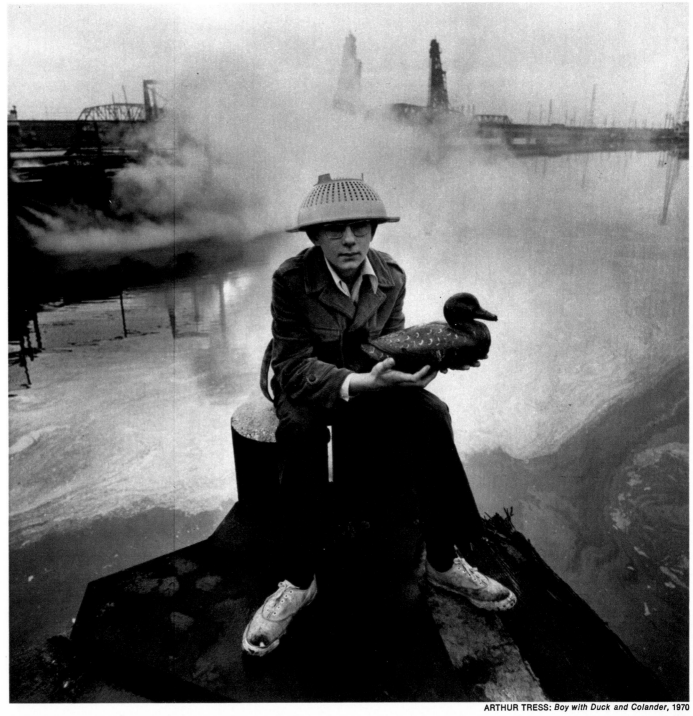

ARTHUR TRESS: *Boy with Duck and Colander*, 1970

Ideal, Real, Surreal: Reaching beyond Reality

*When the photographer saw this massive white
wall in an urban renewal project in Jersey City, he
was impressed by its huge unbroken expanse. He
placed a boy in front of it, and to add a
surrealistic touch had him put a common kitchen
strainer over his face. In the resulting
picture the boy serves as a symbolic masked
actor in a mystery play taking place before
the enigmatic backdrop of white stucco.*

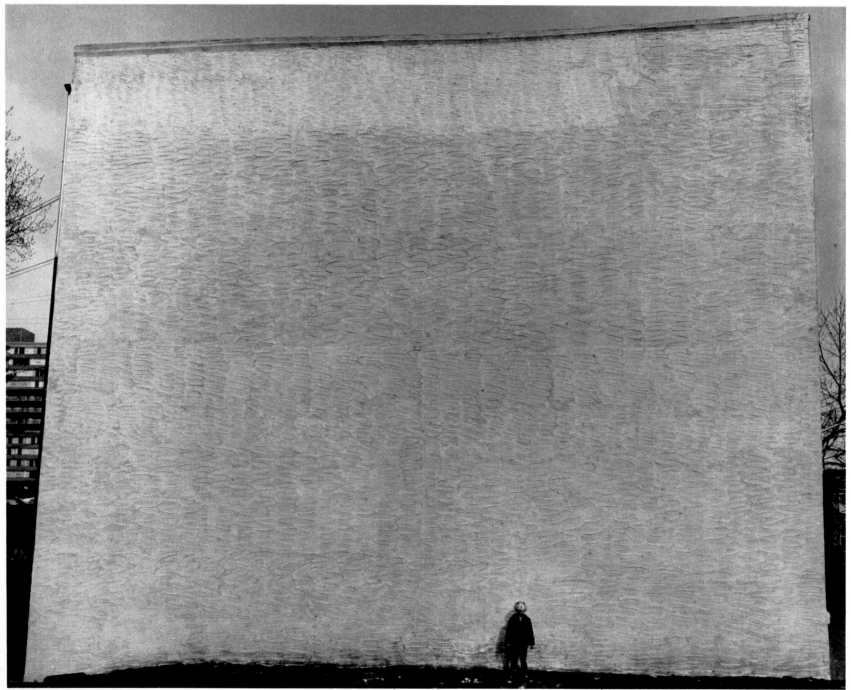

ARTHUR TRESS: *Masked Boy, 1968*

Baby Pictures **3**

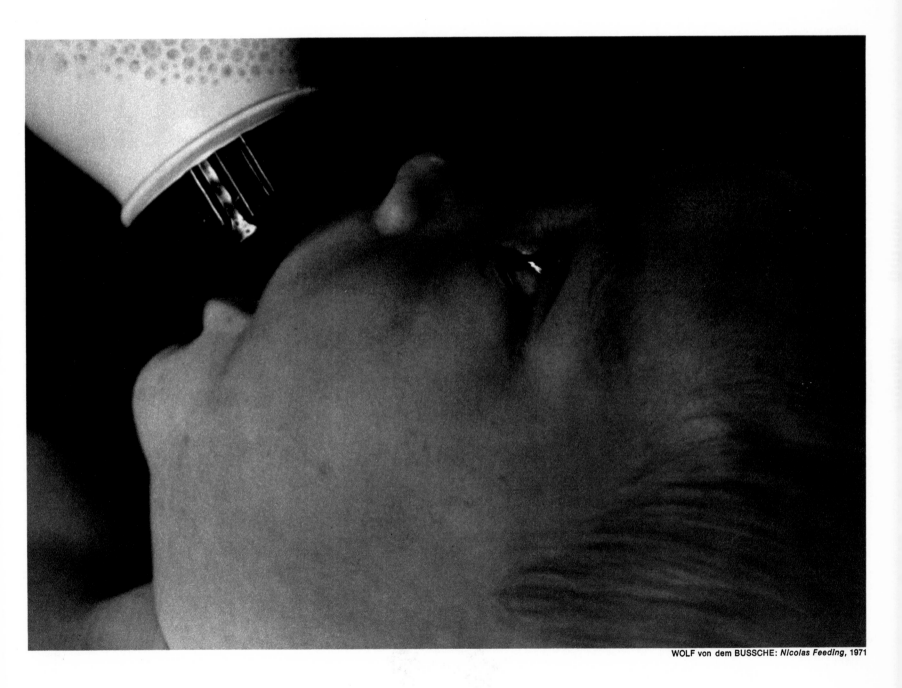

WOLF von dem BUSSCHE: *Nicolas Feeding*, 1971

The Rewarding Record of a New Life

Child photography begins with the newborn baby. Pictures of a baby may be taken even before he leaves the hospital, and every act that helps initiate him into the world is a subject for a photograph—the arrival home, the first bath, the first venture outdoors, the first birthday. Yet while such occasions are obvious picture material, many parents either overlook them or are reluctant to approach them with a camera. The hospital, they feel, is too active (or too inhospitable) a place for baby photographs. When the infant comes home, a snapshot of him lying in his crib seems sufficient to send to relatives and friends. After that, picture-taking often falls into a stereotyped pattern. On scheduled occasions, the baby is scrubbed and dressed in his best outfit, his wisps of hair neatly combed. Then, willing or unwilling, he is placed before the camera while his parents struggle desperately to coax a smile or at least a pleasant expression.

This method of photographing babies, while long in tradition, seldom succeeds in reflecting a child's personality and distinctive manner. Baby photography need not be limited to noteworthy occasions and standard poses. Nor does it have to be a boring chore for either the photographer or the child. Quite the contrary, its rewards and pleasures are immeasurably greater when it becomes a warm, spontaneous act that captures the child in all his naturalness and complexity.

During the first months of a child's existence he learns incredibly much, and fast, about the business of living. Things that he will be taking for granted at the venerable age of two are sources of infinite curiosity to the infant. Discovering that hands are for grasping, identifying a sound with its source, propping up his body on his two arms to take a look at the world—all these are revelations whose excitement he can communicate not only through cries and gurgles, but also through facial and body expressions that can be captured photographically. The very lack of spoken language helps make such pictures eloquent and appealing, for they openly reflect the emotions of the subject. Few expressions are as eloquent as the open, questioning wonder of a baby's eyes.

Although each baby develops at his own pace, a general itinerary of his rapid journey from infancy and babyhood into childhood has been plotted by the Yale University Clinic of Child Development after close observation of thousands of children. Each of these stages of development provides valuable insights into what to look for as photographable behavior. Among the triumphs of a four-week-old baby, small achievements that a picture-taking parent might want to record are his ability to focus on an object while on his back and to lift his head while lying on his stomach. At eight weeks, the baby can be photographed as he delivers his first social smile, his head now "bobbingly alert," his eyes capable of following a moving person or object. The

baby first attempts sitting up, chuckling and cooing when he is about 12 weeks old; at 16 weeks he plays with his hands and reaches for things, providing pictures that reveal the exploratory nature of a child, his infatuation with his own hands and his desire to use them. At 20 weeks, a baby laughs at his image in a mirror, and at 28 weeks he pats his reflection; both are good subjects for photographs. The child's first attempt at standing—an exciting moment for child and parent and a significant milestone in his development—comes at about the 32nd week.

The picture possibilities keep cropping up thereafter: at 36 weeks the baby may be able to stand in his playpen holding onto the rail; four weeks later he begins to participate in some of the classic games adults play with children—pattycake and waving bye-bye. At six months he may be propelling himself about in a walker. At one year he can walk by himself while holding onto something with one hand; he can also play with a ball and scribble with crayons. The important pictures of his first tentative solo steps—however halting—can usually be made when the baby is about 15 months old. At this stage he also can creep up a flight of stairs, or turn the pages of a book. By the time he is two, a photograph of the baby walking up and down stairs alone is possible, as are shots of him feeding himself with a spoon, putting on simple clothes and even mimicking other people.

At whatever age, the baby in repose provides an appealing photographic subject. A sleeping baby seen against the background design of his crib or with a pattern of shadows falling across him is the perfect subject for a still life. His body itself, like sculpture in miniature, his delicate features, his small hands and feet with their even smaller fingers and toes, all make unusual and appealing photographs. The very vulnerability of a baby—his dependence, fragility and innocence—can be photographed in many ways: his mother supporting his head in her hands as she holds him in her lap, his heroic efforts to turn himself over, his cry to be fed when he is hungry.

But how to make these pictures? Most parents, busy running a home and earning a living, do not have the time to be always on watch, endlessly clicking a shutter. An easy and convenient answer is simply to accept the camera as a familiar, utilitarian part of the household, to be picked up whenever a scene or activity calls for it, and not to be locked away in a cupboard. Preferably it should be loaded with fast, light-sensitive film, since flash can be distracting. With the camera always handy, parents can take pictures at will. Moreover, if the camera is treated casually, there is less chance of its catching the baby's attention, and he will react to it naturally. Babyhood, one of life's most active and challenging times, is crowded with picture-worthy events. And a good honest photographic record of these first years is certain to be a cherished addition to the family history. □

Photographing the Infant under Glass

It seems easier than it actually is to take a baby's picture in the hospital. Most hospitals display the babies behind plate glass, which does not obstruct the parents' view but does present problems for the camera. The pictures on these pages suggest methods for surmounting such obstacles.

Even before the photograph can be made, some formalities usually have to be settled with the hospital administration. Many hospitals allow cameras in their maternity wards, but others have strict rules about cameras and still others forbid them. So the photographer-parent should go to the hospital office and ask what the rules are. Usually the only requirement is a statement signed by the parents, affirming that the photographs are made for private viewing and not for publication (to protect the hospital's privacy). Ordinarily, picture taking is confined to visiting hours. In some cases flash bulbs are prohibited.

The head nurse may suggest a time when there are usually fewer visitors to get in the way. And although hospitals generally forbid photographs of the baby while he is being moved from the nursery to the mother's room to be fed, many of them allow the father to be present during the feeding. This is an especially poignant time for catching those first close-ups of the infant.

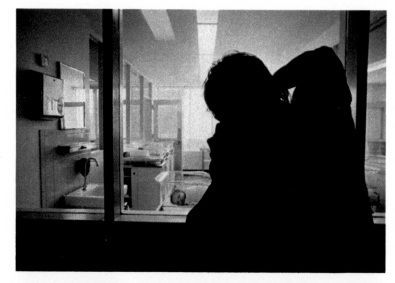

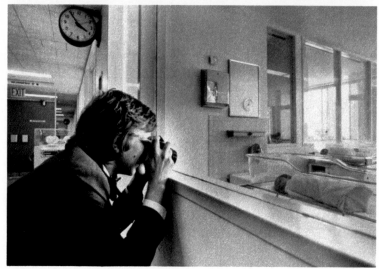

There are several simple but effective ways of keeping reflections and glare from spoiling pictures of the new baby taken through the hospital nursery window. One is to stand back a few feet from the glass and use your body—and a raised arm or even a coat—to block reflections of the hallway lights (top). Another way is to press the camera lens against the window itself (bottom), to gain a clear view of the nursery interior.

Since in some hospitals the baby is photographed from a distance and through plastic as well as glass, the results can look monotonous. Variety can be achieved, however, by using lenses of different focal lengths. In the picture at right, taken with the 55mm lens that is standard equipment for a 35mm camera, the baby boy is seen in his new environment: a plastic bassinet.

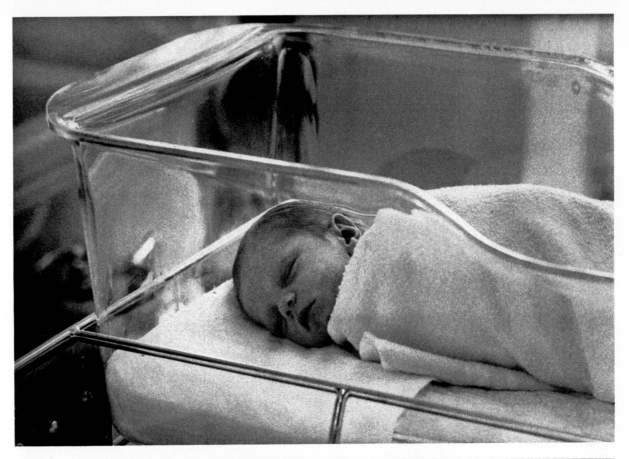

A longer 105mm lens produces a picture that focuses through the plastic onto the baby's face. Here he is effectively isolated from the impersonal hospital atmosphere, and is shown as a charming newborn human being in his own right.

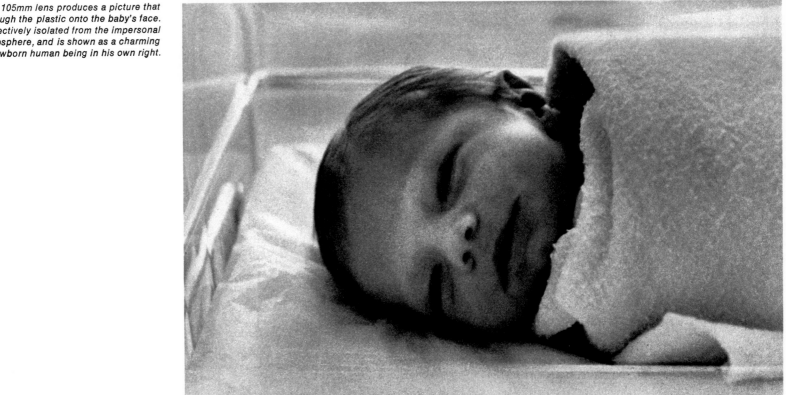

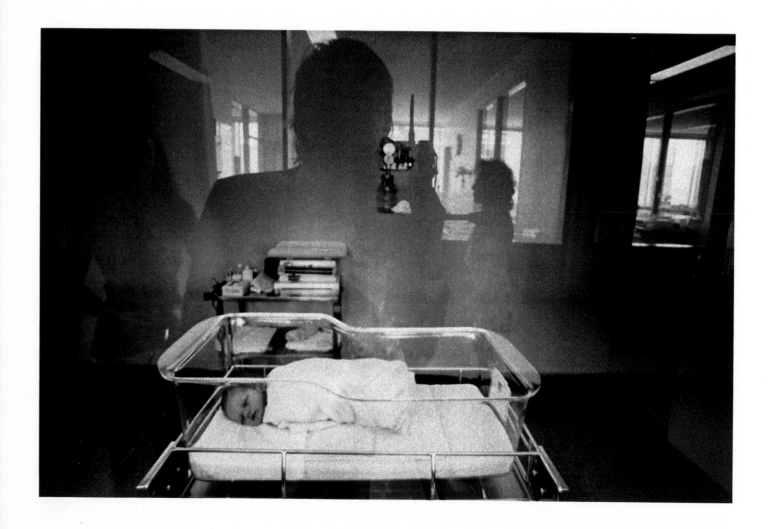

Reflections are not always unwelcome in pictures taken at the hospital nursery. Sometimes they can be effectively incorporated into a picture to convey a sense of place and mood.

Part of the excitement surrounding a new birth is the gathering of relatives and friends, and their reflections in the observation window can be used to literally mirror their feelings of pride and pleasure at seeing the newest family member. The reflections of people who have come to see other babies can also add interest to the picture since they too express the universal feeling of wonder and tenderness for the newly born. Their facial expressions may not appear in the window glass or on film, but their very presence lends an air of celebration to the event.

Taking advantage of the reflections in the nursery window, a photographer-father snaps a picture of himself and some friends (above) as they all admire his baby son. By not blocking out the reflections in the glass, in contrast to the methods shown on the preceding pages, the photographer captures the festive spirit that accompanies a birth—and also gets an unusual photograph.

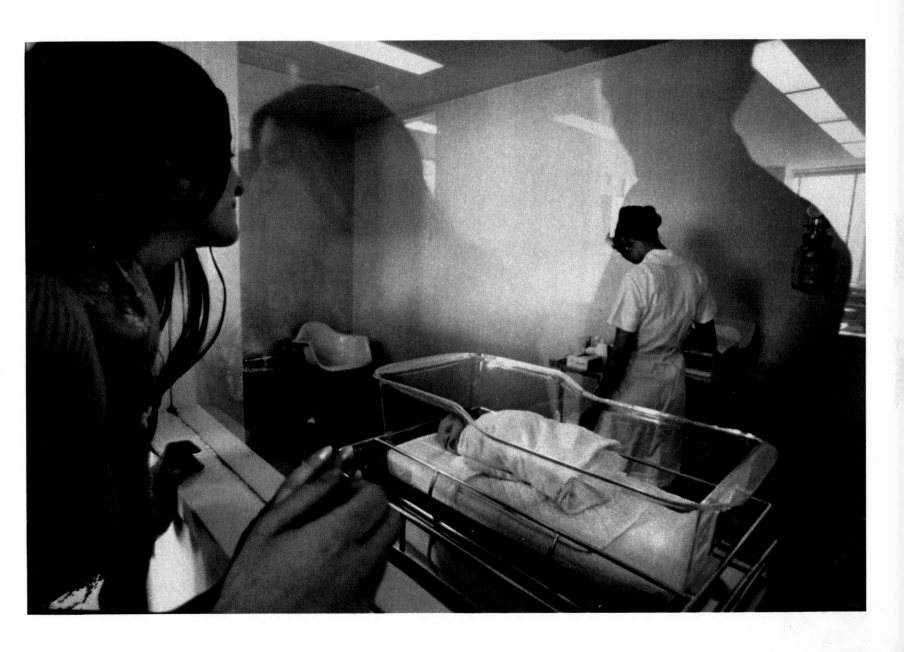

The postures and expressions of those observing a baby often make for good photographs, as further shown in this picture intermingling reflections and real images. As a nurse works behind the sleeping baby, a girl smiles through the observation window, her expression—and its reflection—revealing her delight. The image of the man standing near her adds a sense of unity.

Recording the Earliest Days at Home

Once home and removed from the restrictions of the hospital, the new baby instantly becomes the subject and the source of infinitely broader photographic opportunities. The reaction of the family to his arrival and his presence about the house, the infant's own increasing abilities and his dawning awareness of himself and the world around him, all combine to supply rich inspiration for pictures.

Wolf von dem Bussche and his wife Judith began to discover all this as soon as they brought their firstborn son Nicolas home to their New York apartment and started to chronicle on film the adventures of the new arrival. The task had an especially compelling incentive—Nicolas being the first child of a professional photographer who knew an appealing subject when he saw one. But instead of plunging into a crash program entailing scores of pictures on dozens of rolls of film, von dem Bussche found that he spent most of his time watching and waiting. His loaded camera was never far from hand, but seldom was it at work. The result, instead of a frantic chronicle of Nicolas' every twitch, was a slowly evolving series of photographs that unmistakably record the unhurried growth of a child during his first few weeks of life.

In line with his low-key approach, von dem Bussche did not burden himself with a complex array of cameras and lenses. He used only one 35mm camera and one highly versatile lens, a 50mm f/1.9 macro with a range of six inches to infinity. At close range he could of course have fitted a 50mm lens with a close-up attachment. But the advantage of his fast macro lens, which combined the advantages of close-up and normal lenses, was that he could shoot at any distance without pausing to add or remove any attachments.

Like many parents who watch their baby's development, von dem Bussche found that he was actually recording a "trip of discovery." The pictures on these and the following pages preserve the earliest stages of that exciting trip, beginning with the first photographs of Nicolas at his home and continuing through his routines of feeding, bathing and visiting the doctor—all taken during those exceedingly eventful first two months of his life on earth.

As in any such intensely personal photographic venture, the pictures were their own reward. Yet there were some other parental dividends. The pictures tended to clarify and reinforce the father's participation in the experience of watching his son develop. Thus, in a subtle way, the act of taking pictures of his baby made him even more deeply involved than usual in the process of rearing a child.

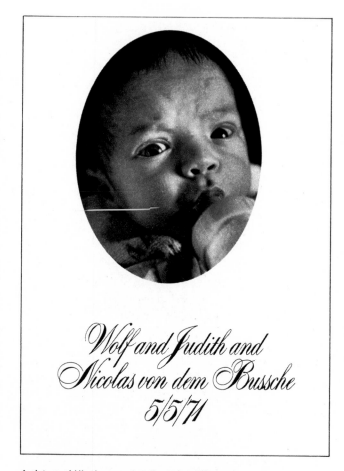

Wolf and Judith and
Nicolas von dem Bussche
5/5/71

A picture of Nicolas von dem Bussche at the age of nine days decorates the birth announcement sent by the photographer and his wife. The picture was one of the first that the father took after Nicolas was brought home from the hospital. Picture-taking had to wait until then because, as it happened, the photographer's son was born in a hospital that forbids the use of cameras.

In quest of an unusual father-and-son photograph, ► von dem Bussche held young Nicolas up in front of a mirror and started snapping pictures. After several exposures, the baby, understandably unconcerned with portraiture, started to yawn —and his father caught this amusing comment on the proceeding. The photographer deliberately failed to show his entire face or head, preferring instead to let his arm around his son convey the sense of a protective parental presence.

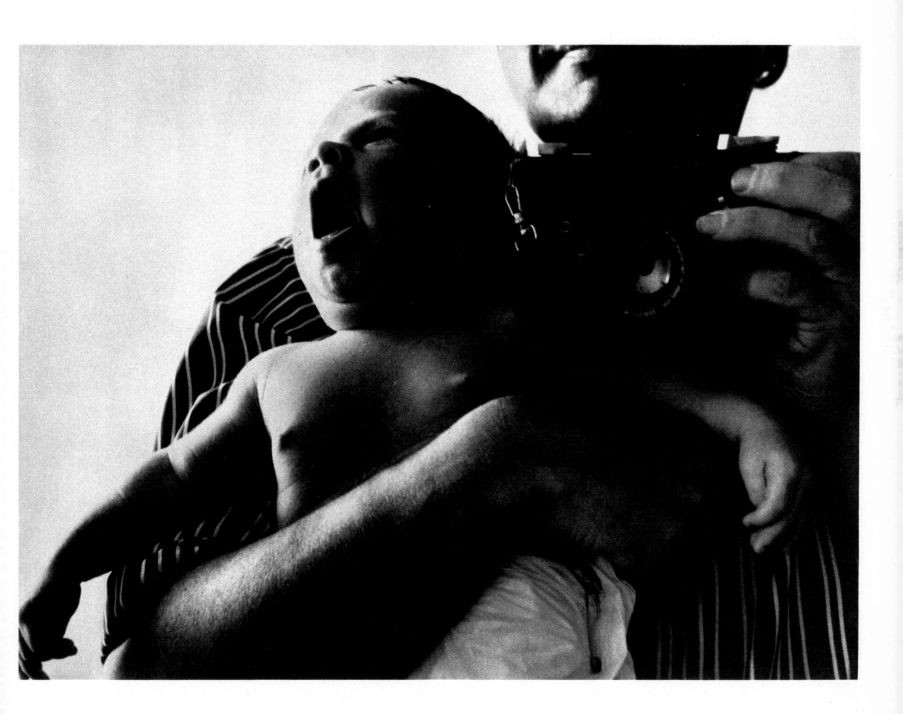

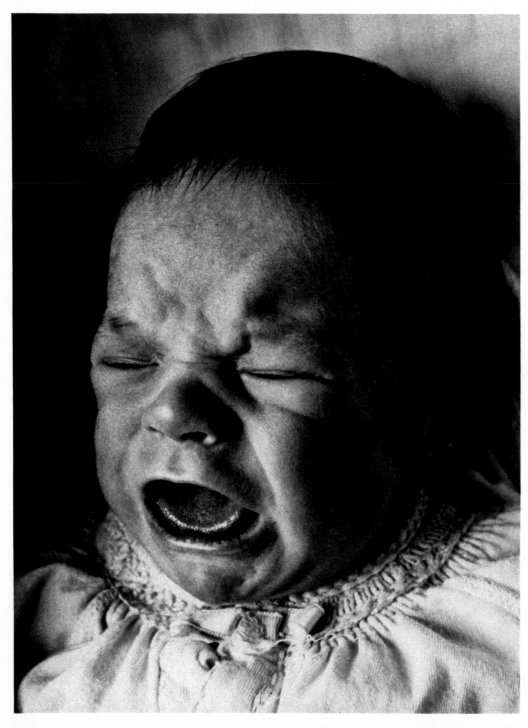

Crying lustily for his feeding (left), Nicolas presents a face that contrasts with his angelic gown. But he quickly lapses into silence as his mother answers his hungry call (opposite). Mother and child were photographed in natural light coming from windows behind and on either side of them. This backlighting offset the hard lines of the table in front of them and the radiator in the background, and gave the picture a softness in keeping with the serenity of the moment.

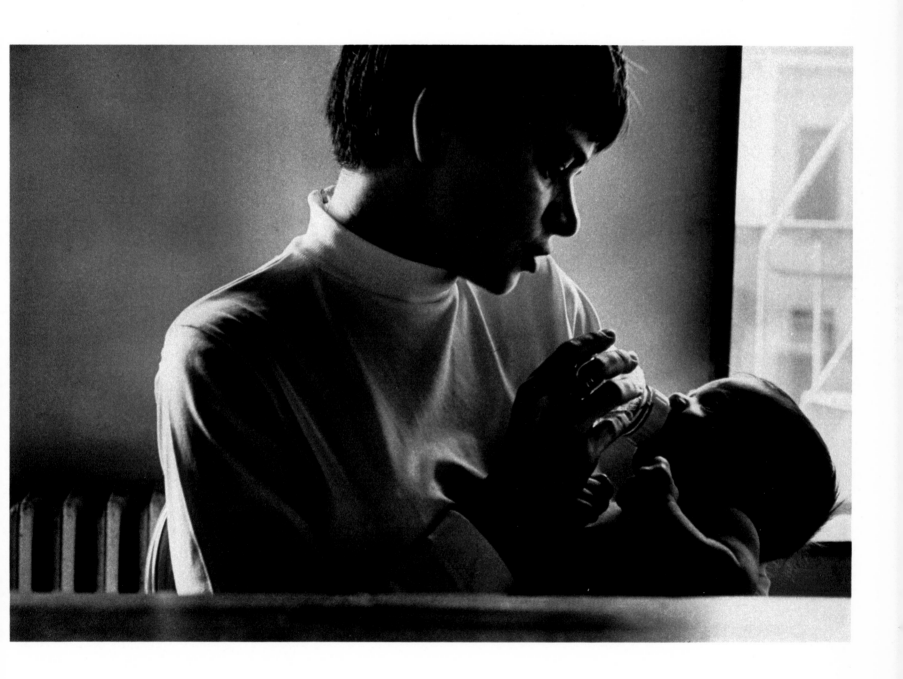

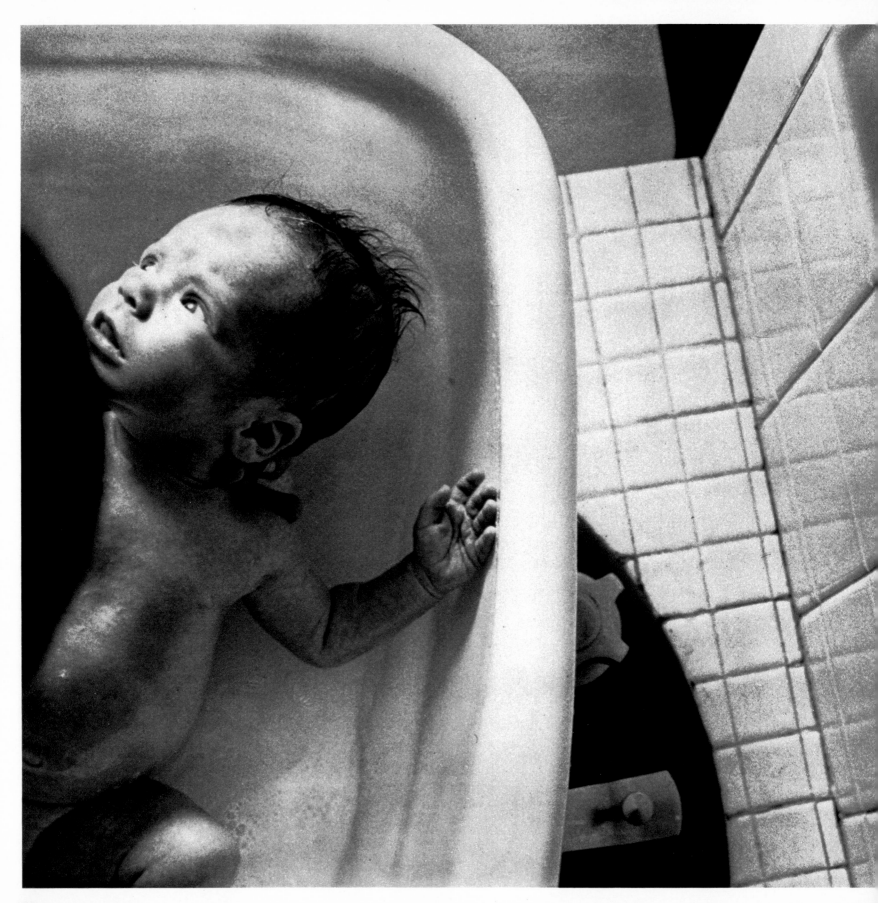

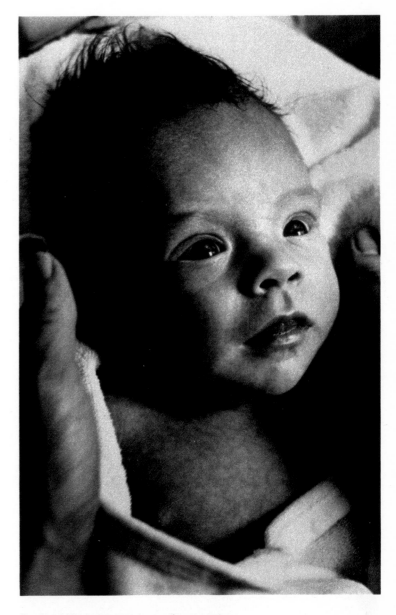

To record Nicolas' expression on the momentous occasion of his first bath—in a baby tub placed in the bathroom sink—his father took the picture at left by standing on the toilet and shooting down. His picture caught both the baby's apprehensive reaction to the water and his reflection in the medicine cabinet mirror. After his bath, held by his mother and snugly wrapped in a turkish towel (above), Nicolas is still wide-eyed but content.

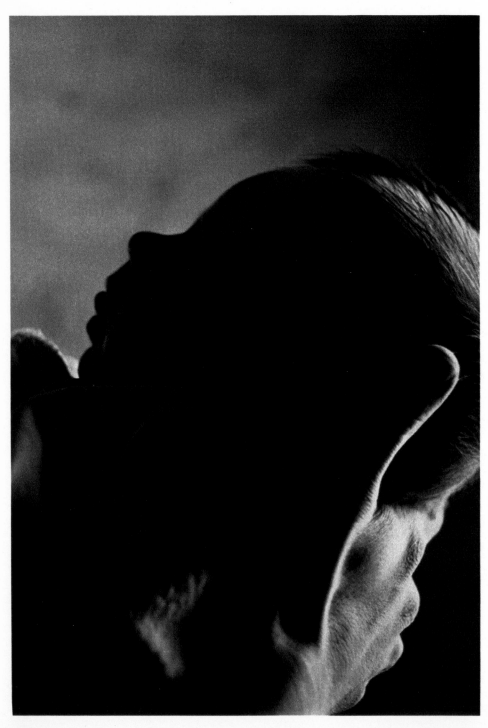

The fragile dependence of a three-week-old child is evoked in this photograph of Nicolas with his head tenderly cradled in his mother's hand (left). Lighted by a window out of camera range at right, the picture also conveys the quiet mood of late afternoon, when the sun casts long shadows.

A study in infant obliviousness and canine ► anguish resulted when the father stood on a window sill to take this picture of the baby asleep in his bassinet. While Nicolas napped, Clamor, the family's English bulldog, gazed up at his master with the classic expression of the pet that has had to give way to the intruder.

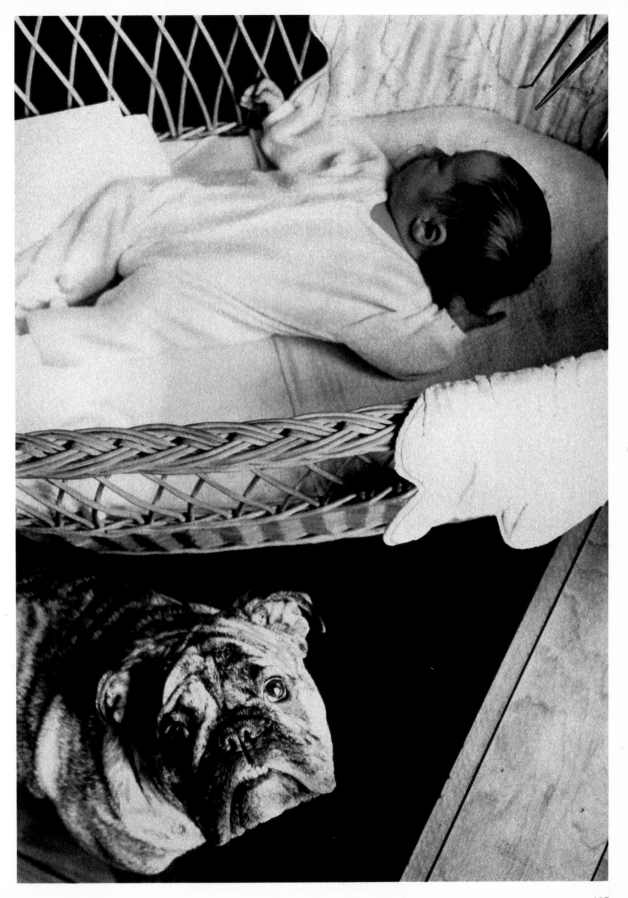

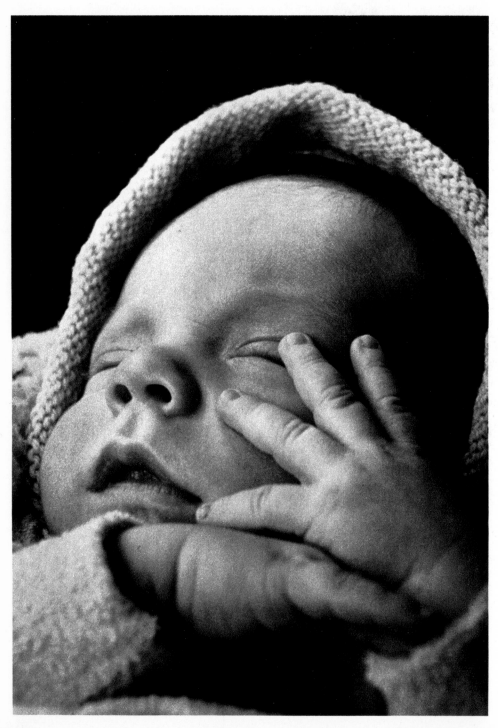

On Nicolas' first outing from home—a trip to the pediatrician's office for a checkup—the bundled-up baby unconcernedly dozed off in the car. When his father stopped at a red light, he noticed the snoozing face and the expressive position of the hands. He picked up his camera, and snapped the shutter just before the light turned green.

Placed on his belly, Nicolas lay slightly humped-up but still as the doctor examined him. To heighten the contrast between quiet baby and active doctor, the father slowed the exposure time to 1/15 second so that the adult hands blurred while the child remained in focus. The fluorescent lights overhead provided enough illumination for the picture to be made at this speed without flash.

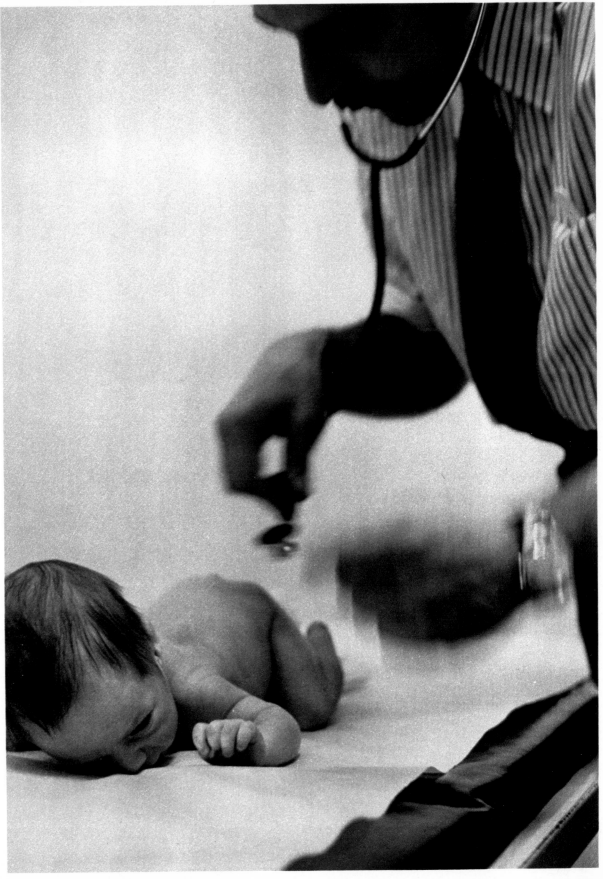

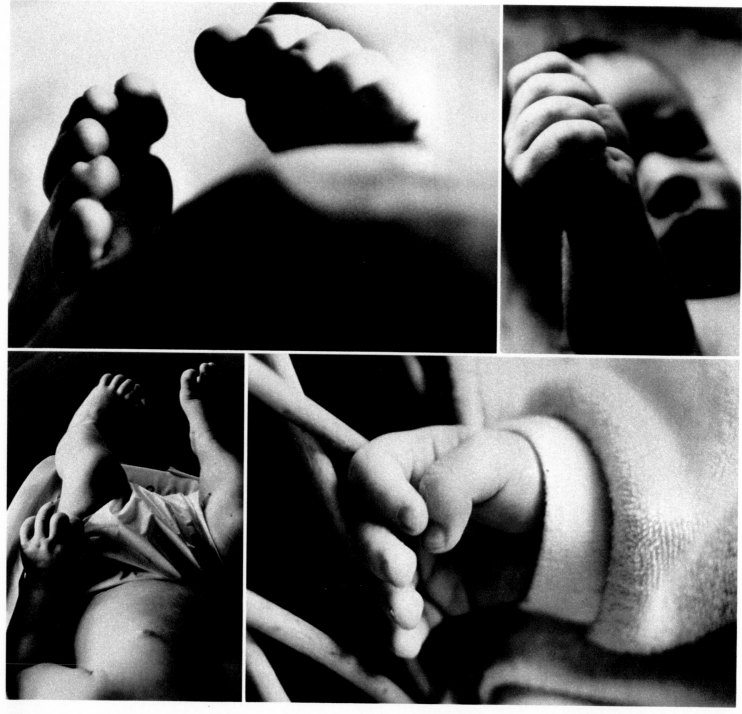

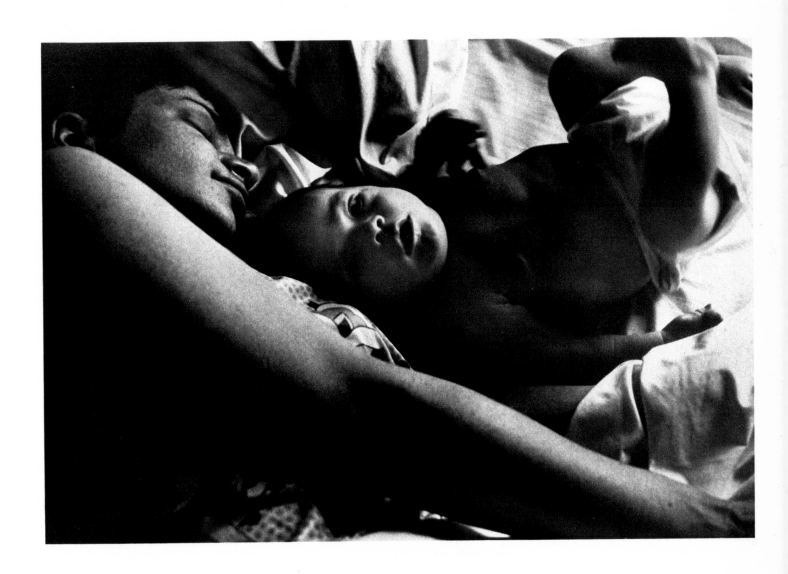

◄ The close-ups of Nicolas at left, made when he was about four weeks old, show that the parts of a baby can be as photogenic as the whole: the squirming toes, the clenching fist, the plump, pumping legs, the ever-curious fingers that may or may not feel a stray wisp of lint.

The security that a baby feels in the company of his parents is caught in this warm portrait, taken in natural light, of seven-week-old Nicolas as he begins his day with a visit to his mother's bed. At 7 a.m. he is wide-eyed and kicking, while his mother tries to catch a last few winks of sleep.

The Child's Broadening World

After the first months, as babies begin to exert their independence—holding their own bottles, crawling, ultimately taking their first faltering steps—pictures of them tend to become more mannered. They are posed formally and are encouraged to show expressions that adults want rather than the natural, if occasionally quirky, attitudes of their own. Or if the child is caught in an odd expression, it is too often used to make a clever shot rather than a realistic portrait. In this way the youngster is lost as an individual.

The fact is that during the early years, while the baby is busily engaged in discovering how he fits into the world, he makes a perfect subject for informal pictures, for he is now engaged in spontaneous, natural activity that can be taken from whatever distance or angle that seems appropriate. In photographing this developing, exploring baby, as in photographing newborn infants, the photographer should keep the picture simple and should himself be as unobtrusive as possible. And since the older the baby grows the more active he becomes, the photographer-parent should be ready to make plenty of exposures, to be sure of capturing the critical action or expression.

He should also be ready to break the rules if it will help the picture. One widely circulated formula, for example, exhorts the photographer to place the camera at the baby's level and move in close. A glance at the picture at right shows how effectively that rule can be broken. This is a shot taken from an adult's height and not particularly close to the subject. Yet the result is a superb study, filled with warmth and joy.

Another traditional rule is to use plenty of light; flash bulbs have long been regarded as indispensable for baby pictures indoors. Yet most of the pictures on the following pages were shot in soft natural light. Also, although baby photographers are usually admonished to concentrate on the child's face and expression, some of the most expressive and appealing pictures on these pages were made without the face showing at all.

The rules were not made just to be broken, of course. The parent with a camera will make a rewarding record of the baby's development even at the baby's level, with lots of light and emphasis on the subject's face—so long as he lets the child dictate what pictures are taken, and watches for the natural and spontaneous moments.

No one could expect Amanda, celebrating her first ▶ birthday, to sit still long enough for a portrait. Instead her father deliberately capitalized on her joyous agitation. He used a Rolleiflex wide open at f/3.5 with available light coming from overhead. The slow exposure softened her smile and caught the graceful curve described by her busy hands.

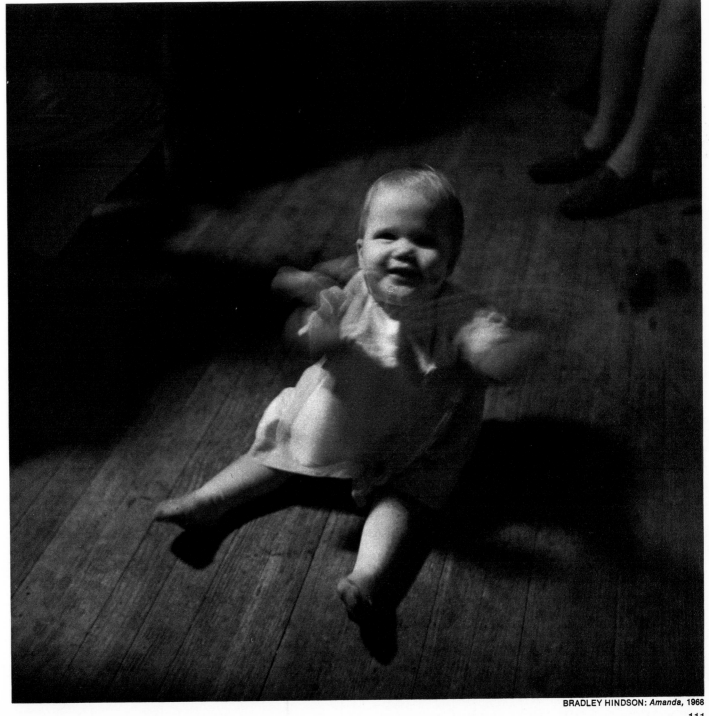

BRADLEY HINDSON: *Amanda*, 1968

Everything Goes into the Mouth

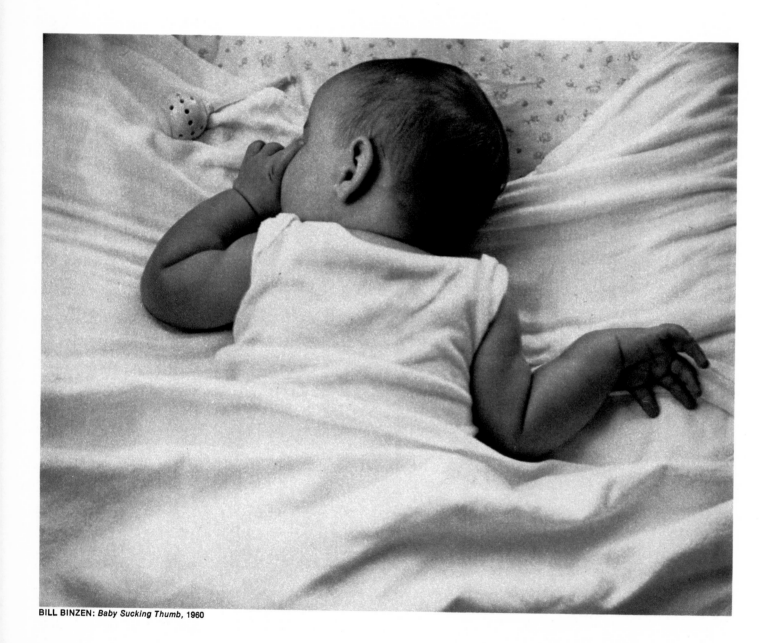

BILL BINZEN: *Baby Sucking Thumb,* 1960

Babies spend a lot of time and energy stuffing things into their mouths—and almost always in photogenic ways. The sleeping baby at left is content with her thumb, and the curled fingers of her right hand show her complete relaxation. The clamshell-gnawer at right is intent on a new taste experience. And the recumbent child in the sleep suit (below right) munches on his toes with almost the air of a scholar pulling on a pipe. The camera merely observes all this; it does not intrude.

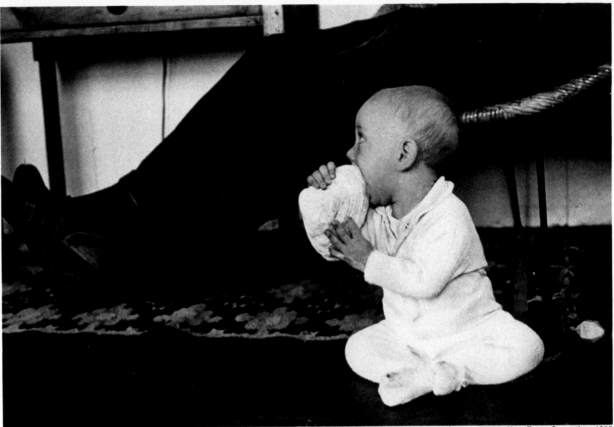

DENA: *New Taste Sensation,* 1965

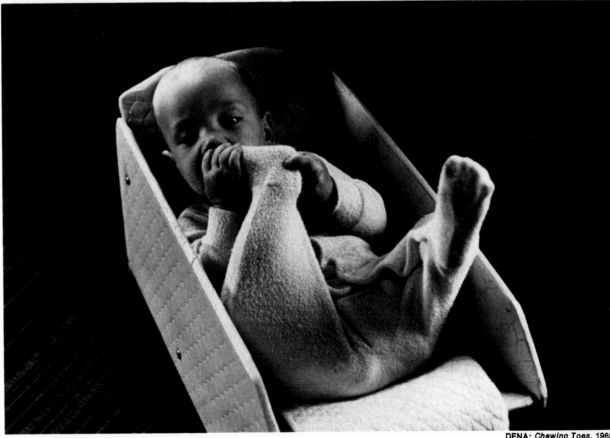

DENA: *Chewing Toes,* 1965

Mastering the Arts of Crawling, Standing and Toddling

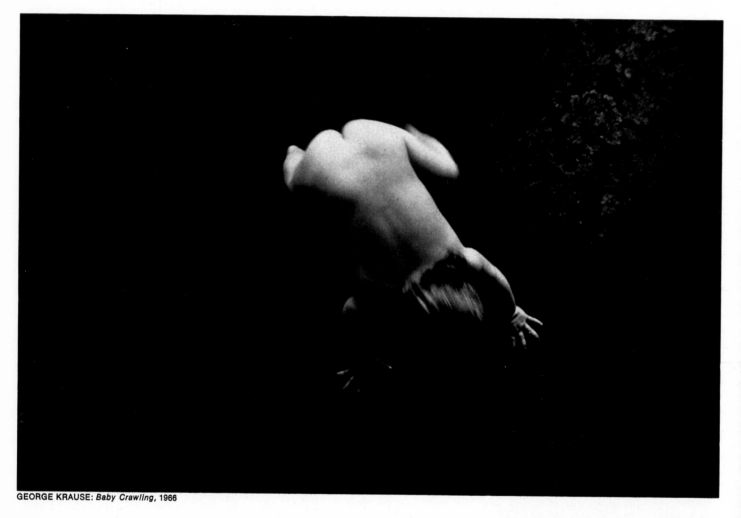

GEORGE KRAUSE: *Baby Crawling,* 1966

To suggest the triumph of self-propulsion in a
crawling child, the photographer used a slow
exposure (1/15 second), producing a slightly
blurred effect in his daughter's moving legs. Her
hands, being still, are in sharp focus. Her father
also was intrigued by the textural contrast
between the baby's soft, smoothly rounded body
and the plushy, intricately patterned Persian rug.

A shaft of early morning sunlight from the window
happened to fall on the baby at right as she
paused for a moment in an exploratory walk,
enclosed by the design in the braided rug. The
photograph was not posed; the photographer had
his camera at hand, and he shot without
distracting his subject, who was completely
absorbed in the unaccustomed feat of locomotion.

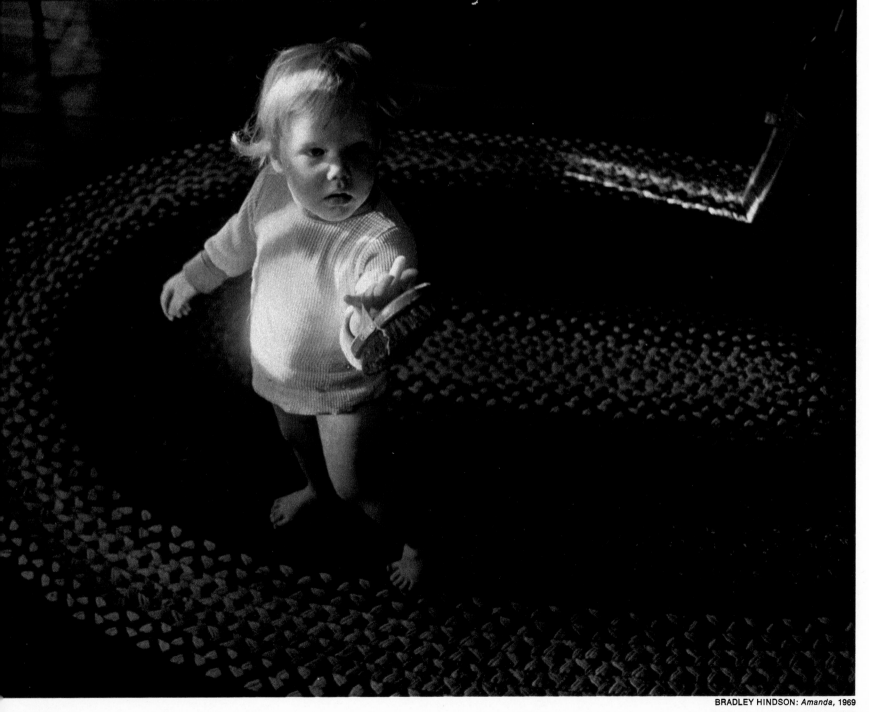

BRADLEY HINDSON: *Amanda,* 1969

New Discoveries, New Friends

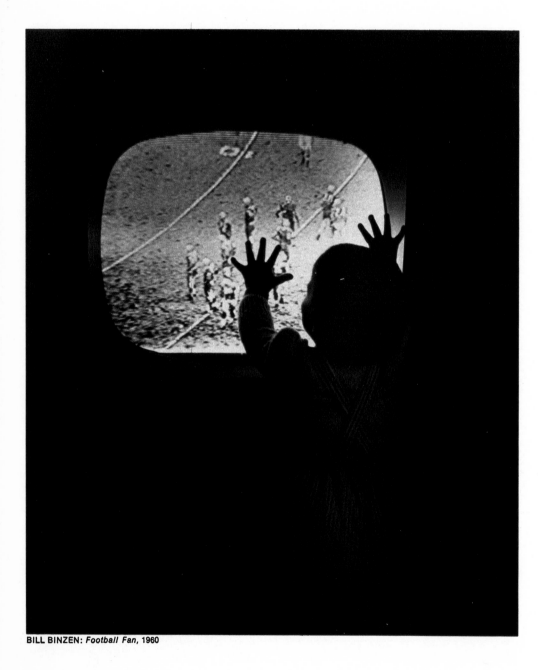

BILL BINZEN: *Football Fan, 1960*

As expressive as a full-face view, this silhouette of a baby reveals his rapt fascination with the brightly lighted television screen and its moving images. The photographer used only available light, mostly from the screen itself, which threw the baby into silhouette; he shot at slow speed (1/30 second at f/2.8) because at faster speeds the entire TV image would not appear in the picture.

Babies and pets seem to exert a mutual attraction, ▶ perhaps in part because they are smaller than others around them and both spend much of their time down on all fours. In the picture at right, the photographer caught cat and baby in the same posture; by shooting down on them, he was able to emphasize their relative smallness, which is also underscored by the width of the floor boards and the size of the orange in the foreground.

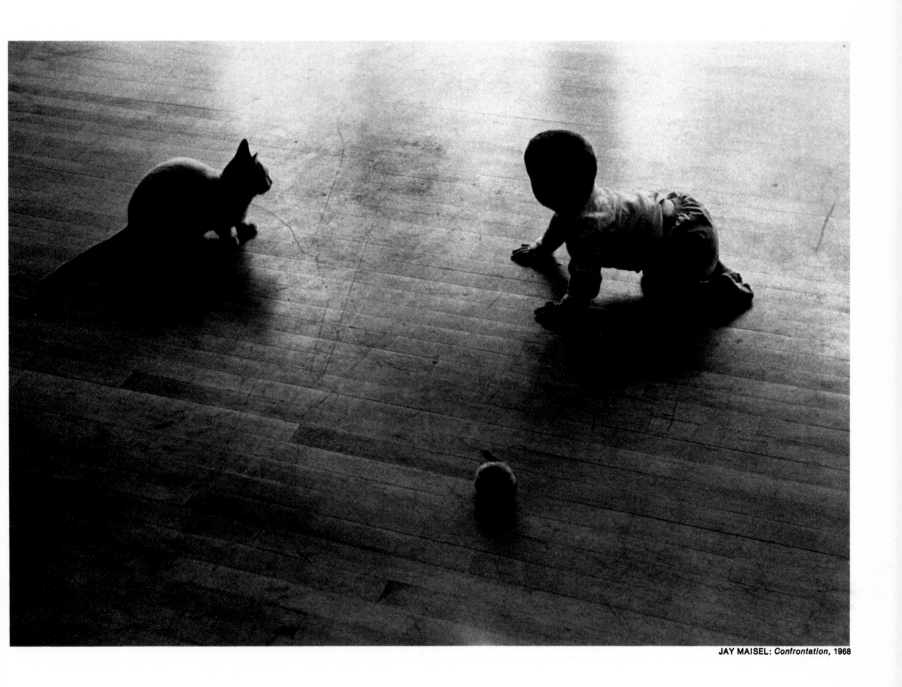

JAY MAISEL: *Confrontation*, 1968

117

The Things a Baby Gets Into

When Bill Binzen photographed his daughter Susanna between the ages of 8 and 18 months, he learned what every parent-photographer finds out —that there is no end to the things a growing baby gets into, and thus no end to the succession of picture-taking opportunities. Absorbed in her growing powers, Susanna tended to ignore the camera, and with patience and timing her father was able to capture a variety of incidents in her development, from carefully pulling a cookie apart to gleefully reaching out for a flower. Binzen compiled these and other pictures into a private album called "What Hands Are For," an idea that any parent-photographer, choosing his own theme, could exploit.

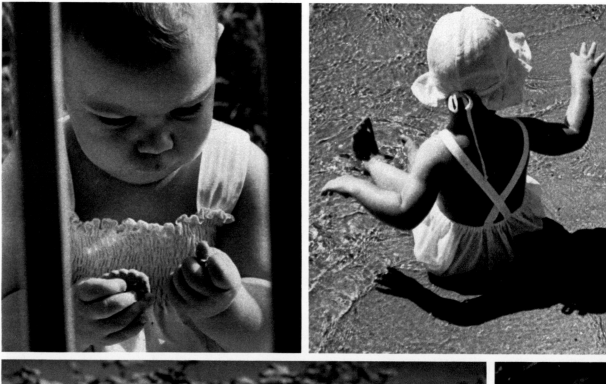

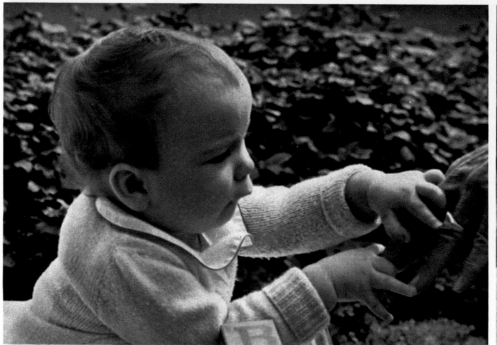

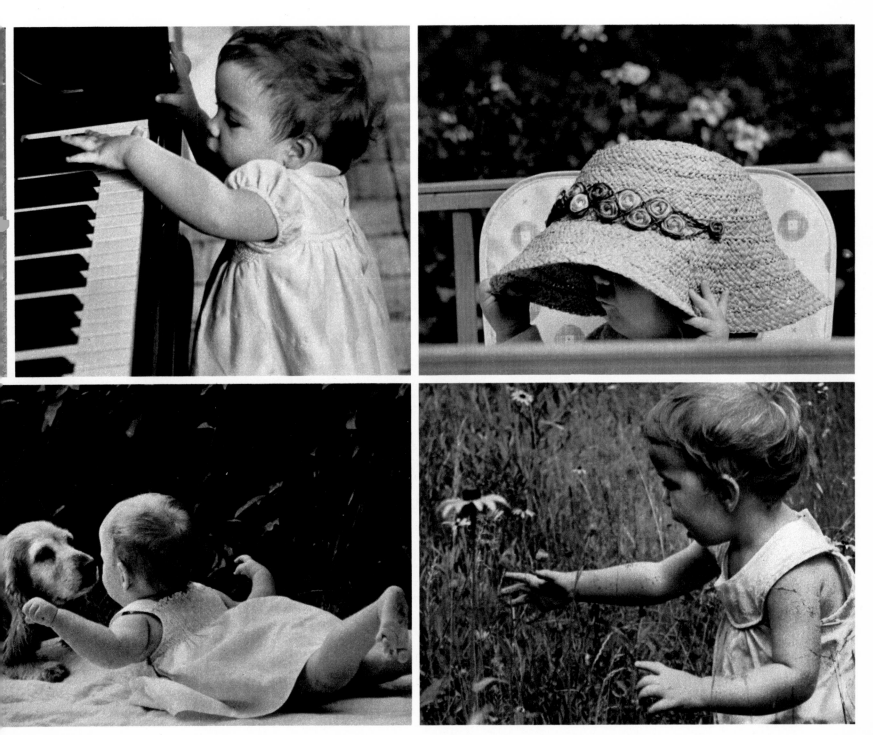

Settings That Add Interest

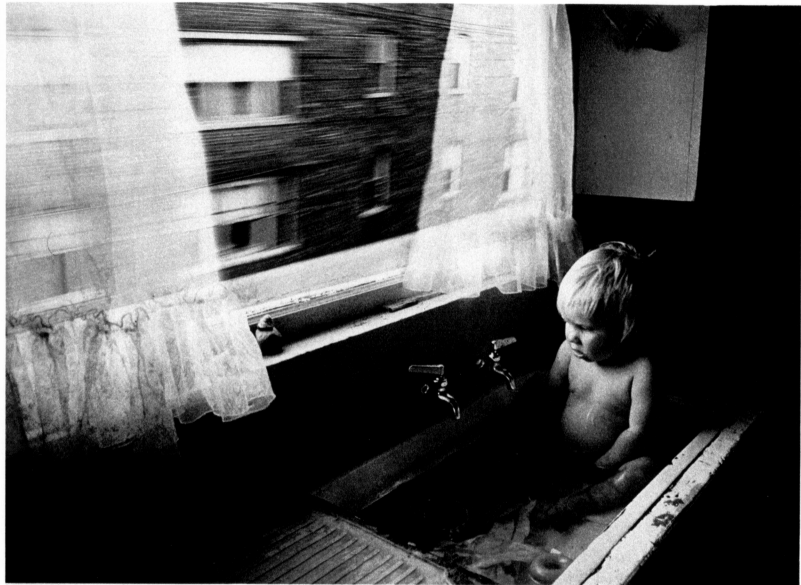

RON MESAROS: *Baby in the Sink*, 1970

A familiar act (a bath), in an unfamiliar setting (a kitchen sink) is an opportunity to record a child's reaction to new experiences. The baby, captivated by the shiny faucets, ignores his bath toys. The blur of a passing train is taken from a separate picture; to emphasize the potential involvement of the immobile child in the moving world, the photographer combined the two negatives.

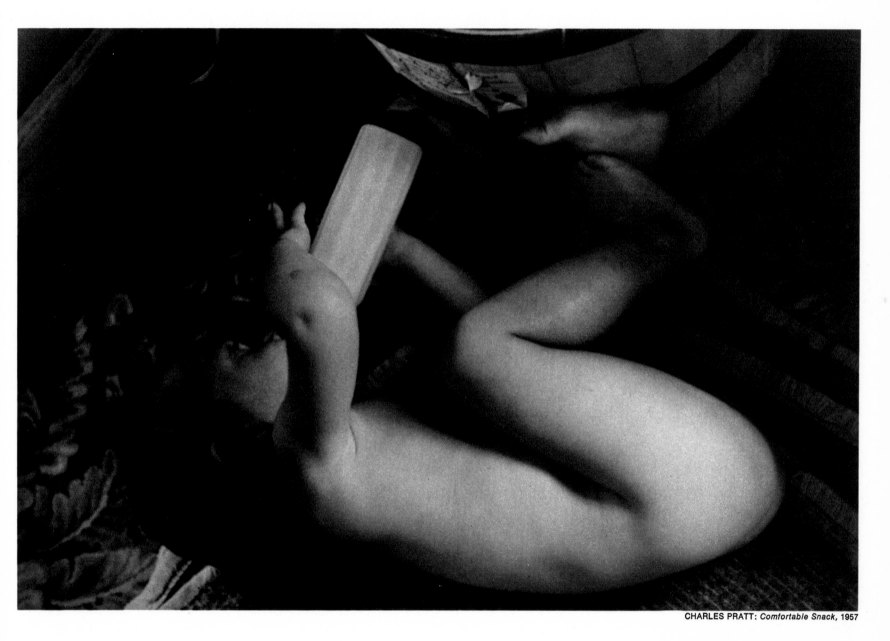

CHARLES PRATT: *Comfortable Snack*, 1957

The photographer spotted two-year-old Adam Cohen having a snack in the shady corner of a sunlit room, and "liked the way he looked." The soft shadows gave the picture a dreamy quality, the baby's skin luminous against the rough blanket. The triangular shape of the blanket frames Adam's curved body and also helps to emphasize the repeated curve of the barrel.

121

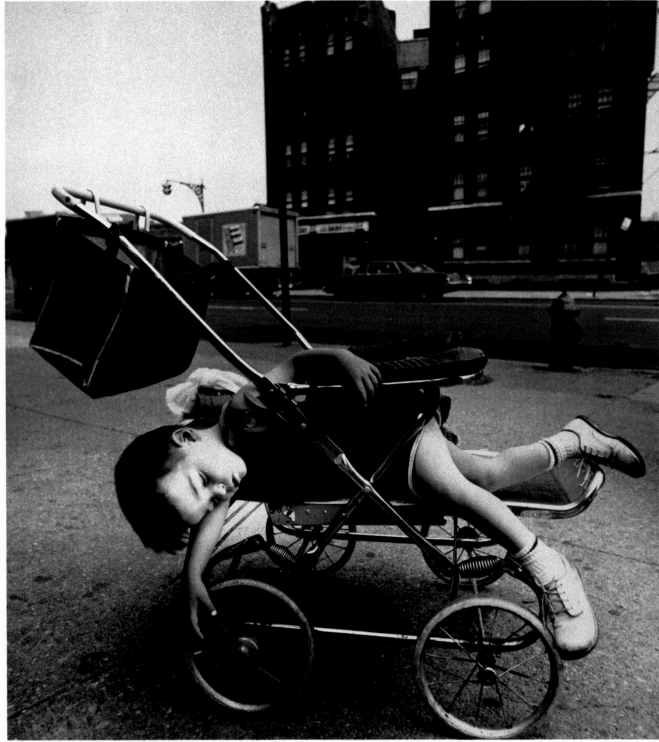

ARTHUR TRESS: *Dead to the World,* 1971

On certain rare occasions an active baby will accommodate the photographer by simply drifting off into sleep, like this young man oblivious to the street scene, the discomforts of his outgrown stroller and the camera. In this case the photographer was struck by an unconscious pose that no adult subject would assume in public, and shot to take advantage of the baby's graceful, curving form, sprawled in utter relaxation against the harsh shapes in the background.

Kid vs. Camera **4**

A. DOREN: *Boys on Brooklyn Bridge,* 1967

Dealing with the Aware—or Unaware—Subject

As the baby is inevitably transformed into a child, day-to-day growth is imperceptible; yet the photographer of children must watch closely as his subject gradually grows more competent, more independent, more complicated —and more interesting. Liberated from the crib, the bottle and the diaper, the child ranges farther afield, and becomes less predictable in his comings and goings. His body, risen from all fours onto a pair of rubbery legs, co-ordinates into an engine of ceaseless locomotion. His mind, lately so insular and self-absorbed, connects with the outside world through omnivorous senses and expressive speech. The child moves mentally and physically around a constantly expanding universe, obeying the urge to explore his estate and the temptation to try the ways of the grown-up world. Sometimes appealingly, sometimes implacably, the child asserts himself as a *person.*

The changes offer new opportunities to the photographer, and new challenges. One problem is that as the child becomes more and more aware of the world around him, he becomes more aware of the camera. That can be a serious drawback if it makes the child self-conscious, stiff and unnatural; or it can be a boon, if the child can be induced to participate naturally in the photography. Most children are easily persuaded to cooperate, at the very least by making sport of posing and sometimes even to the extent of helping compose the pictures. Bruce Davidson says, "I let children discover me. I tell them exactly what I want them to do and they decide how to do it." Another photographer, Marie Cosindas, puts little girls at ease with tea parties, so that by the time the dishes are cleared away and the camera comes out the children have come to regard her as a friend and social equal, and sitting for her is part of the day's adventure.

But frequently a child is too self-conscious or shy to cooperate. The alternative then is to take pictures without letting him become aware of it. This feat is easier with children than with adults because children throw themselves into their own activities with such earnest absorption that they may not even know that the camera is near. This obliviousness can also come if the photographer spends enough time among the same children, like Wayne Miller on page 189, so that they will go about their own affairs, knowing the camera is there but accustomed to it and at ease.

Either way the possibilities are unlimited. No professional on a dream assignment to some exotic end of the earth could hope to find subjects more mysterious and alive and expressive than these proto-people who are right at hand everywhere. It does not follow, however, that availability makes the job easier. In many ways, photography is a simpler matter on either side of childhood. A baby can be immobilized in someone's arms or in a high chair; an adult comes to the camera with a catalogue of habitual expressions, gestures, postures and props that have become his own through long use. But

the people in between—the children—are still in that unfixed, formative and ambiguous state that makes photography a challenge.

The same child may be one thing—dependent, active, naive—or the opposite—self-sufficient, passive, knowing—or sometimes all these at the same time. A child is all angles and awkwardness; he is also the epitome of grace. Rapt in daydreams, he is often creative when he seems to be doing nothing. And when he seems finally to be one thing, he is already on the way to becoming something else.

What can the photographer accurately say in a fraction of a second about such a paradoxical subject? As with all photography, it is less a matter of cameras and lenses than of the photographer's attitude. And the photographer's most productive attitude toward children is to let them be themselves. In the beginning of photography, almost 50 years and nobody knows how much photographic emulsion were devoted to portraying children as little men and women *(pages 40-41)* and later as little angels *(pages 42-43).* The development of modern candid photography coincided with still another perception of children, and examples of that attitude are shown in this chapter. The photographers represented here have portrayed children, as nearly as grownups can, in the children's own world. Some of the subjects were fully conscious of the camera; others were absorbed in quiet play or heated activity. But in every case the photographers have tried to see children as the children see themselves, to respond to them as people in their own right. To capture an image of childhood on these terms requires of the photographer the skill of a craftsman, the eye of an artist, and—most important—all the enlightened insight and best instincts of a friend. □

Kid vs. Camera
Putting on an Act

A photographer trying to catch a child in the act of being a child gets caught in the act himself. His face hidden by his camera, feeling very much the unobserved observer, he suddenly sees the child's eye meeting his own through the viewfinder. Feeling a trespasser in the child's world, the photographer tends to become ill at ease. His finger freezes on the shutter; seeing the whites of his subject's eyes, he cannot shoot. And the child, all too aware of the camera and reacting to the photographer's discomfort, becomes equally uncomfortable or defiant. The moment is lost; a photograph is irretrievably missed.

But the picture need not be lost simply because the photographer observes himself being observed. He can turn such a confrontation to his own advantage, as in the classic example at right. A group of children are surprised while scribbling on a wall in Montreal. But instead of running away or hiding their faces, they recognize that the camera can express their feelings more faithfully than anything they can chalk on brick, and they flaunt themselves in poses that proclaim: "Here I am and what are you going to do about it?"

Henri Cartier-Bresson, the photographer who encountered the boys, ordinarily makes a fetish of working inconspicuously, concealing his own identity while revealing his subject's. He even forbids photographs of himself, partly for fear that his appearance will become as widely known as his name and work, and make his candid photography more difficult. In this exception to his own rule, he let the children (who didn't know him anyway) use his camera, as it were, to reveal themselves as they would like to be seen.

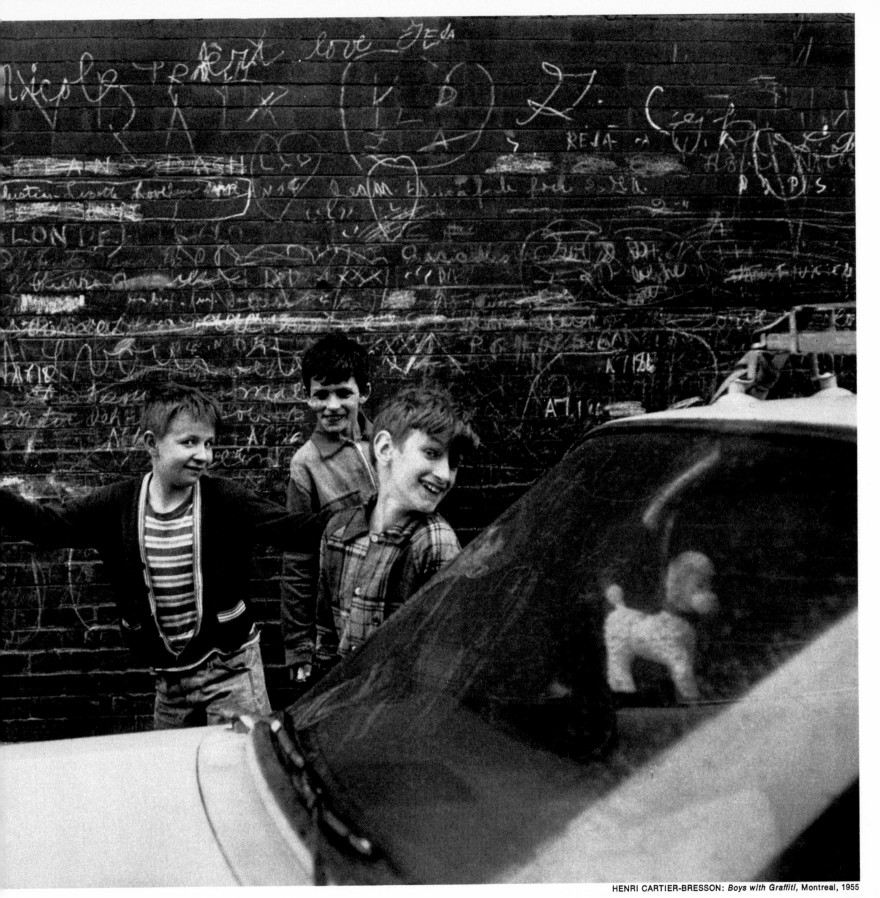

HENRI CARTIER-BRESSON: *Boys with Graffiti*, Montreal, 1955

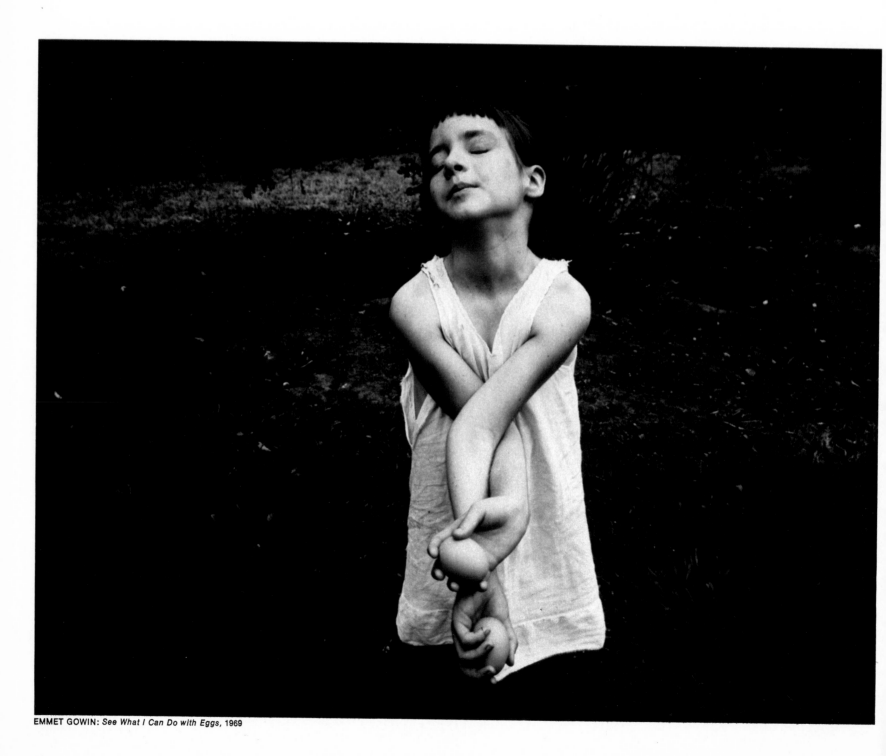

EMMET GOWIN: *See What I Can Do with Eggs*, 1969

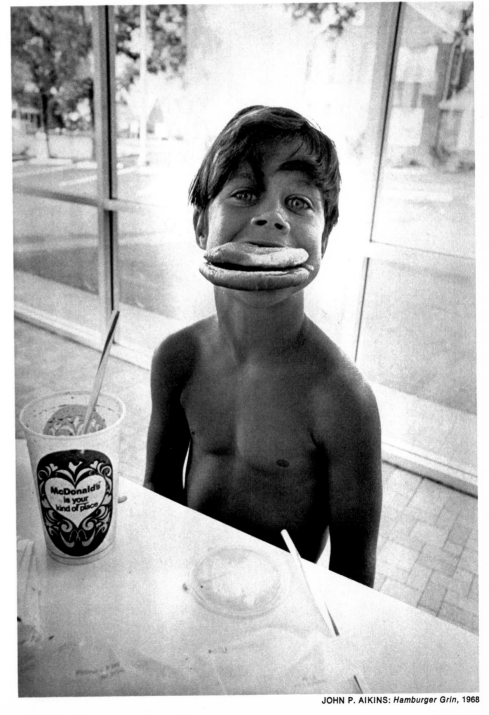

JOHN P. AIKINS: *Hamburger Grin*, 1968

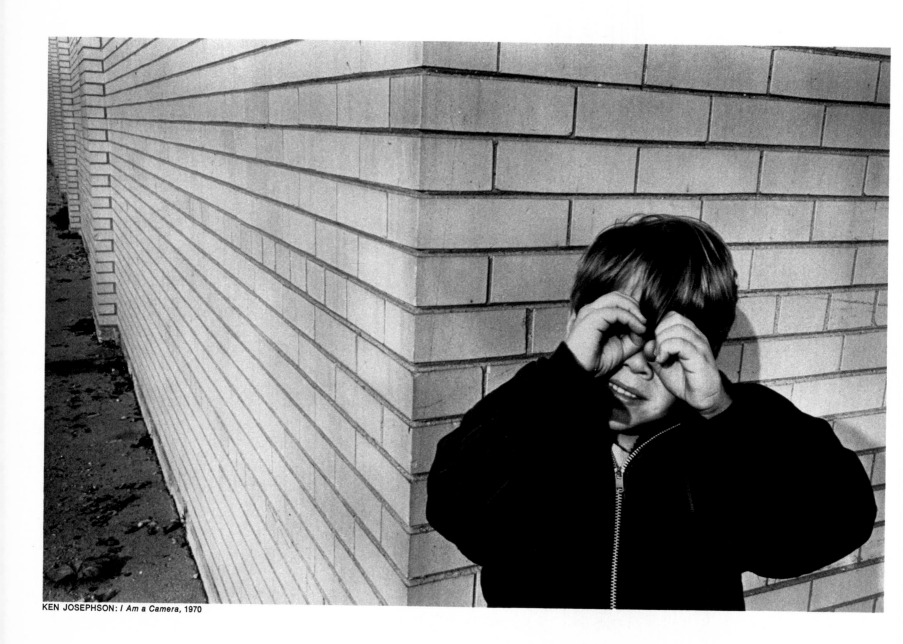

KEN JOSEPHSON: *I Am a Camera*, 1970

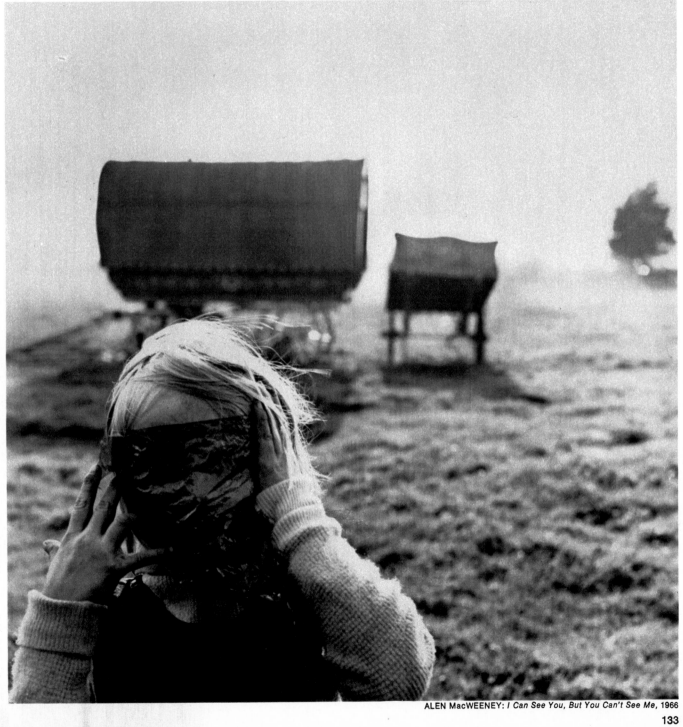

ALEN MacWEENEY: *I Can See You, But You Can't See Me,* 1966

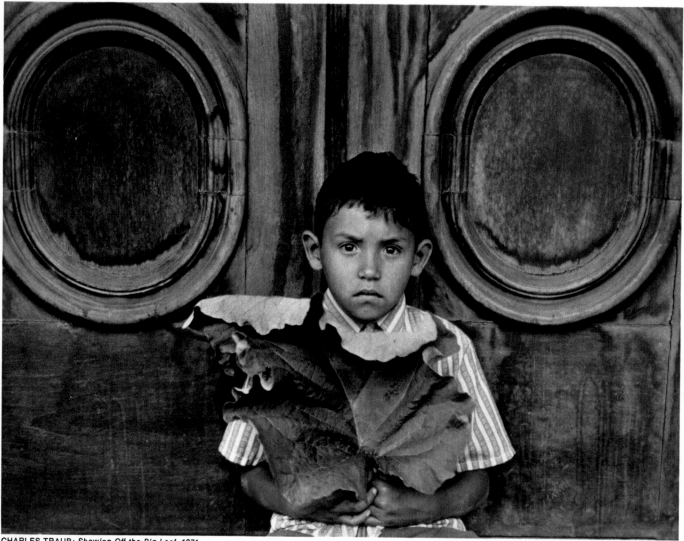

CHARLES TRAUB: *Showing Off the Big Leaf*, 1971

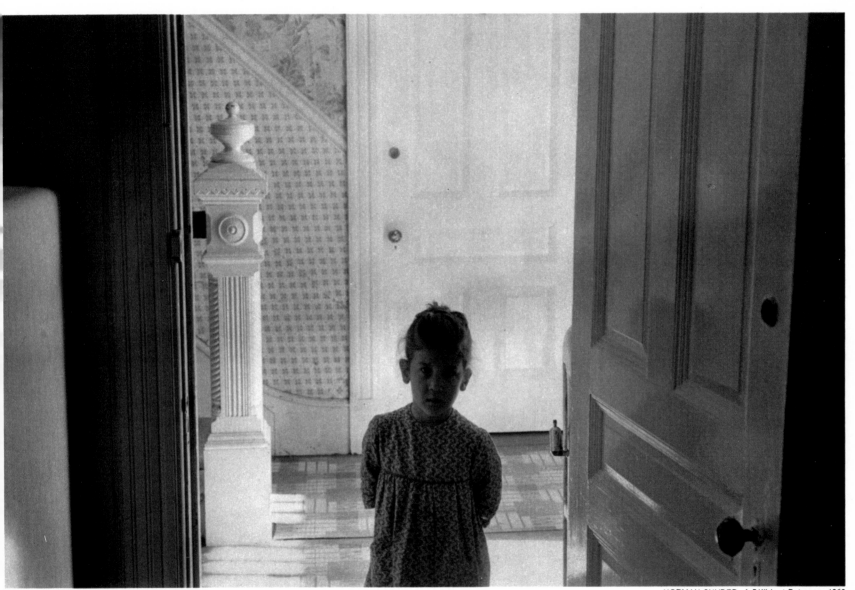

NORMAN SNYDER: *A Diffident Entrance*, 1969

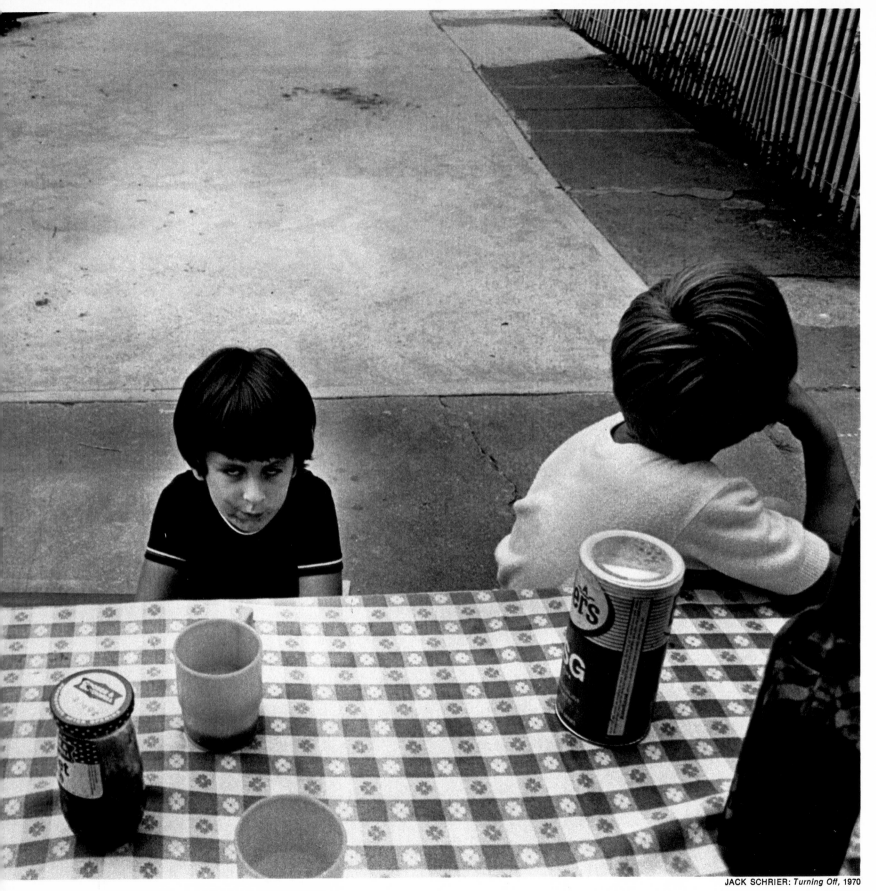

JACK SCHRIER: *Turning Off*, 1970

137

Doing What Comes Naturally

While a child mugging for the camera can make a beguiling picture, as the previous pages demonstrate, the more normal state for most children is absorption in some other activity—and that's the way candid photographs are made. Since a healthy child is the closest thing known to a perpetual-motion machine, the photographer rarely has long to wait before some form of preoccupation puts his subject off guard and at ease, in a situation where he cannot help being himself. The pictures that result may not be so striking as some of the more self-consciously posed ones, but they are more natural —and often more revealing of the child.

Although the photographer may subtly suggest some diversion, the child's own untrammeled imagination and his high-powered metabolism will inspire a range of action beyond adult invention, often involving objects that are beneath adult notice. The child can turn scraps of wood and tatters of cloth into the stuff of drama; he can transform a cocoa break with friends into an occasion for intimate intrigue; or he can ride a bicycle, a slide or a swing right out of this world—and into a picture. Even when he seems to be in suspended animation, doing nothing at all, the child may be concentrating hardest, daydreaming whole worlds into vivid existence and revealing his fantasies for the camera through his rapt expression.

At such moments, when the child is most quiet, and his mood seemingly most fragile, the temptation for the photographer is to retreat to a respectful distance and use a long lens. But often this is not necessary. In many of the pictures that follow, the photographer has chosen a bolder approach, counting on the child's self-absorption to make possible photography at close range without distraction.

In the photographs that begin on pages 148 and 149, the youngster is on the run, his activity violent and wide-ranging. Such situations tax the photographer's ingenuity even more. To keep his elusive subject in camera range, he can follow along on foot or with the long reach of a telephoto lens. He can choose a shutter speed fast enough to freeze the action completely or a slower one to allow the slight blurring that suggests motion. A long exposure will emphasize the blur. If he wants a clear subject he pans with the motion, to blur the background; if he wants a sharp background he can hold steady and let the subject blur. Even after he has made such technical determinations to achieve an overall effect, the photographer still must make the most crucial choice of all: the split-second selection of the time during the activity when subject and action coalesce—that magic moment when the movement reveals the child.

From a roof top overlooking a New York City park Raimondo Borea photographed the children below without calling attention to himself. His high point of view in this telephoto shot also enabled him to silhouette the legs of the boys —copied by the little one—striding in step, an unconscious affirmation of their comradeship.

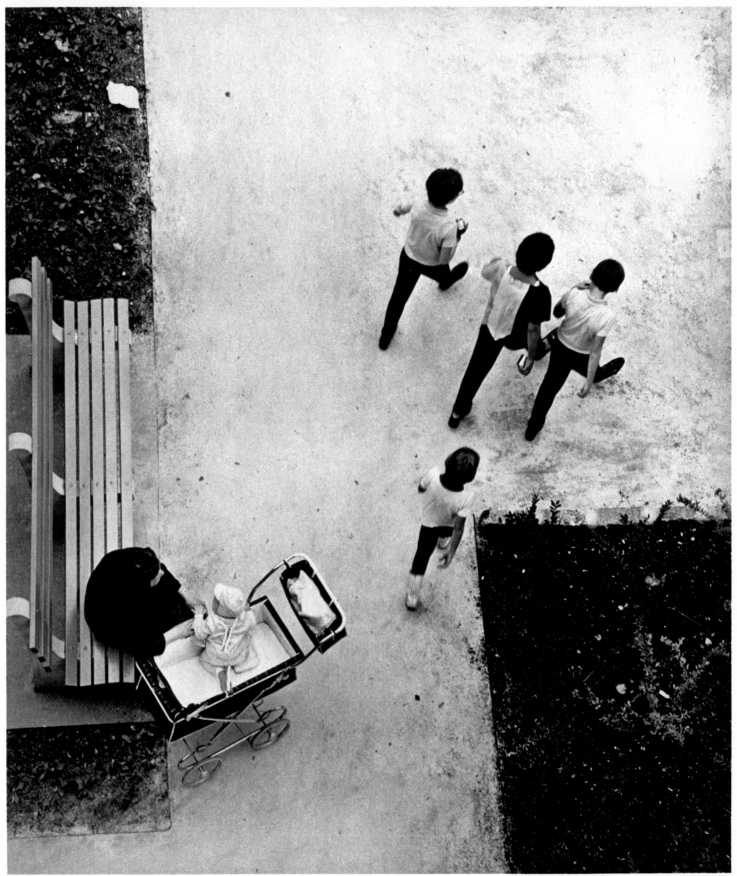

RAIMONDO BOREA: *Children Walking in Step,* 1966

139

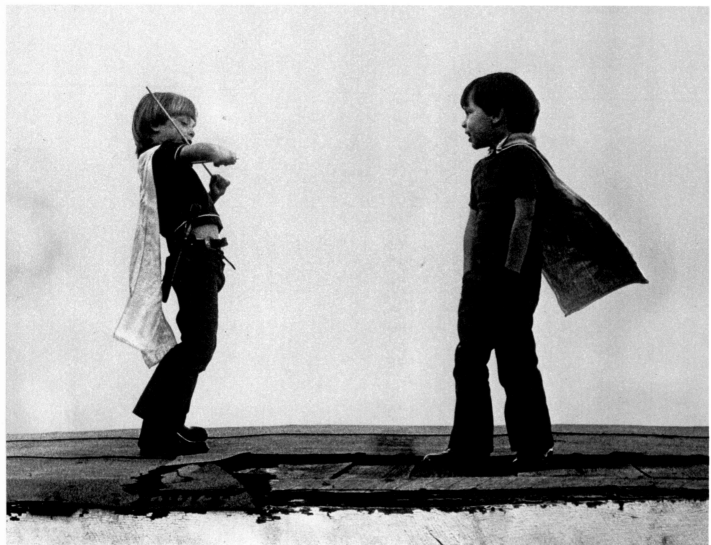

TERRY BISBEE: *Batman and Robin,* 1970

Her sympathy with children's make-believe made the photographer an accomplice to the pair of juvenile imposters at left. Shot from below to isolate them against the sky, the would-be Batman and Robin loom larger-than-life in the eye of the camera, just as they do in their own minds.

The behind-the-scenes view of a makeshift puppet theater, at right, captures both the facility of the young operators at pretending and their audience's whole-hearted involvement in the fantasy. None of them is aware of the camera.

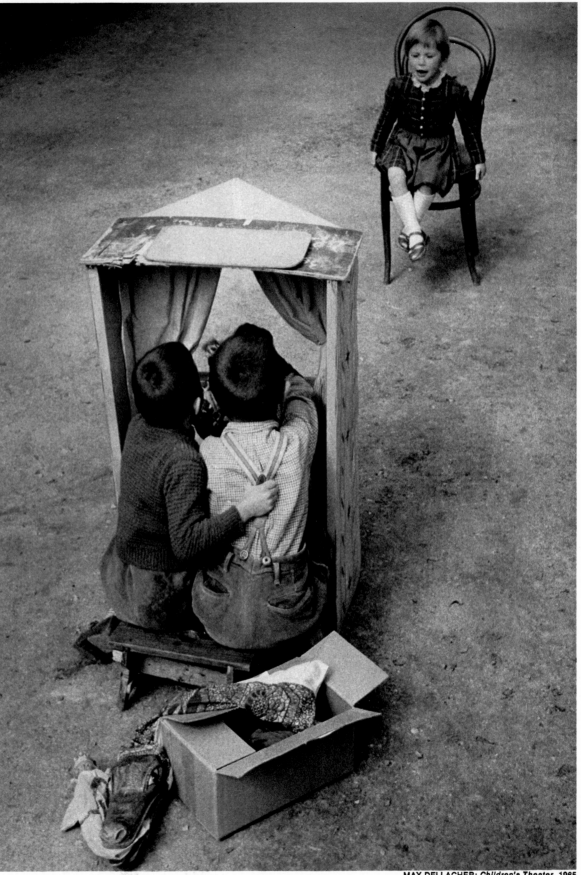

MAX DELLACHER: *Children's Theater*, 1965

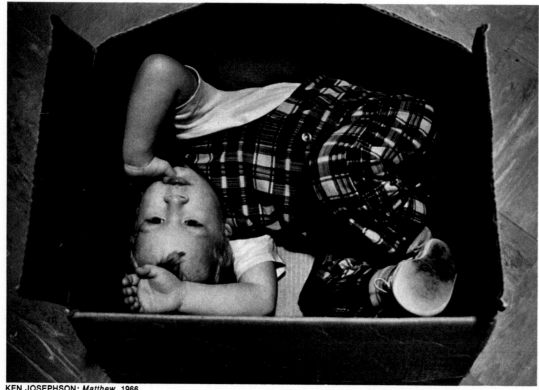

KEN JOSEPHSON: *Matthew*, 1966

Photographing his son, Ken Josephson found two ways to get a normally hard-to-pin-down subject nicely restrained and completely preoccupied as well. Above, young Matthew is snugly framed in a cardboard box. He is topsy-turvy but unbothered, evidently as indifferent to what is "right side up" and "upside down" as are unborn infants and astronauts in space. In the picture at right, he is all wrapped up in the Sunday funnies in a literal blending of real-life and comic-strip action.

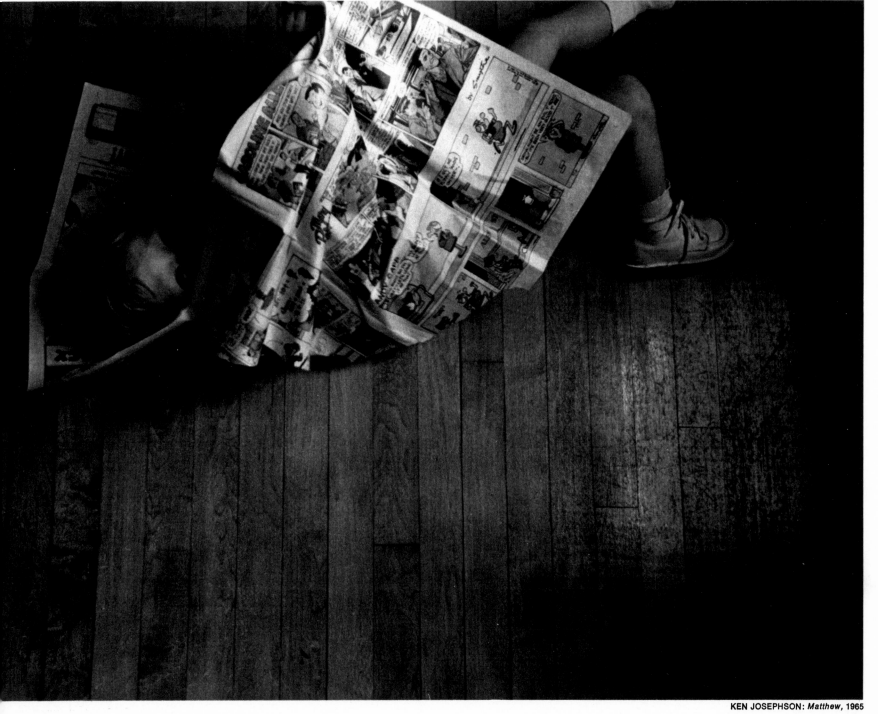

KEN JOSEPHSON: *Matthew*, 1965

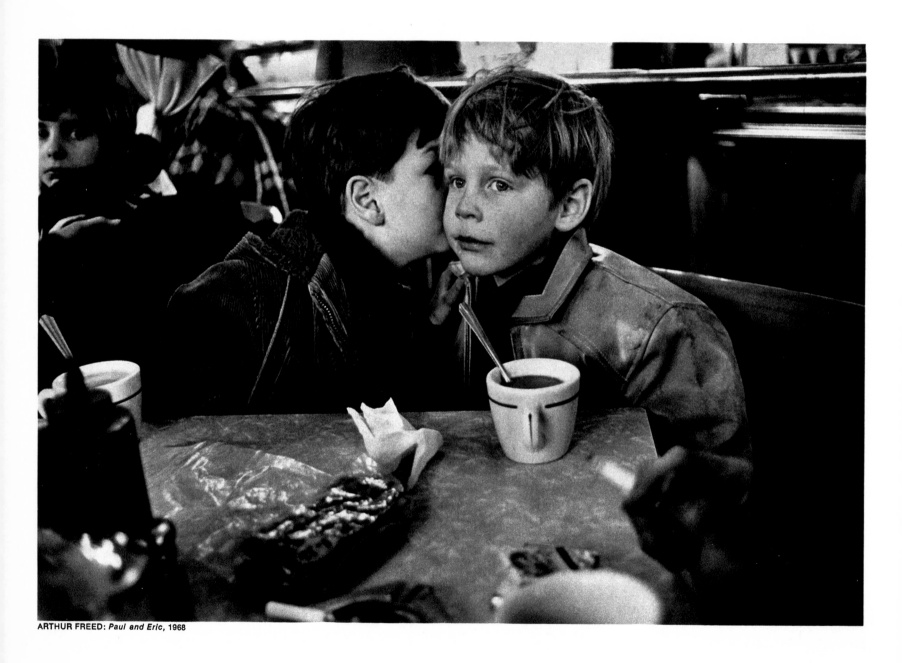

ARTHUR FREED: *Paul and Eric*, 1968

*Sharing some secret over cups of chocolate in a
lunchroom, these friends are too busy with their
own business to pay attention to the photographer.*

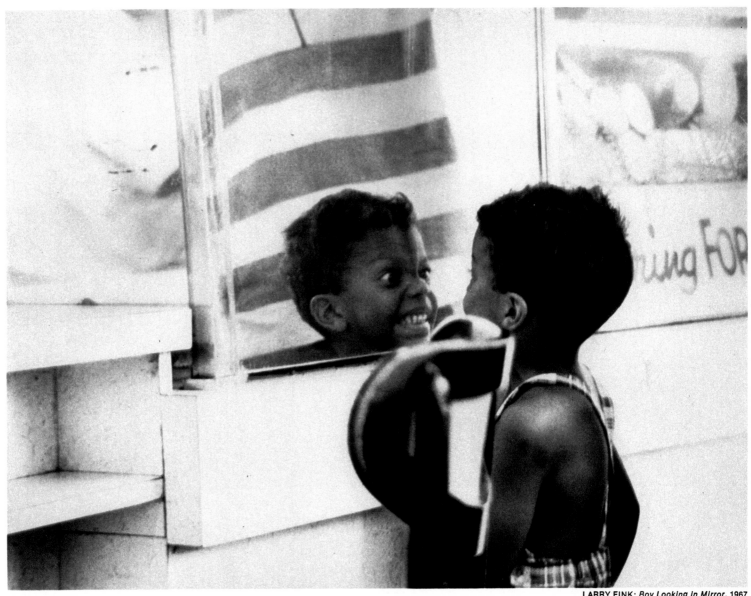

LARRY FINK: *Boy Looking In Mirror*, 1967

A boy's fascination with the expressiveness of his
own face reflected in a delicatessen mirror
prompted this eloquent image of childhood. A
zoom lens enabled the photographer to achieve a
medium close-up effect without distracting
the young man by actually moving in on him.

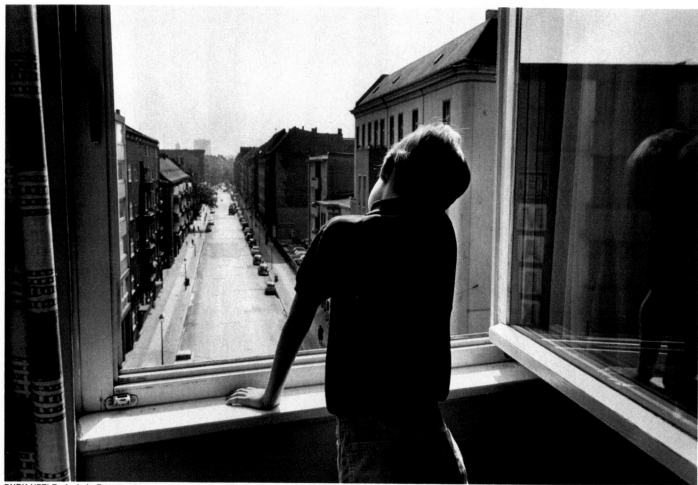

BURK UZZLE: *Andy in Europe,* 1966

The boy, the hotel room and the city outside the window are all anonymous in this strong composition. The suppression of such specific detail as facial features and furniture enabled the photographer to concentrate on symbolism: standing on the inside looking out, the child may be dreaming of home, the world, the future.

There are rare moments of suspended animation ►in the life of the most active child, when even a relatively cumbersome camera technique can achieve the natural effect of candid photography. In this example, the photographer's need of a quiet subject for his first experiments with a tripod-mounted 4 x 5 camera coincided happily with his young subject's desire to daydream in the intimate company of her collection of dolls.

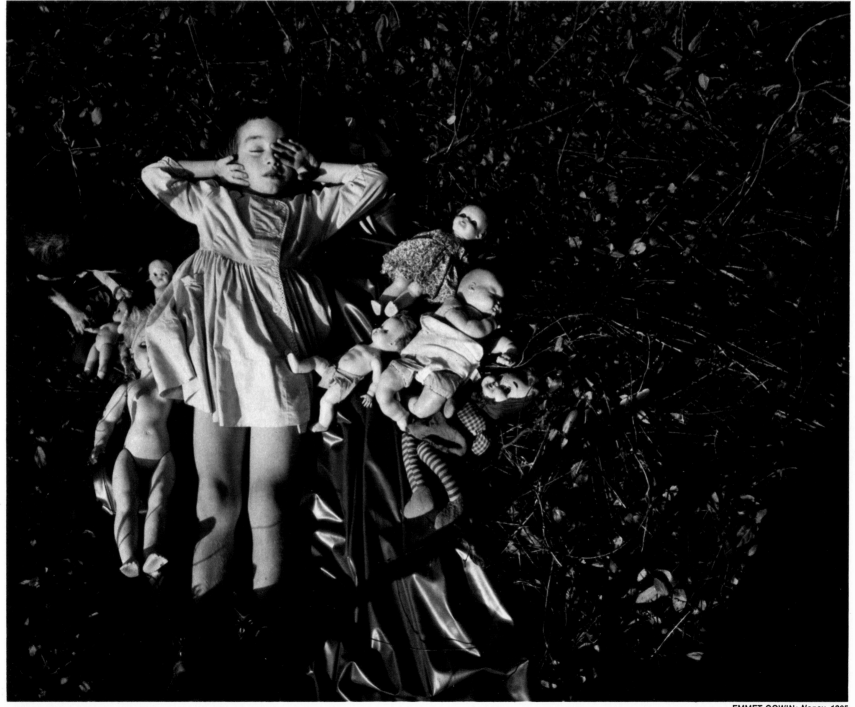

EMMET GOWIN: *Nancy*, 1965

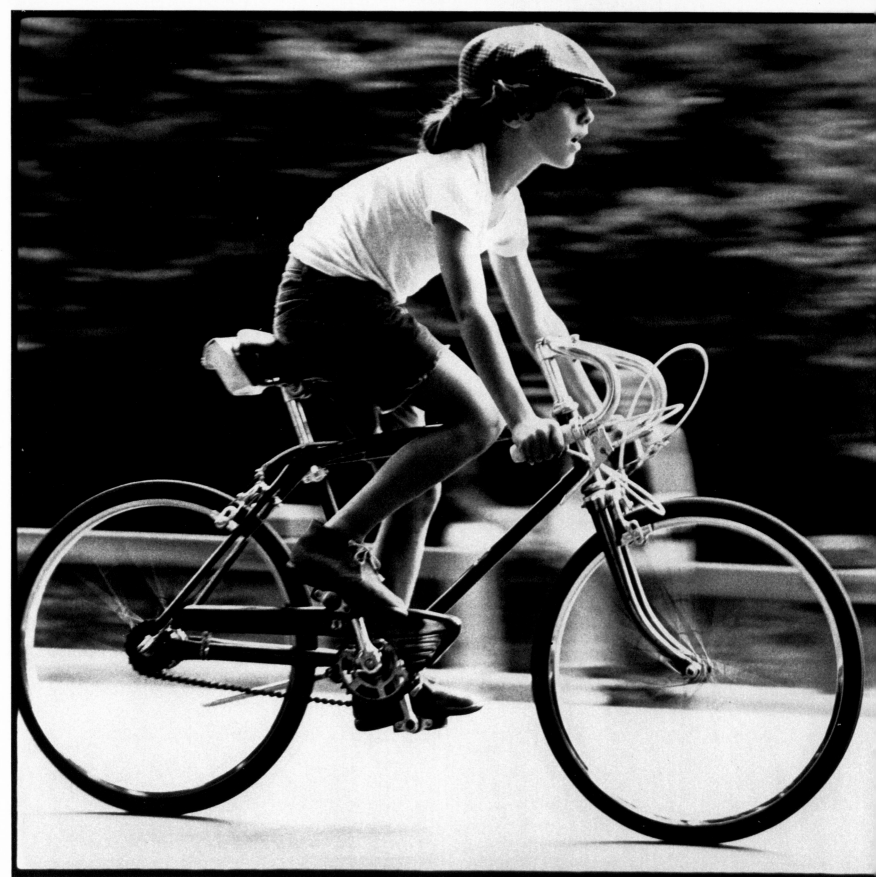

ARMEN KACHATURIAN: *Boy on a Bike*, 1970

148

The Boundless Energy of Childhood

The blurred background (the result of shooting at a slow shutter speed while panning to keep the subject stationary) says the bike is going fast. The forward pitch of the boy's taut body and his straight-ahead look say he is too intent on driving and on the road ahead to be camera-conscious.

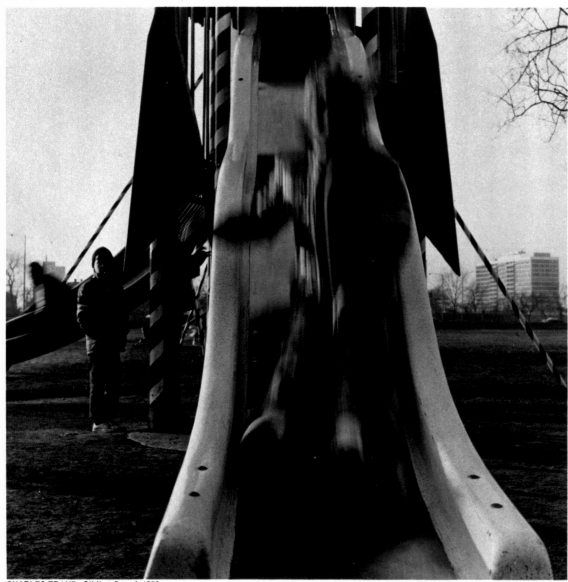

CHARLES TRAUB: *Sliding Board*, 1970

A momentary surrender to gravity on a playground slide can look like a test of disaster-defying courage: with the lens closed way down and the shutter held open for a full second, the camera keeps the playground equipment sharply defined while making the child a speeding blur.

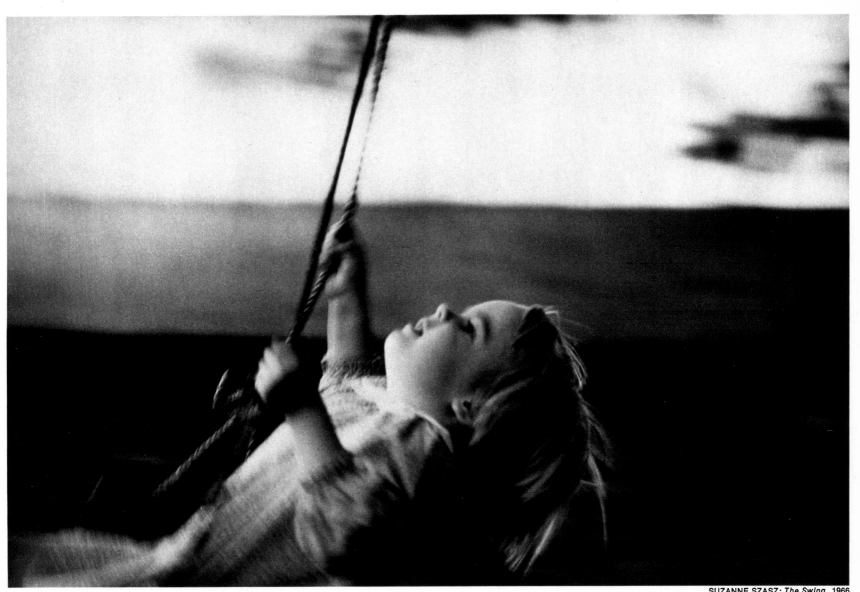

SUZANNE SZASZ: *The Swing*, 1966

The photographer concentrated on the child's
head, the posture of her body, the angle of
the ropes and the blurred background; the girl
just concentrated on the joy of swinging. The
picture is thus all action—and devoid of acting.

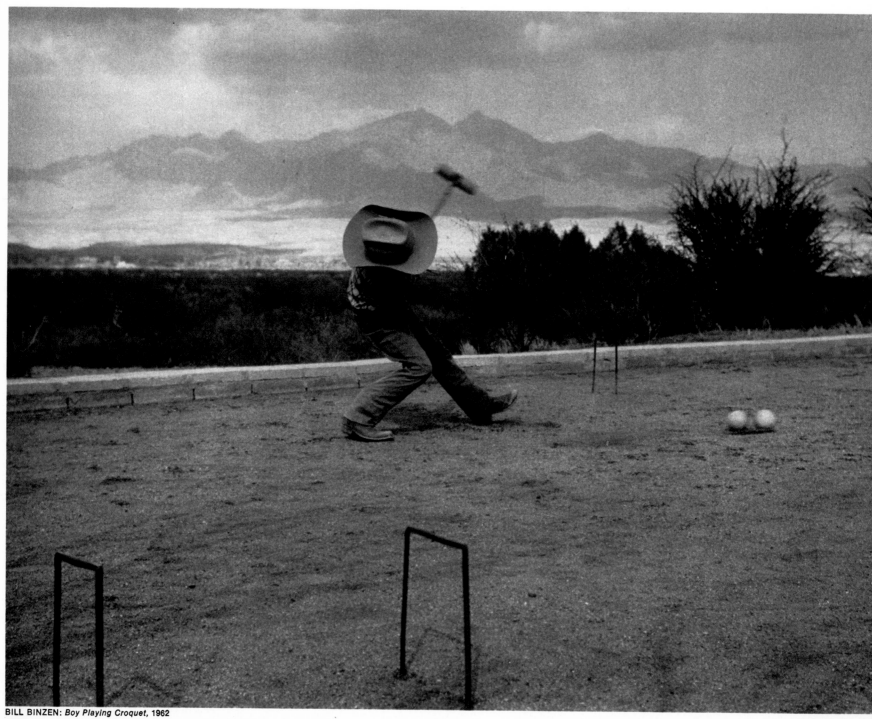

BILL BINZEN: *Boy Playing Croquet*, 1962

Caught off-balance as well as off-guard, a half-pint kid with a ten-gallon hat swings his croquet mallet like a baseball bat on what passes for a grassy playing field at an Arizona dude ranch.

Too intent on the satisfying job of destroying something to pay any heed to the camera, a Welsh boy labors mightily but happily with a rock over a discarded, already-battered baby grand.

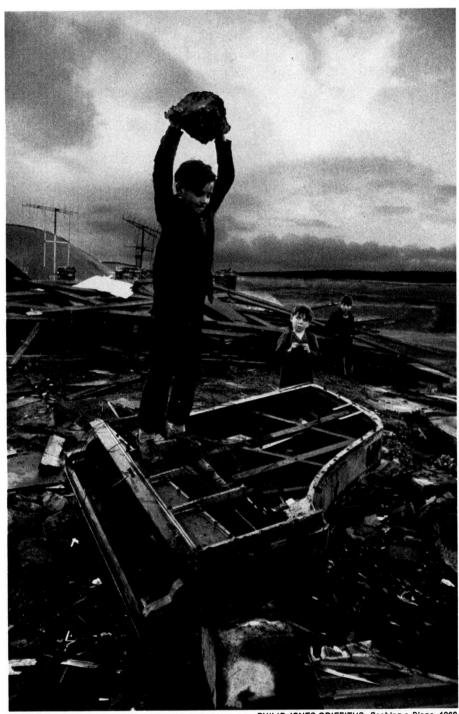

PHILIP JONES GRIFFITHS: *Bashing a Piano,* 1962

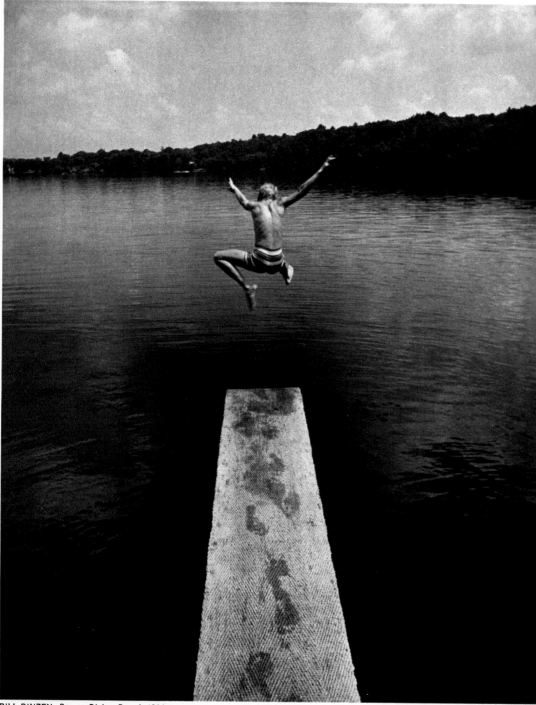

The boy is all flung-out arms and legs, but there is something graceful about the wild way he jumps into a quiet summer lake. The diving board makes the picture work: it not only counters the asymmetrical tension of the child's body, but leads the eye right to the boy and emphasizes the bold thrust of his leap, frozen in mid-air.

Children often show off their physical prowess. ▶ In this picture of a girl engrossed in gymnastics on a California beach, the photographer shot to exaggerate the size of the arcade and make the figure appear small as a doll, suggesting a childhood ritual in a monumental setting.

BILL BINZEN: *Boy on Diving Board, 1964*

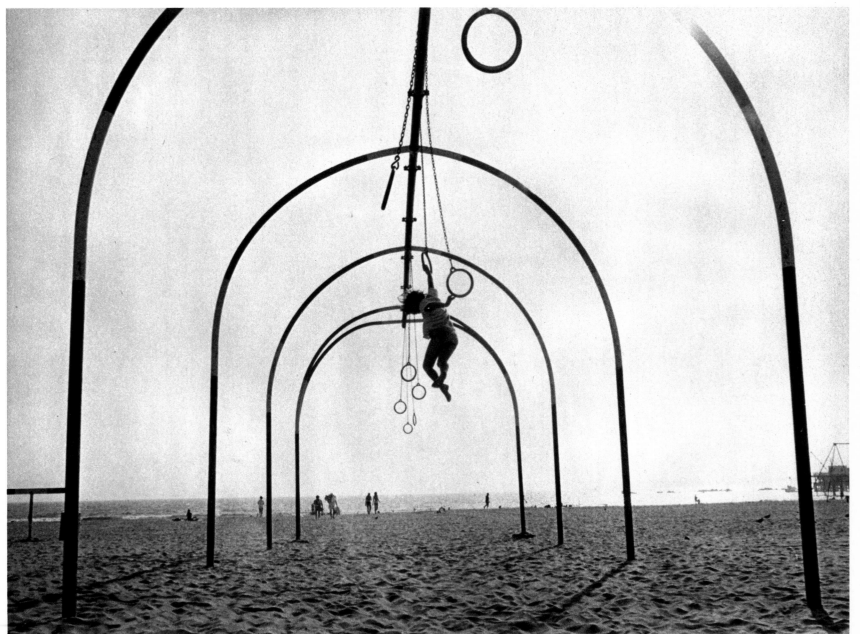

RON MESAROS: *Muscle Beach*, 1968

A long-focal-length lens and an overlooking
terrace allowed the photographer to zero in on
this child pretending to swim in a puddle. Only the
texture of the pavement suggests the urban
setting of this shallow pool, where concentric
ripples evaporate on a concrete shoreline.

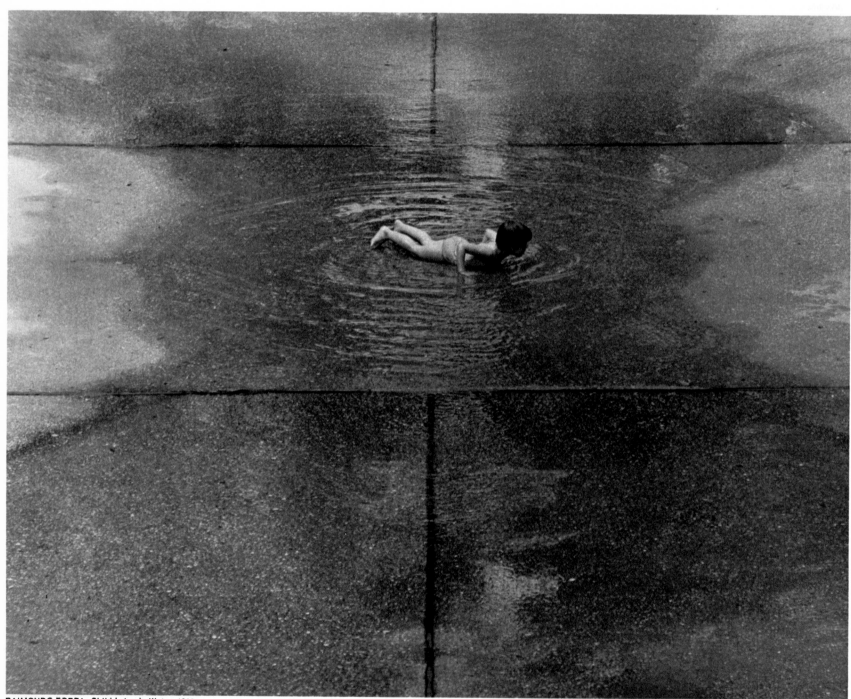

RAIMONDO BOREA: *Child Lying In Water*, 1968

Portrait of the Child

5

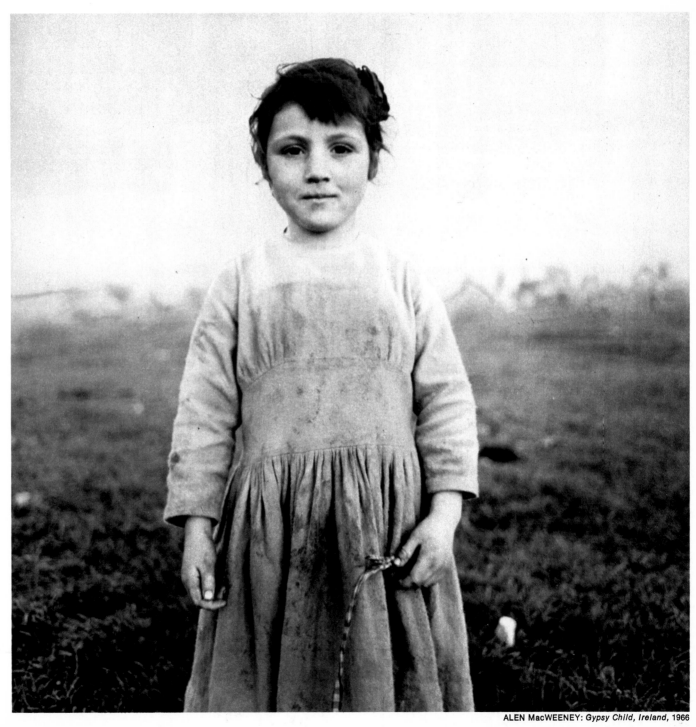

ALEN MacWEENEY: *Gypsy Child, Ireland,* 1966

Revealing the Signs of Character and Mood

It is almost a truism that children are frequently photographed but seldom portrayed. Millions of snapshots attest to the parental proclivity for preserving a record of their offspring's charming childhood. Yet few of these family album photographs do more than catch a glimpse of the child in a moment of time; what the child was really like at that time is still left to memory.

The true portrait must also catch that evanescent element that reveals the child as well as the moment. The feat does not depend alone upon focus or exposure setting, on lens or lighting. The actual photograph might show the child's face or the back of his head. It might be a literal likeness or an ideal one. It can set him against a complex backdrop or spotlight him starkly in a void. It may catch him unaware or record a histrionic performance. And the depiction of character may be plain and clear or elusive and puzzling.

But it must be there. By definition the portrait should tell something more about the subject than that he was young at the time. On canvas and on film, for five centuries and through countless changes of style and emphasis, the proper portrait of a child has made him instantly recognizable as the young person he was. And the best portraits have provided an added insight into his special nature—an insight that, because human traits are universal, is perceptible even to one who does not know him. If beyond all this the result has a pictorial quality that makes it a work of art, the photographer has achieved the portraitist's highest ambition.

He starts with an advantage if his subject is a child. And it is, oddly, a comparatively recent advantage. The English critic John Ruskin observed in the 19th Century: "The singular defect of Greek art is its absence of children." It took the world of Western sculpture and painting some 16 centuries to remedy the defect. Photographers were not so tardy; the camera was no sooner invented than it was trained on children. In one respect the photographers have had an easier time of it, since the camera is quicker than the chisel or the brush and need not tax the patience of a small and energetic model. (In fact, Norman Rockwell frequently used a camera on his young models and worked from their photographs to produce his famous paintings of effervescent American youth.) The sheer volume of photographic child portraiture is impressive. Professional portrait photographers estimate that half of their sitters are children, whose parents have them photographed several times in infancy and once a year thereafter until they reach their teens—while the parents themselves have their portraits taken once a decade or less. The average camera-carrying parent probably figures that a good deal more than half of his film goes for pictures of his children.

There are good reasons why it does, apart from parental pride or even the desire to record each fast-vanishing stage of their children's youth. Children simply make fascinating portraits. Because they are discovering so many

things for the first time, yet simultaneously love the ritual of repetition; because they are unfettered in their spontaneity even as they are circumscribed by the rules of their grown-up tutors; because childhood is a world apart—for all these reasons, the portrait of the child contains within it many of the best elements of photography.

The good portrait requires a good photographer at work, however, as well as a fascinating subject. And the good portrait photographer combines an image in his mind's eye with the response he gets from his model. That response—and image—may be as simple and unrehearsed as Alen MacWeeney's plain little waif in Ireland, on the preceding page, or as elaborately staged as the portrait of Ralph Eugene Meatyard's son, on the next page. In the first instance the child, a five-year-old, was one of a dozen children in a family of gypsy tinkers who roamed the countryside mending pots and pans. She was homeless except for the turf that stretches behind her to the horizon —a prop of nature that reinforces the fearless curiosity and unstudied self-assurance with which she regards the camera. The Meatyard picture stands at the other extreme. All his portraits are carefully posed and all are carefully thought out, some so intricately that they become portraits with the extra dimensions of allegory.

Neither photograph is that cliché, the "flattering" portrait. And in general this chapter seeks to avoid the obvious in favor of some more revealing, not-so-obvious ways of portraiture. As such, these photographs respond to an elemental challenge: children, in all their variety of character and impulse and mood, deserve portrait photography at its best. □

The Direct View

The traditional way to make a portrait of a child is the direct way: place him in front of the camera and photograph him head-on. But a revealing portrait requires more than that, as the photographs on these 30-odd pages show.

Props, pose and costume, and the careful setting of all these against a planned background, are essential in conveying the character and the mood of the child. And they are more fitting in the portraiture of children than of adults because children use props and costume more often, more casually and more imaginatively in their everyday lives. They ordinarily wear a wider range of costume than adults, assume more varied expressions and poses, and fit naturally into a greater assortment of props. Thus the extremes of setting can be used to draw attention to the characteristics of the child.

Ralph Eugene Meatyard, who died in 1972, specialized in symbolism, encouraging children to act out complex ideas about the meaning of life. He was an artist with a private vision, who juxtaposed symbols of life and death, decay and rebirth, reality and artifice. *(See pages 216-217.)* Because children are imaginative and readily engage in make-believe, they make perfect subjects for this kind of photography—and they unwittingly disclose their individual characters in the process, as does the child at right.

But most of the pictures shown on these pages are the simple, direct and unadorned views that come naturally to children. A child can look eloquently into a pair of human eyes or into a camera without the embarrassment that an adult often feels. The portrait photographer can hardly ask for more.

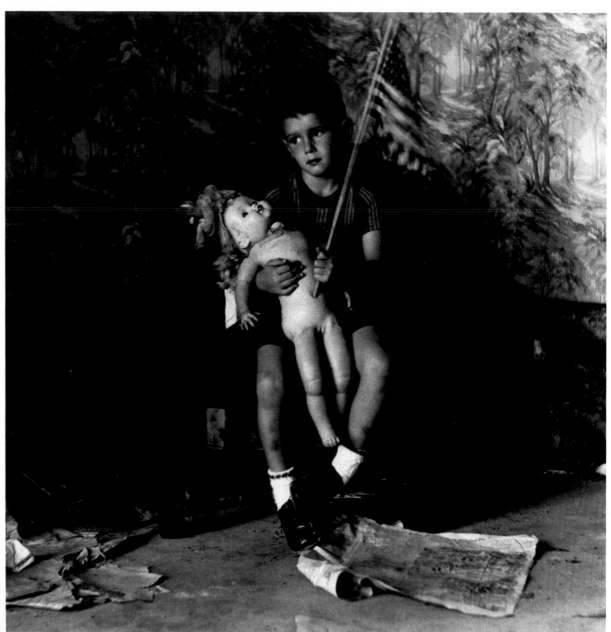

RALPH EUGENE MEATYARD: *Christopher and the Rebuilding of America*, Kentucky, 1961

In a dilapidated mansion in Lexington, Kentucky (left), the photographer placed his seven-year-old son in a chair that had survived from an earlier era. The peeling wallpaper, the drooping and tattered doll and the torn newspaper on the floor —all symbols of decay—contrast with the hope and regeneration suggested by the fresh-skinned boy and his fluttering flag, and contribute to portraying him as the idealistic child he is.

In a Parisian studio Sylvie sits firmly in an old-fashioned chair, a study in solemnity and discipline. All of the props—the straight-backed chair with its floral-patterned upholstery, the old photographic dropcloth and the canary perched on the child's hand (a Renaissance symbol associated with the Christ child)—reinforce her look of classic grace and well-bred manner.

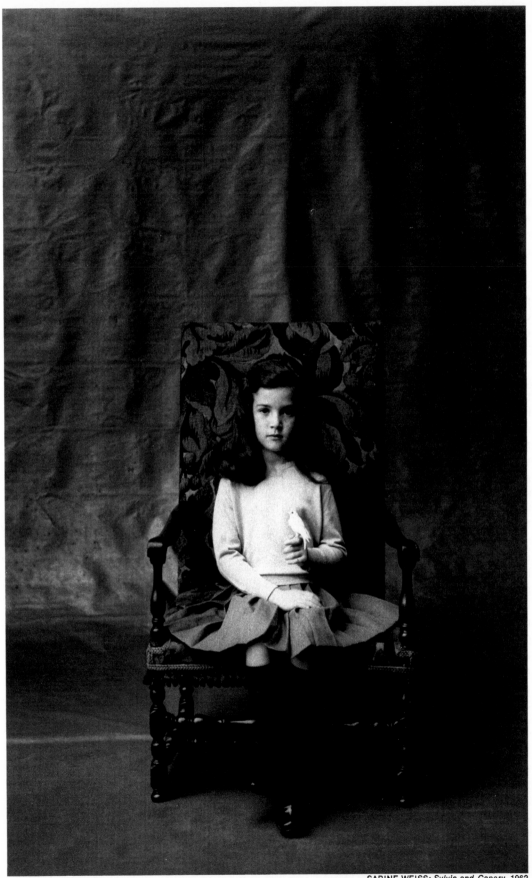

SABINE WEISS: *Sylvie and Canary, 1962*

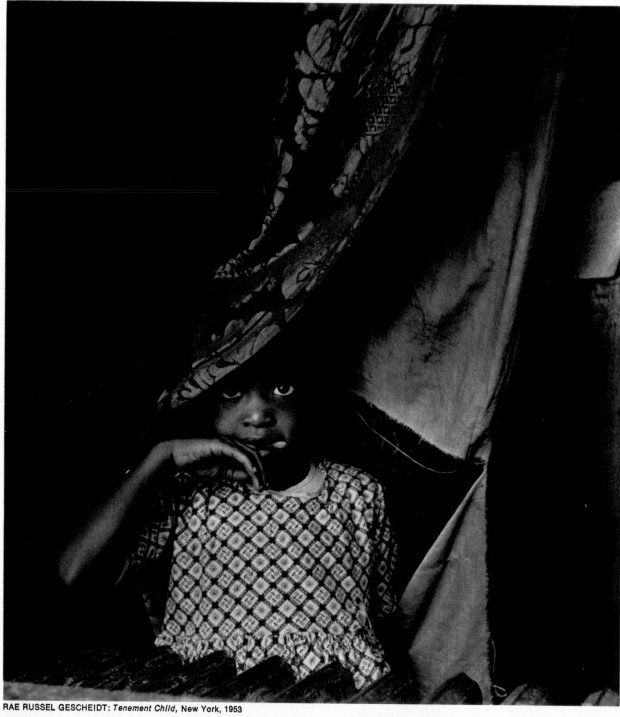

RAE RUSSEL GESCHEIDT: *Tenement Child,* New York, 1953

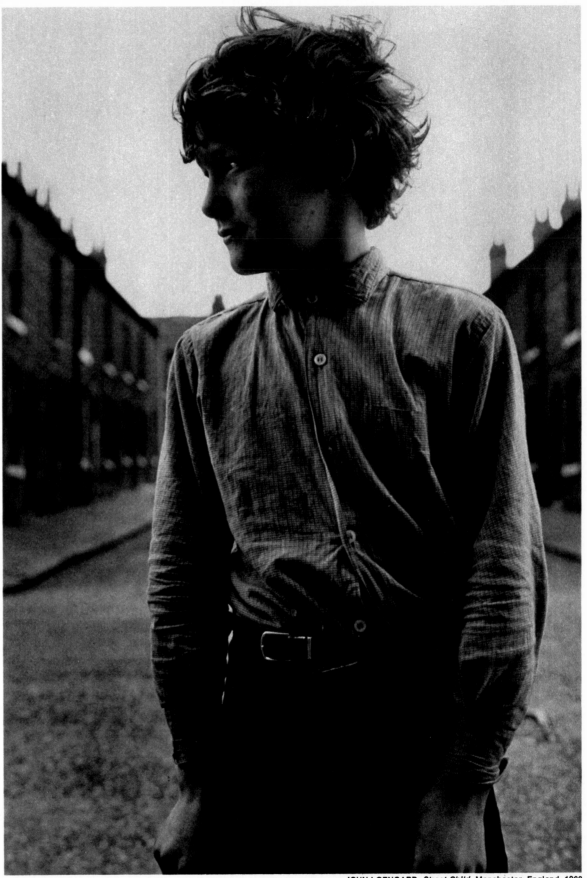

◄ *Regarding the camera with uncertainty, a timid little girl half hides behind torn drapery in the bleak New York tenement where she lives.*

Lord of all he surveys, a self-assured English lad looms large in the frame of the picture. His domain may be the drab street of an industrial city, but to all appearances he rules it proudly.

JOHN LOENGARD: *Street Child*, Manchester, England, 1968

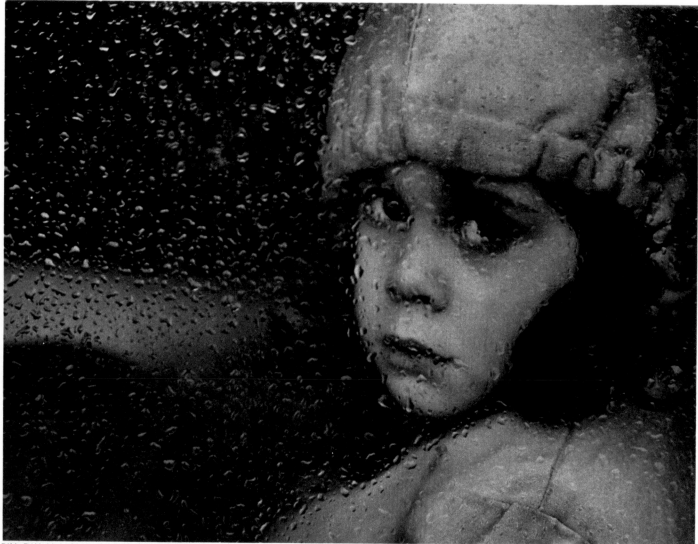

BILL RAY: *Little Girl in the Rain*, Canada, 1959

Raindrops splashing on a car window lend melancholy to this child's grave face and intensify its sense of mystery. The photographer glimpsed her on a Canadian highway while he was en route to Alaska. Her head and shoulders, with no other props than the raindrops and the hood of her snowsuit, make her a fragment in space and time; the child looks lost, perhaps no better able than the viewer to tell where she is going or why.

Equally grave but far from adrift is firm-eyed Tang ▶ Yung-Mei, two-year-old daughter of a Chinese diplomat. The paneled door and the polished chair behind her, and the embroidered silk she wears, all suggesting opulence, reinforce the sense of self-confidence radiated by her facial expression and demonstrated by her action—she has walked boldly into the grownups' quarters, without apology and without embarrassment.

166

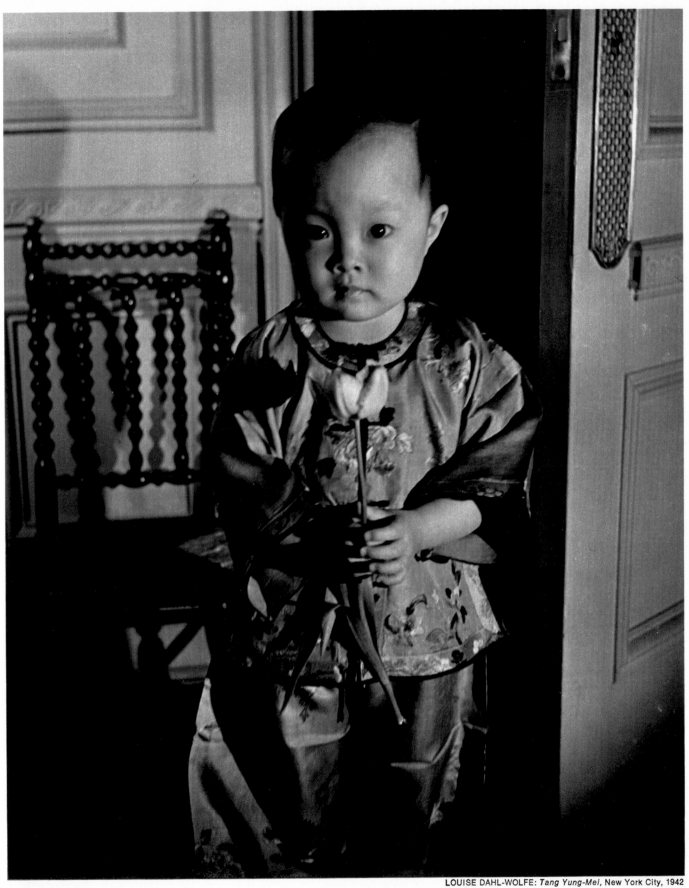

LOUISE DAHL-WOLFE: *Tang Yung-Mei*, New York City, 1942

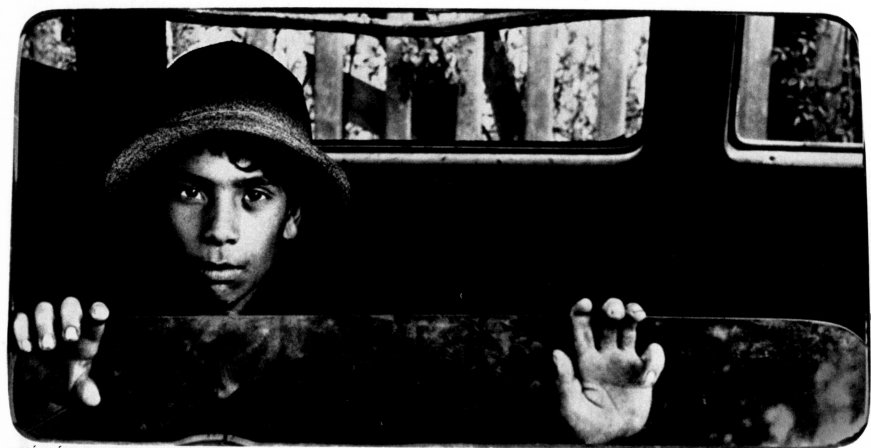

ANDRÉ A. LÓPEZ, *Gypsy Child in a Van*, France, 1968

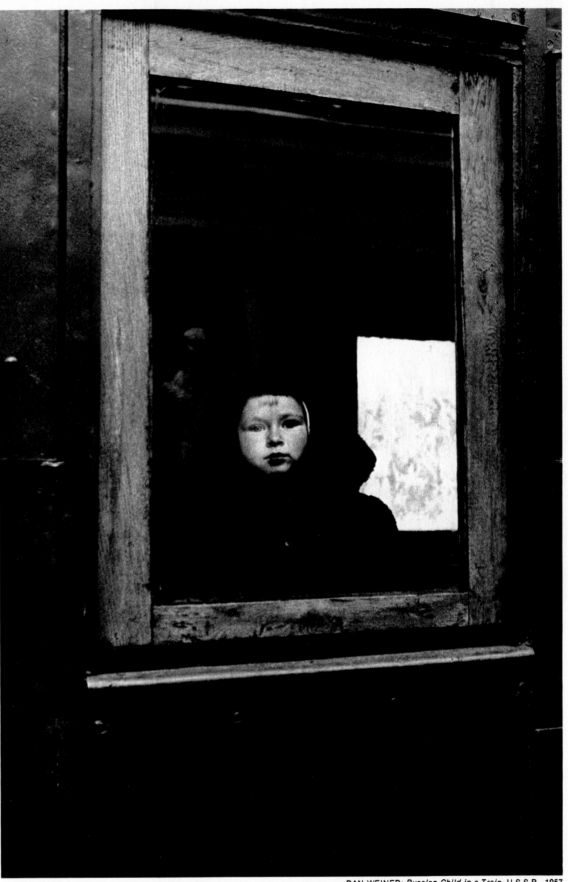

Children, being naturally curious, peer into and out of any window that presents itself—and the window provides the photographer with a ready-made frame that adds to the impression the viewer is seeing into an area normally kept private. The boy in the picture at left dispassionately takes the photographer's measure, studying him with the precocious savoir faire that has made gypsy children favorite subjects of artists in every medium. Through the van window behind the boy appear tree trunks, setting the scene in the woods in which this child's family has camped.

In a mood of dreamy wonder and uncertainty, a bundled-up Russian child looks out the window of an amusement-park train at his waiting mother, whose reflection shows up in the glass.

DAN WEINER: *Russian Child in a Train*, U.S.S.R., 1957

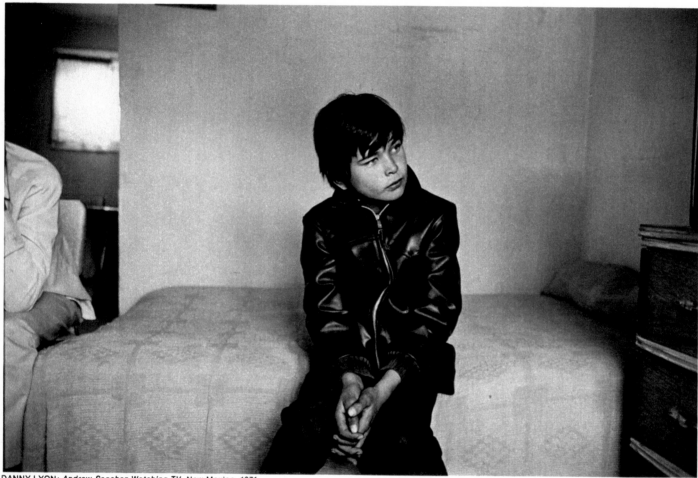

DANNY LYON: *Andrew Sanchez Watching TV*, New Mexico, 1971

A setting can often dramatize a child's nature as revealed in his face. In the picture above, the tough leathery jacket, the hard bed and the rigid wooden bureau set off the impressionable face of a boy who was photographed while watching television at his sister's house.

In the portrait of the enigmatic little girl at right, ▶ there is an almost spectral juxtaposition of the natural and the artificial. The whiteness of her face is not photographic trickery, nor is her placid pose the photographer's whim: the girl is probably anemic. Set as she is among nature's leaves and flowers—whose pattern is echoed in the embroidery of her dress—she has the inert quality of a manufactured china doll.

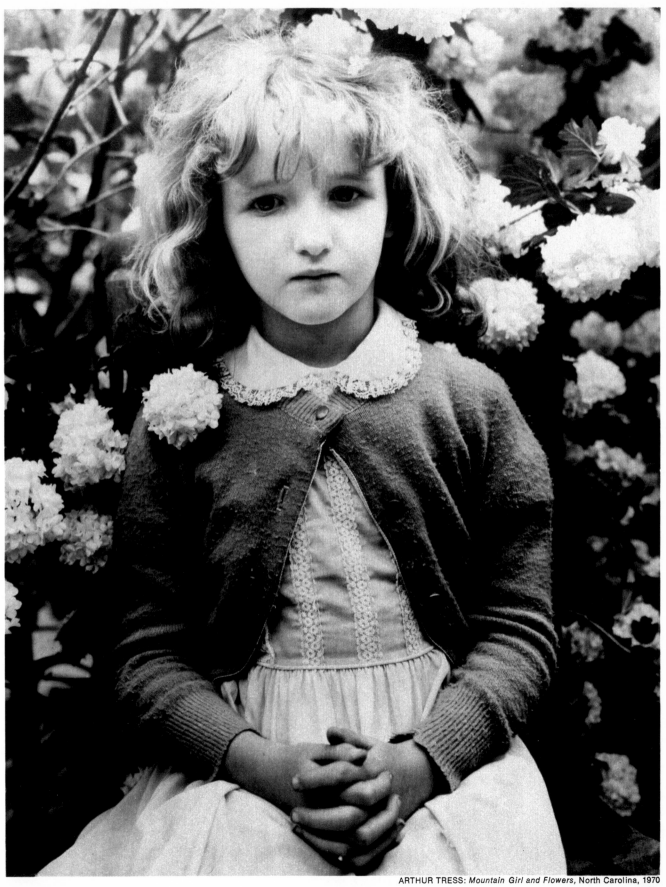

ARTHUR TRESS: *Mountain Girl and Flowers*, North Carolina, 1970

The Unexpected View

Walk down a street several yards behind a child you know, and you will be able to tell who he is even if he never turns in your direction. Not only will the contours of his head, shoulders, torso and limbs be distinctive and familiar, but so will his gait, his stance if he halts, the cant of his head, the movements of his hands and arms.

Such facts have a direct application to portraiture, for the observant photographer can make fascinating portraits by recording the varied traits and gestures that bespeak—as tellingly as the face and its expression do—the uniqueness of the child. Far more than adults, children make such indirect portraiture easy to do, for much of the time children are altogether unselfconscious, and even when they ham for the camera they exhibit a distinctive combination of worldliness and innocence that makes interesting and endearing pictures.

Gently or boldly, the photographs of children that follow challenge the conventional definition of the portrait. In their use of postures and expressions, possessions and settings, they are not at all what the portraitist traditionally has assumed a portrait should be. Yet they are true portraits all the same, inasmuch as they make significant statements about the nature of their subjects. Such is certainly the case in the picture at right, the portrait of a reflective little girl whose father came upon her at the beach. Whether she is contemplating the water, happily examining the reeds she has found or having a good cry over some mishap of childhood, the viewer cannot know. But he can judge her to be a person absorbed in her own important thoughts.

The photographer and his family were visiting a ▶ friend in the country when he saw his five-year-old daughter communing with herself, and he aimed his camera without her knowing it. To those who know her the child is instantly recognizable by the tilt of her head, her pigtails, the shape of her body and the placement of her small feet. But even to those who do not, she has lent herself to a charming portrait of childish contemplation.

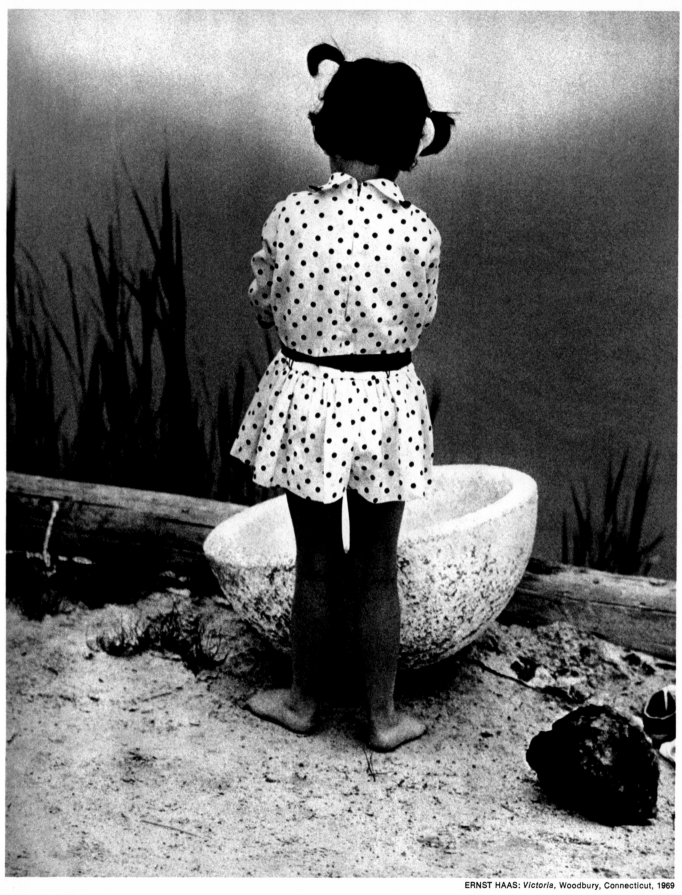

ERNST HAAS: *Victoria*, Woodbury, Connecticut, 1969

Character in Action

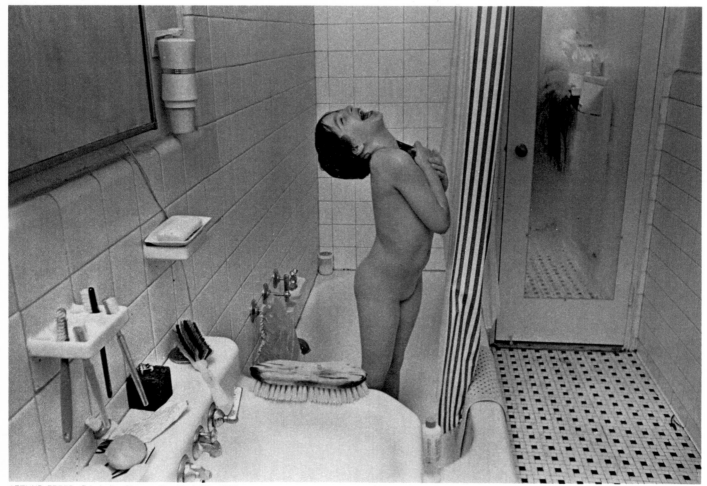

ARTHUR FREED: *Erin in the Shower*, New York City, 1970

*The simple pleasure of a bedtime shower evoked
this demonstration of sheer delight in the
photographer's nine-year-old daughter. To get
sharpness of detail he stopped down his lens and
used an electronic flash, bounced off the ceiling,
to provide sufficient light for the small aperture.*

The epitome of grief, this child was photographed in Hungary during the chaos that engulfed much of Europe after World War II. What scene she is witnessing is anyone's guess; her emotions of anguish and fear are what make the portrait.

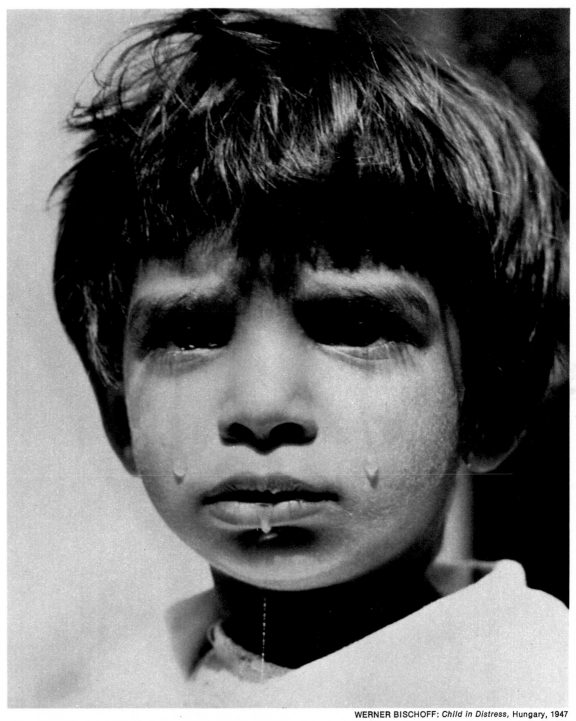

WERNER BISCHOFF: *Child in Distress*, Hungary, 1947

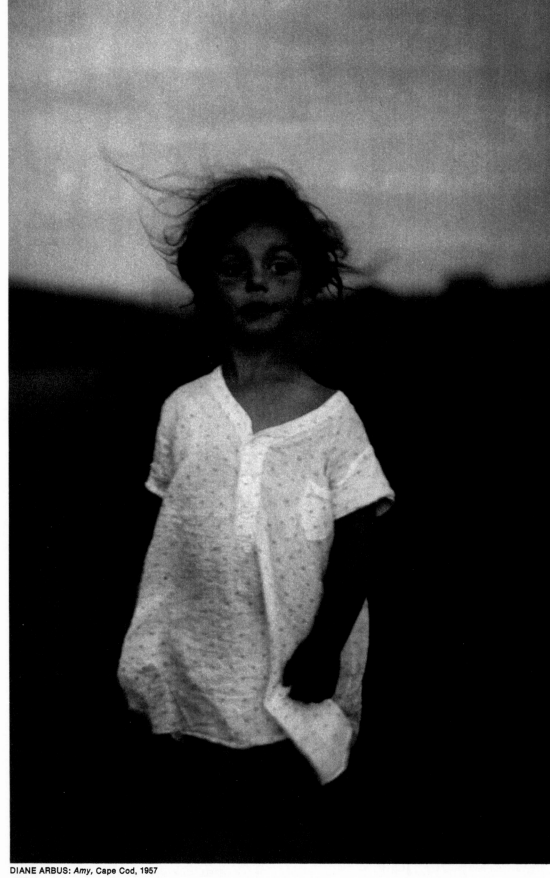

The photographer took this picture of her daughter just before the child was to take an afternoon nap. The storm clouds and wind-tossed hair are symbols appropriate to the child, who appears to have all the charged emotion of a 19th Century romantic. Her straight back, her firm jaw and the purposeful stride with which she seems to move forward out of the picture suggest that, nap time notwithstanding, Amy has determined her own course for the afternoon.

For a more tranquil picture, one that evokes the ► optimism of the turn of the century, a child sits in an old costume. Eleven-year-old Stephanie willingly assumed a pose harmonious with the costume, as peaceable as the grass and the stream that recede into the background.

DIANE ARBUS: *Amy,* Cape Cod, 1957

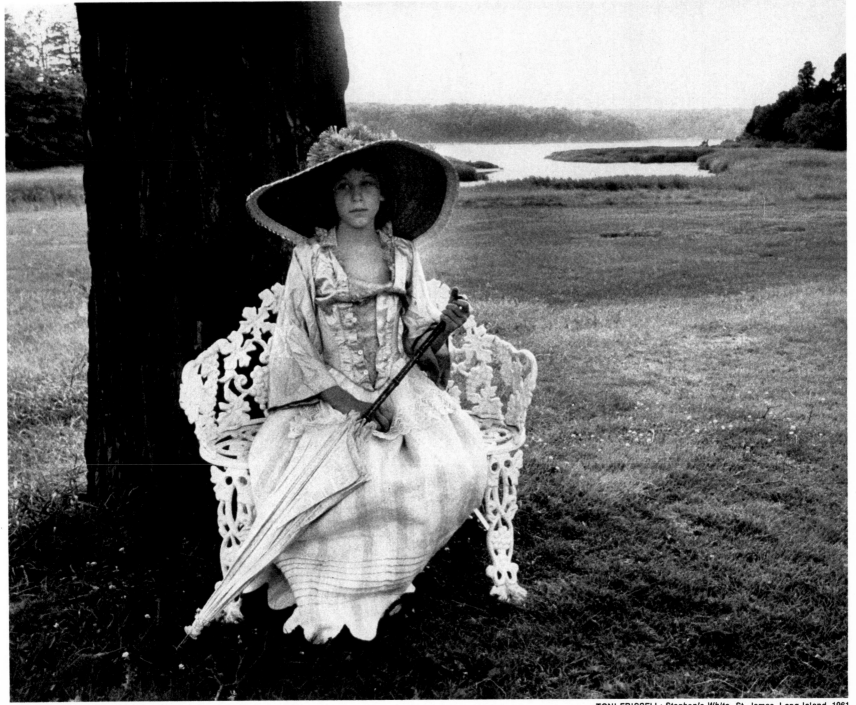

TONI FRISSELL: *Stephanie White*, St. James, Long Island, 1961

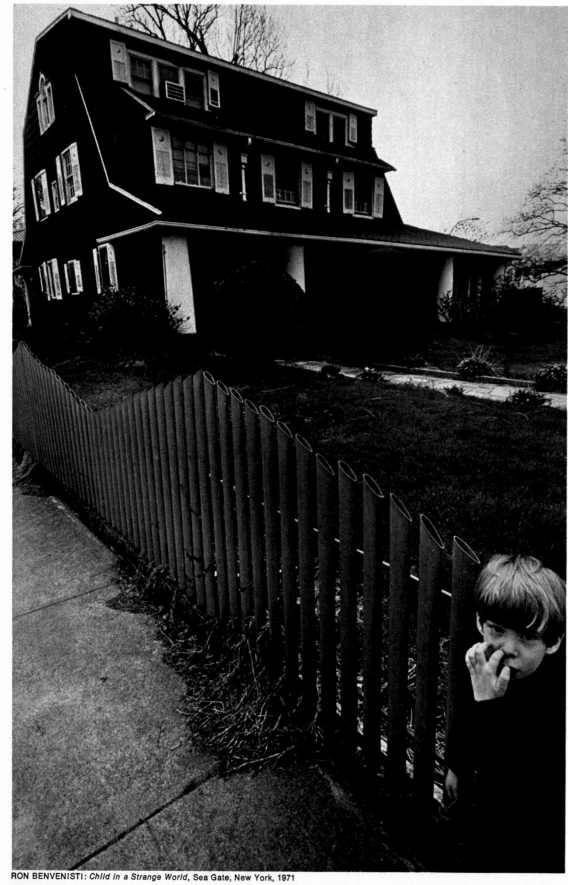

A big house with jutting eaves and a zigzag fence —both made formidable and grotesque by means of a wide-angle lens—help to portray this child, whom the photographer found on a beach resort sidewalk, as if cowering in a vast and mystifying world, overwhelmed by all that surrounds him.

Asserting his growing independence and pride of ▶ possession, a cool and confident teenager hangs one leg over the splendid bicycle that proclaims his status and supports his self-esteem.

RON BENVENISTI: *Child in a Strange World*, Sea Gate, New York, 1971

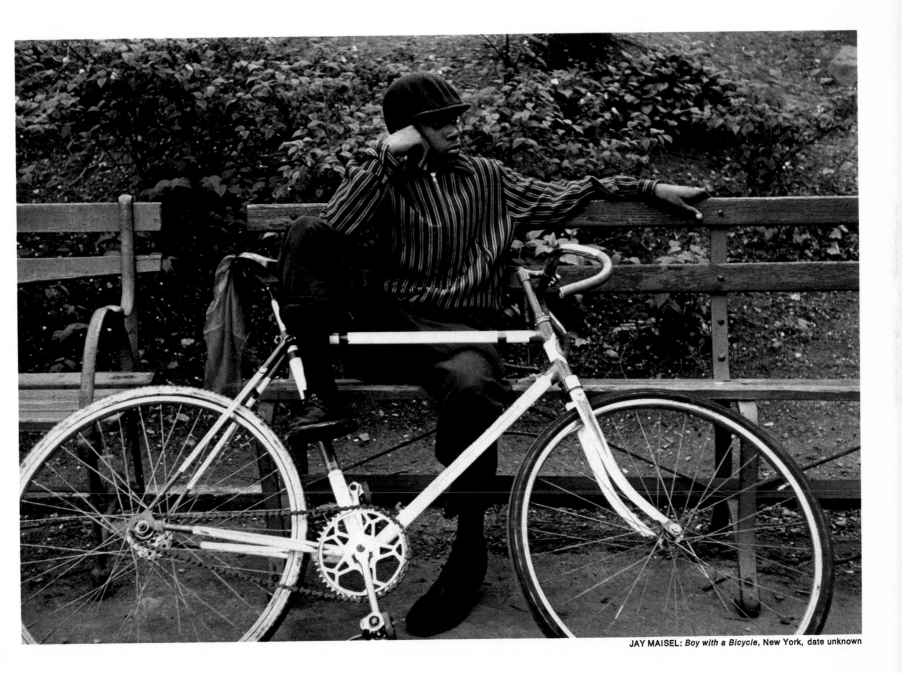

JAY MAISEL: *Boy with a Bicycle*, New York, date unknown

Instant Bravado; a Careful Composite

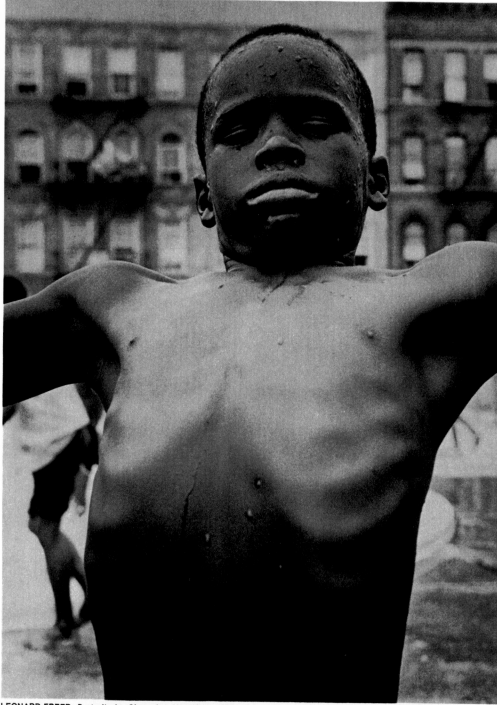

The photographer was on an assignment at a
municipal swimming pool in New York's Harlem
when the boy at left came up and asked to
be included in the pictures. "Why should I
photograph you?" Freed asked in a spirit of
friendly challenge. "Because I'm big and strong,"
the boy replied, and this picture proves it.

If you think you see one somewhat blurred child ►
in the picture at right, look again. It is really
two children, together with both their parents.
This unusual picture was designed by Dominik
Burkhardt for a New Year's card. He had
photographer Nicolas Bossard make four frontal
shots, passport fashion, of Burkhardt, his wife and
their two daughters, taking care to position the
camera so that the distance between the eyes in
each image would be identical. Then darkroom
specialist Lilo Nido printed the four negatives,
one over the other, onto a single sheet of paper,
using a quarter of the usual exposure time for
each, in order to get the normal gray tones. The
result is an unusual portrait in which genetic
likenesses have so merged that the family
appears to be represented as one complete child.

LEONARD FREED: *Portrait of a Champion*, New York, 1966

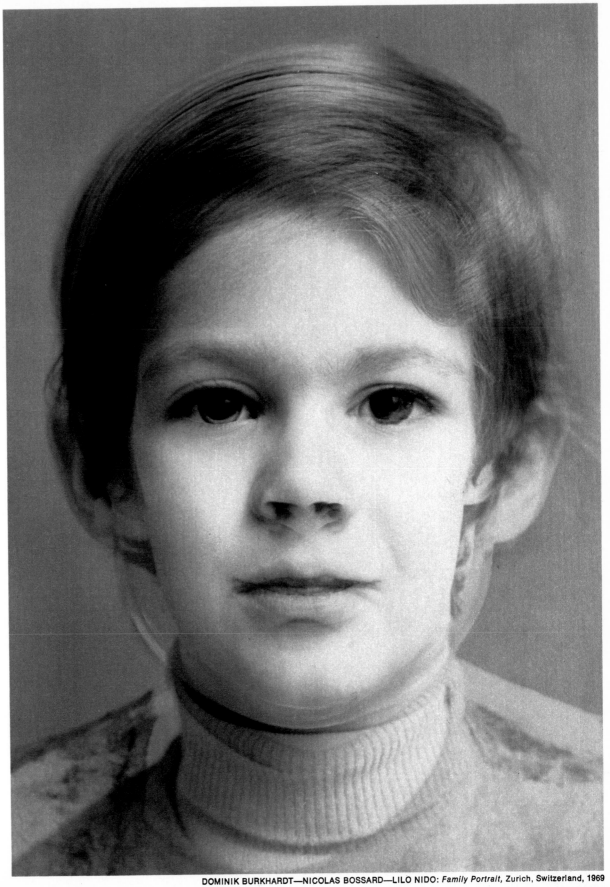

DOMINIK BURKHARDT—NICOLAS BOSSARD—LILO NIDO: *Family Portrait*, Zurich, Switzerland, 1969

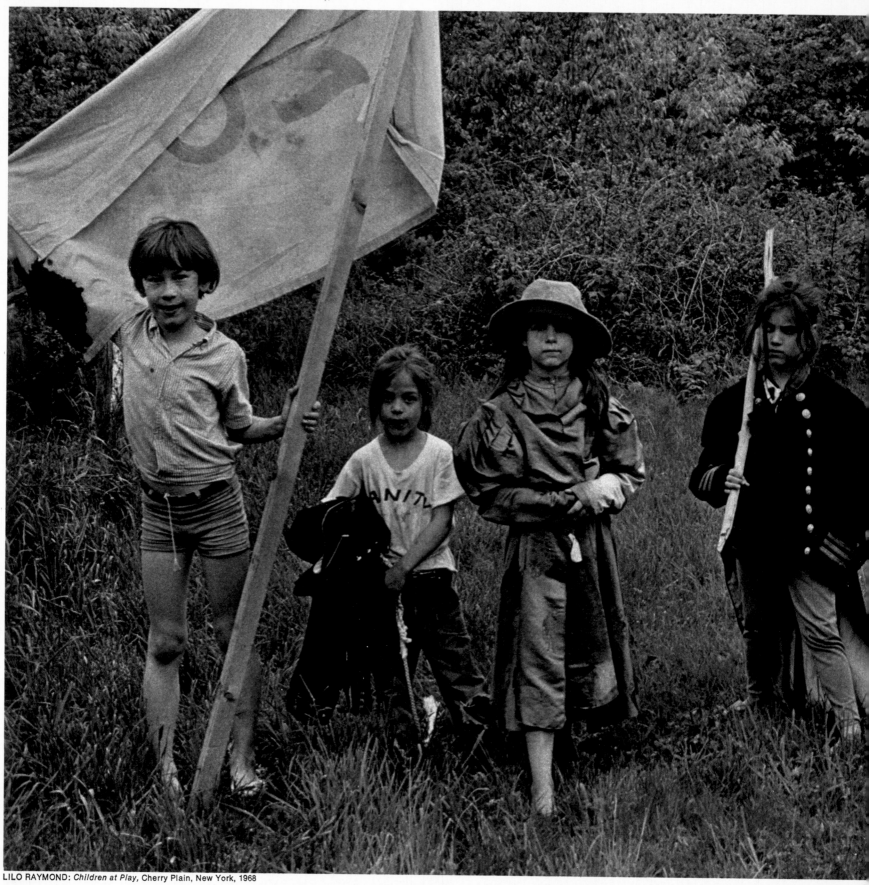

LILO RAYMOND: *Children at Play,* Cherry Plain, New York, 1968

The Gang's All Here

Photographing children in groups is both simpler and more complicated than photographing them singly. It is simpler because children's groups seem to be everywhere—grownups segregate them, and children themselves practically invented the concept of the gang. The gang may consist of a group of siblings, a group of cousins, a group of neighbors; a school class or a group within a class; a group away at camp or a group of scouts at home.

In all their groupings children have at once a cohesiveness and an individuality not common to adults in groups. And the very nature of the groups often tells much about what the children are like. Besides, the activities they engage in—climbing trees and furniture, dressing in school uniforms, playing special games—provide the photographer with an almost infinite variety.

For all that, photographing the group has its own difficulties. The relationships the photographer has to consider increase by geometric progression as the number in the group increases. In a single portrait the only relationships are between sitter and photographer or sitter and viewer; in a group portrait the figures relate to one another as well. And the setting, while it may help to hold the group together, must for the sake of the portrait be a part of the group's *raison d'être.*

Still, as they do singly, children in groups often assist the photographer —unwittingly or on cue. Sometimes a game in progress provides a picture, as on page 190; at other times an interruption is in order. The children at left were playing a game of their own invention with a motley assortment of props when the photographer, who was on a visit in the neighborhood, found them and got their attention. They obligingly struck their poses, unwittingly telling the viewer something about themselves, about the game they were playing and, by extension, about childhood.

A small army pauses between skirmishes in a backyard in upstate New York. The improvised flag and weapons and the outsized costumes denote the seriocomic nature of the game and its participants, who are upper-middle-class children sufficiently privileged to spend their summers in the country whiling away the lazy afternoons at make-believe—the American idealization of how childhood should be spent. Even grouped, the children retain their separate identities, as shown in their varying looks, from four-year-old coquetry to 10-year-old sophistication.

In Uniform and Out

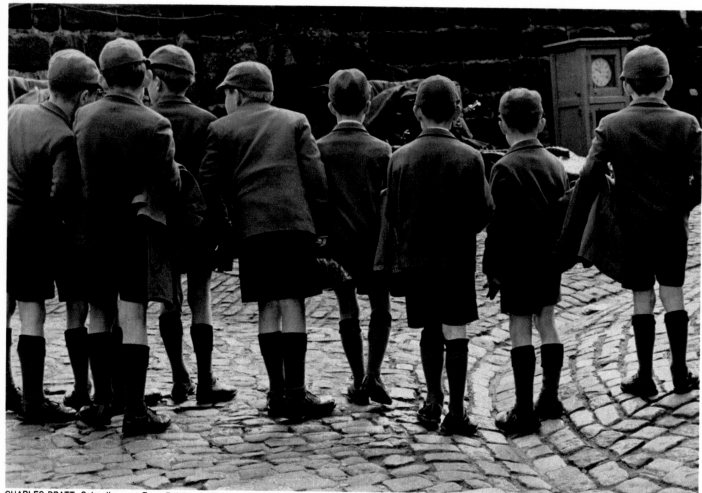

CHARLES PRATT: *Schoolboys on Tour*, Edinburgh, 1966

One way of grouping subjects for a portrait is to give them something in common. In these pictures the common thing is dress—and the lack of it. Both are portraits that could be taken only of children, for adults do not generally tour in uniform, and the nuances of adult nudity usually overshadow character portrayal. These pictures have an unexpected twist, however: the clothed children are quite unaware of the camera, having been caught with their backs turned, while the nudes are staring right into it—two approaches that might more commonly have been made the other way round.

A class of boys, alike in school uniforms and stature, are quite unaware of the camera as they contemplate the weathered stone walls of Edinburgh Castle. By their uniformity of height and dress—from their peaked caps to their knee socks—they proclaim themselves to be of a class.

Four children from neighboring families at a ▶ summer resort face the camera head-on, completely ignoring—as only children could be expected to do—the fact they have no clothes on.

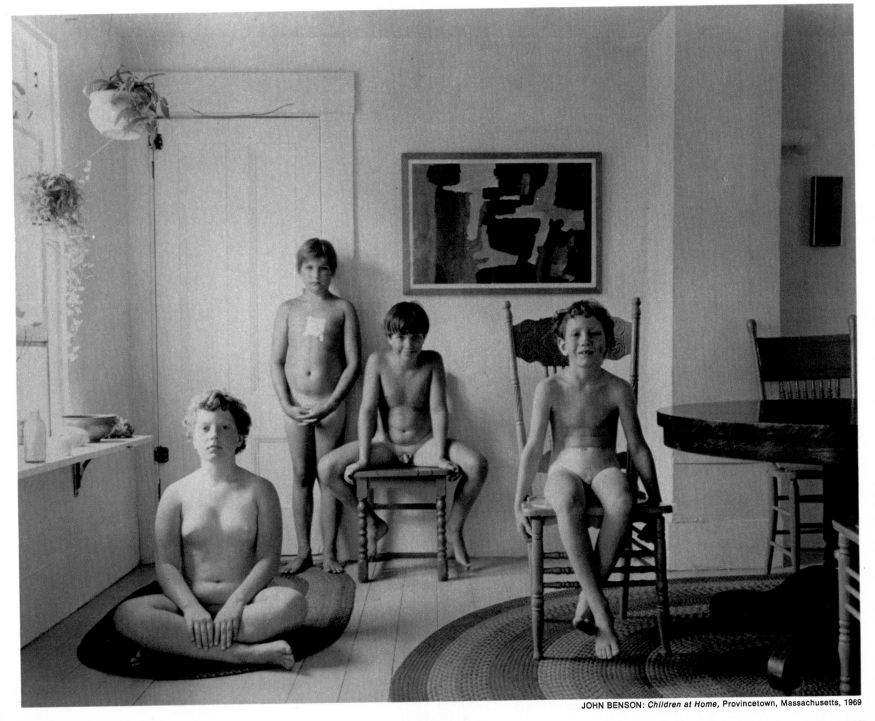

JOHN BENSON: *Children at Home*, Provincetown, Massachusetts, 1969

Framing the Group

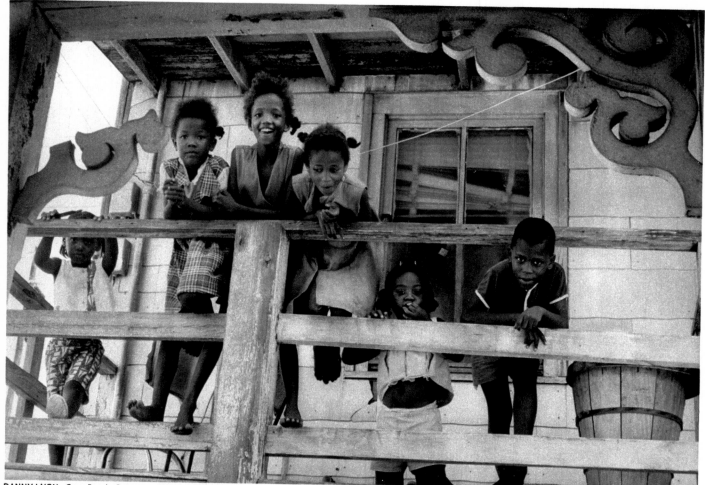

DANNY LYON: *On a Porch*, Galveston, Texas, 1967

Framed by the railing on which they are draped and the gingerbread trimming overhead, six children peer at the photographer with the friendly curiosity that children generally accord a visiting stranger to their neighborhood—and with a range of facial expressions and postures that portray their individual natures, from the cautious peekaboo at left to the come-hither smile at right.

What costume does not do to make a group coalesce, setting often will. Give a group of children a railing to climb or a grove of trees to perch in, and they will often supply their own poses, together with backdrop and framing to complete the picture. What is more, they will do so with an abandon lost to adults, stamping the picture as a portrait of childhood—and of the children within the frame, revealing their moods, their times and their activities.

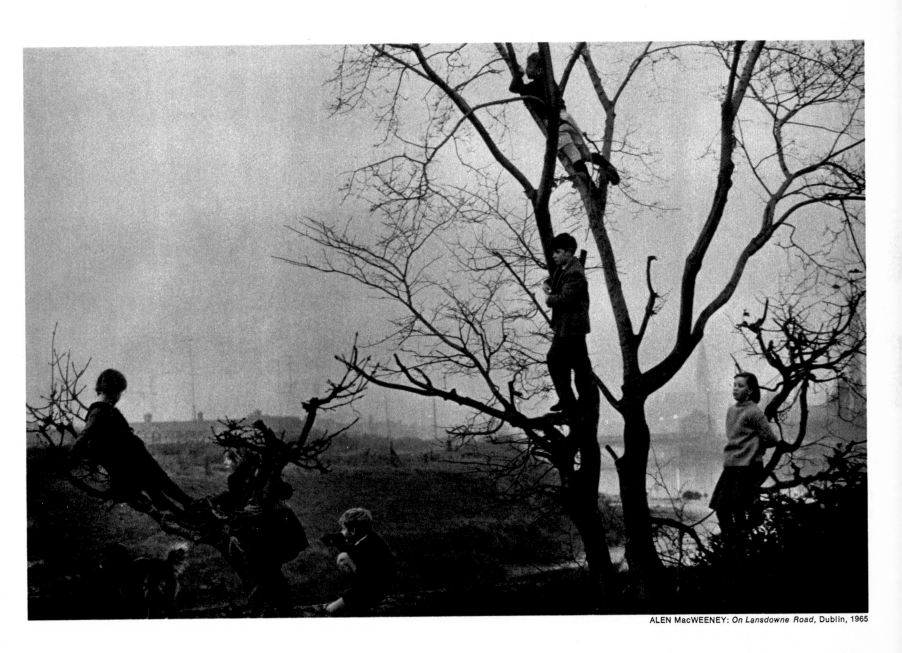

ALEN MacWEENEY: *On Lansdowne Road*, Dublin, 1965

The trees of a wooded park give these six children in tweeds and knits a view of Lansdowne Road Stadium (background). The children themselves show by their absorption in the game their city-bred sophistication; they are children to whom neither strangers nor cameras are curiosities. The leafless trees against the autumn sky provided a striking pattern against which to set them.

A Variety of Feelings Shared

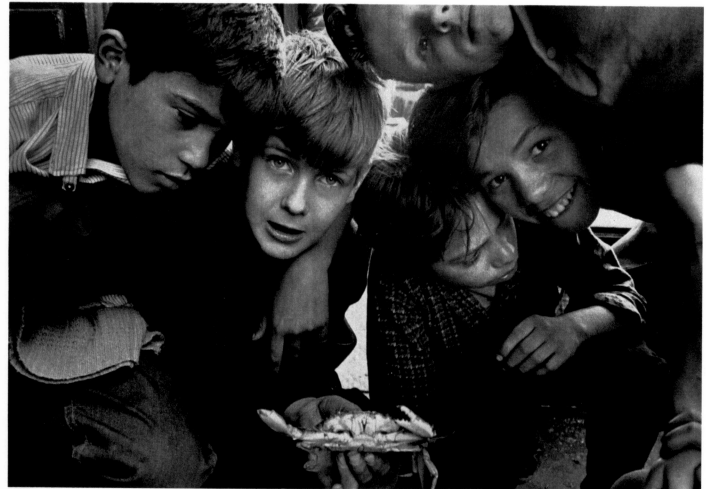

DANNY LYON: *Boys with a Crab*, New York City, 1964

The pastimes of children involve a good deal of physical contact, and often create human clusters of artistic composition. The boys in the picture above came upon a crab at a fish market. Curious, they huddled together when one of them picked it up, and the photographer got a grouping in which the circle of faces and hands leads the viewer's eye right to the crab.

Just as fruitful for the photographer are the routines of everyday life—some of them so repetitious that they slip by hardly noticed by most grownups. Such a scene is the one at right, taken by a photographer who devoted three years to trailing his children with camera in hand. One morning after his daughters had had some friends in for a slumber party, he caught this touching tableau. So accustomed were the children to his camera that they have the look of being unobserved—a dividend of hard-to-capture naturalness.

The novelty of playing with a crab on the pavement of New York's Lower East Side thrust these boys into a natural grouping—and a spontaneous display of a spectrum of reactions, from surprise and curiosity to amusement.

A ritual of hairbrushing yielded this triangular ▶ grouping when the photographer's daughter Dana (in front) lazed abed with her guests, lit by the morning sun coming through a window—an almost classic scene of quiet intimacy and warm feeling.

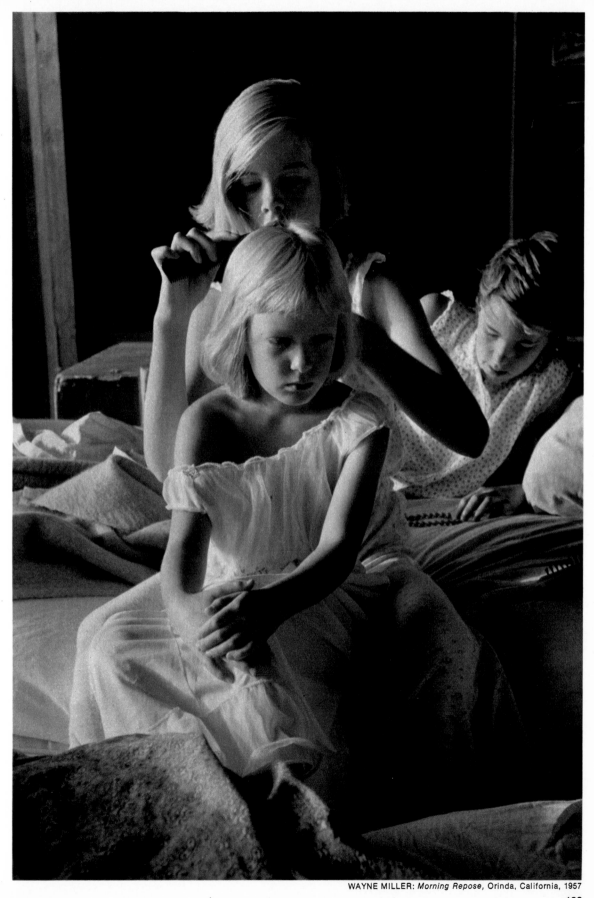

WAYNE MILLER: *Morning Repose*, Orinda, California, 1957

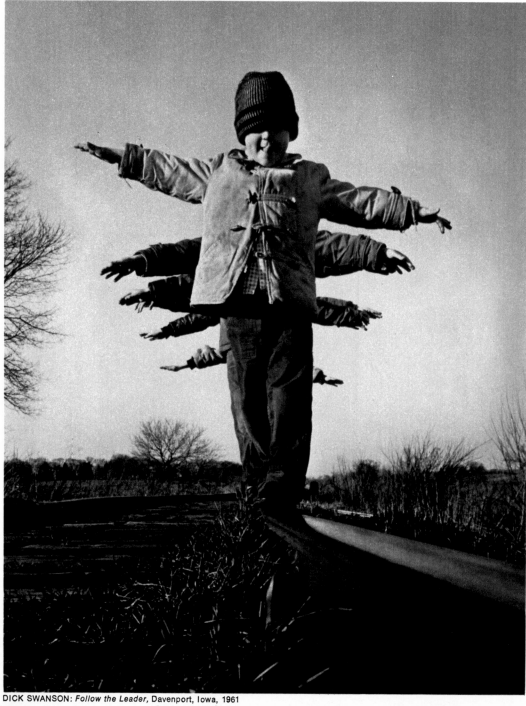

Everybody has seen boys playing follow-the-leader; but how many have seen it from a grasshopper's-eye view? Keeping the mind's eye alert for different perspectives can lead the photographer to unusual pictures such as this, which is simultaneously a group portrait of one of childhood's universal pastimes and a single portrait of the young leader whose playmates, bent to his will, are observed behind him.

DICK SWANSON: *Follow the Leader,* Davenport, Iowa, 1961

A Portfolio of Styles 6

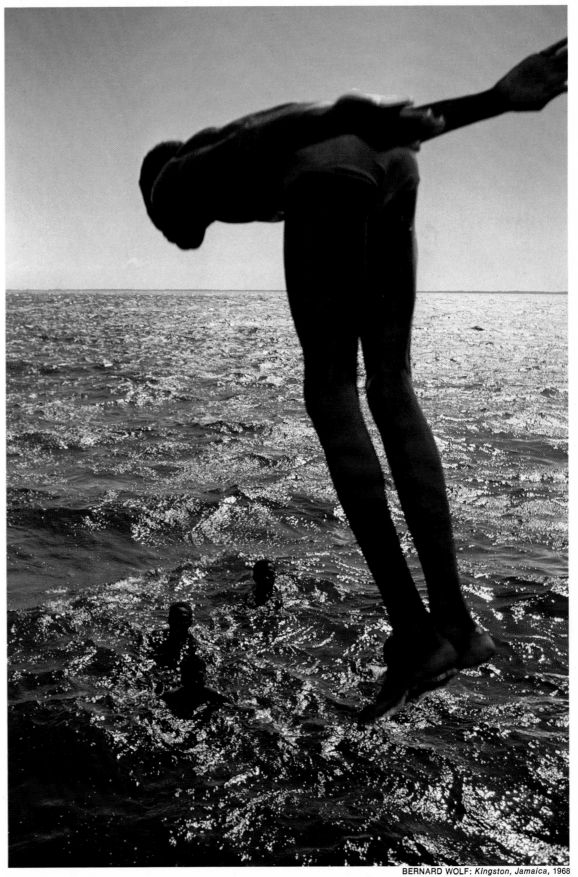

BERNARD WOLF: *Kingston, Jamaica*, 1968

Ten Photographers' Ways with Children

No subject has more obvious appeal to professional photographers than children. Full of spontaneity, with their enthusiasms and disappointments and second thoughts clearly written across their faces, children seem consummately photogenic. They are also innocent subjects, at least in the sense that no barrier of adult inhibitions has yet been erected to come between the child and the camera.

"Children are more natural," in the view of George Krause, who began refining his sensitive artist's eye by taking photographs of youngsters in the late 1950s. "It's easier to see something and to convey it with them." Mary Ellen Mark, a photojournalist who has portrayed people of all ages all around the globe, took many pictures of children at the outset of her career. "Children gave me confidence," she says. "They are easier to approach than adults. Perhaps it's simply because I'm bigger than they are."

Everything about child photography seems easy. Perhaps too easy, for among the millions upon millions of cute babies and beguiling youngsters who smile out of their photographs, only a few are portrayed with real artistic power and conviction. For few photographers manage to evoke in the viewer that special excitement that marks a truly great photograph.

What is the elusive quality that creates this kind of impact? It is not magical. Technical excellence is part of it, certainly—the perfect composition, the sensitive use of colors, the expressive utilization of shapes and tones that produce a well-made photograph. More important, it comes from the photographer's unique personal interpretation of what he sees and records, the special set of attitudes and ideas with which he approaches his work. In short, his style.

Each of the photographers represented on the following pages presents children in ways that are his very own. None of them turns his talents exclusively to children, but each exhibits his own distinguishing style when he does. Sometimes the style may come from his techniques and the equipment he chooses, as when Marie Cosindas uses Polaroid film to produce the rich, muted colors of her consciously nostalgic portraits. Part of it emerges from the rapport that the photographer develops with his subject. A. Doren, for example, exercises a subtle form of stage direction to bring about his direct confrontations with youngsters, while Bernard Wolf, who took the ingratiating portrait of the young girl at right—as well as the soaring diver on the previous page—often uses a telephoto lens to catch his subject unaware.

Sometimes the photographer may imprint his hallmark in the darkroom, which is where David Heath deepens shadows and intensifies highlights to increase the impact of his disquieting images. More basically, style grows out of the way each photographer approaches photography itself. The work of these 10 photographers ranges from the forthright documentary statements of Mary Ellen Mark, through the startling surrealistic fantasies of Arthur Tress, to the enigmatic, deeply personal allegories of Ralph Eugene Meatyard. In each case, the photographer has managed to record on film his own vision of the world in general, as seen through the special world of children. □

All the charm of childhood seems to radiate from this young girl, with her easy pose and gap-toothed smile. But the photograph is more than just another cute picture, for the photographer has brought to it a discerning eye for bright color and balanced design—plus an alertness that caught the girl's smile at its most fetching.

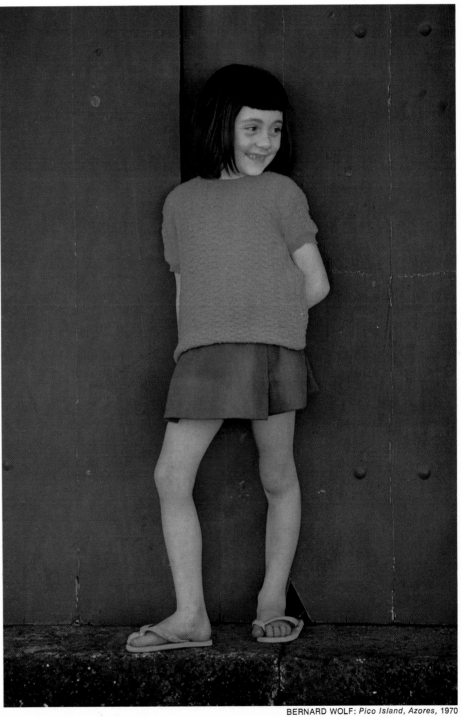

BERNARD WOLF: *Pico Island, Azores,* 1970

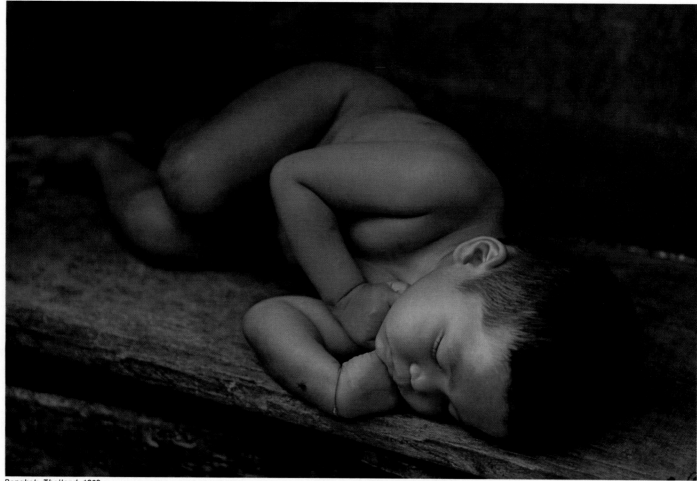

Bangkok, Thailand, 1969

Bernard Wolf is a photojournalist who concentrates on capturing the natural look of the children he frequently photographs. On his assignments to remote and exotic lands, Wolf tries to show people—including children—as they are, "immersed in their environment and culture." Almost never does he pose a child, or consciously intrude into the scene. Instead, he prefers to stroll about, armed with three 35mm cameras, each with a lens of different focal length and each with exposure preset so that he can respond instantly to whatever catches his eye—a child sleeping in a doorway, a bright smile on a youthful face or even a harmonious blend of shapes and colors, as in his picture on the preceding page.

For all their freshness and spontaneity, Wolf's pictures show a masterful control over composition and color. One of his hallmarks is a fondness for combining bright and contrasting hues; the light purple of the child's shirt in the picture opposite makes an interesting combination with the yellows of the costumes worn by the two other figures. But sometimes, as with the infant above, he uses subtle modulations of a single color to bring out shapes and textures. In either case, the effect is one of total naturalism.

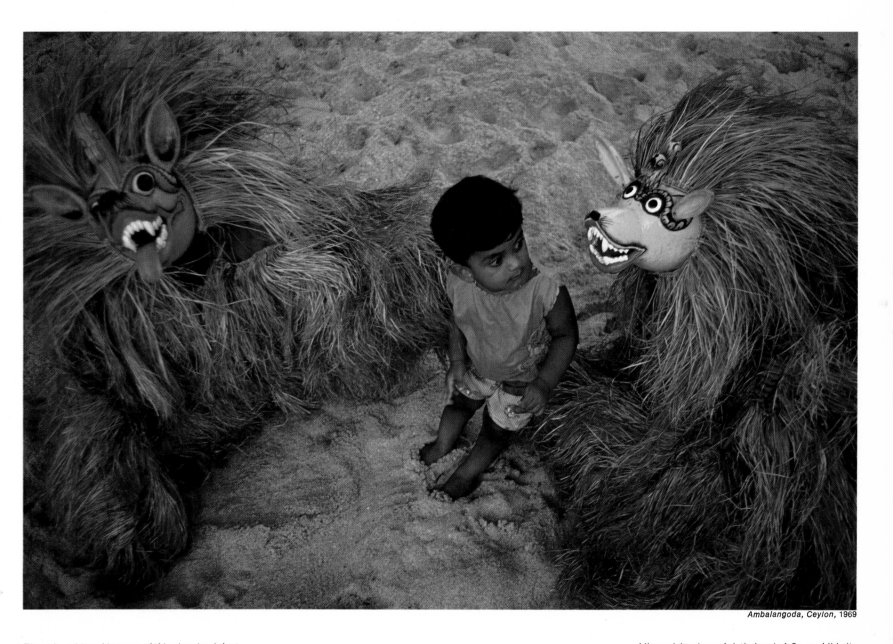

Ambalangoda, Ceylon, 1969

◄ *The soft, golden skin tones of this sleeping infant, curled up on a door sill alongside a street in Bangkok, caught the photographer's eye as he wandered through the city on assignment for a travel magazine. Though the picture is rendered in monochrome, color is one of its most expressive elements: its rich mocha browns seem as warm and enveloping as sleep itself.*

Like a visitor in an Asiatic Land of Oz, a child sits between two performers dressed as animals for a folk dance in a Ceylon village. The child had crawled between the make-believe beasts after the performance, and Wolf deftly turned the situation to pictorial advantage, framing the child between the dancers and catching the moment when the child was as bug-eyed as the beasts.

Mary Ellen Mark

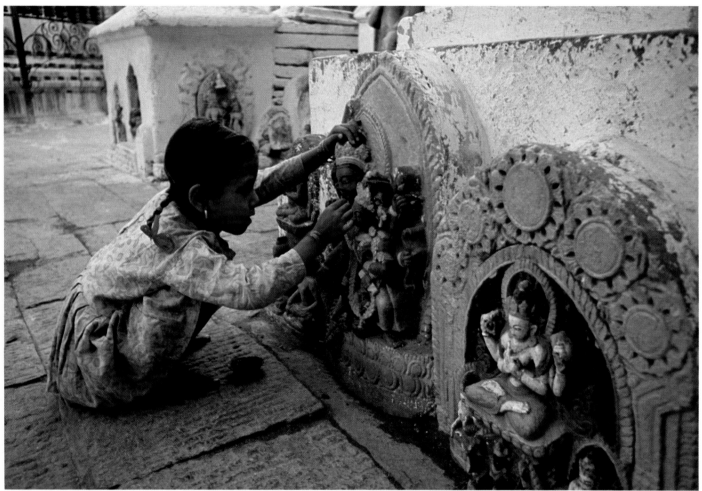

Girl Coloring Sculpture, Katmandu, Nepal, 1970

"I'm interested in kids as people, when they're doing something really revealing, not just something cute or obnoxious." So says Mary Ellen Mark, who has turned her inquisitive reporter's camera on people of all ages in all parts of the world. Her approach to photographing children is to regard them not as a special species requiring special care, but as full-fledged members of the human family. As with most of her sub-

jects, she shows them on location amid their own surroundings, in pictures that usually convey a strong sense of place and atmosphere. Sometimes she captures even more—an attitude, a gesture, a characteristic situation that serves, as Miss Mark describes it, to "peel the skin off something."

For Miss Mark hunts after that universal quarry of photojournalists, the revealing moment. Like Bernard Wolf,

she often tries to take the moment by surprise. The children on these two pages, for example, are so caught up in their own activities that they do not realize they are being photographed.

But at other times, when the moment seems slow in coming, Miss Mark steps in to help it happen. The result can be a direct and memorable encounter between subject and camera, as in the picture on page 201.

198

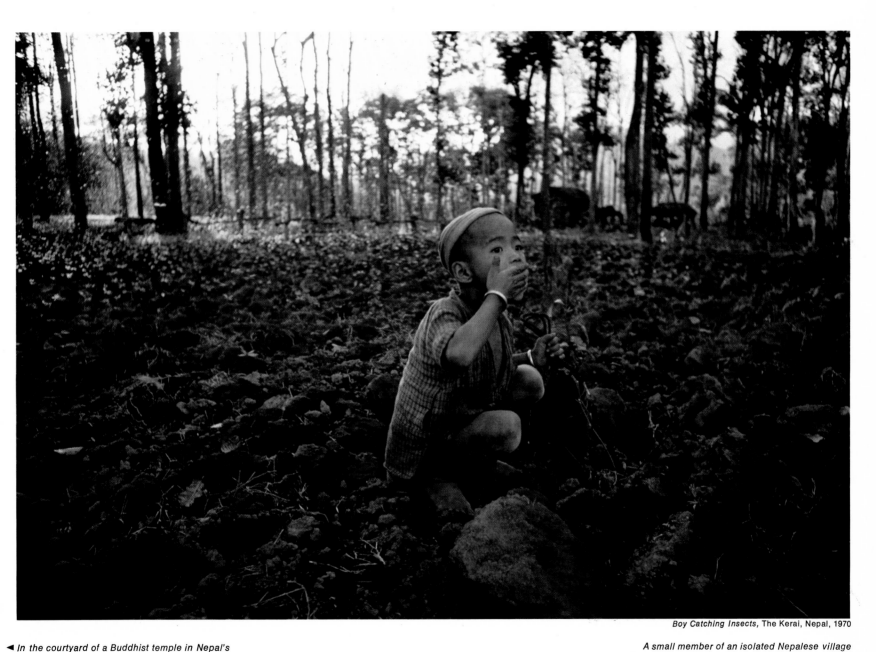

Boy Catching Insects, The Kerai, Nepal, 1970

◄ *In the courtyard of a Buddhist temple in Nepal's capital city, a young worshiper carefully applies pigments to an outdoor shrine. It was not just the little girl, but the entire scene that struck the photographer as "a pretty, charming thing," with its unusual combination of colors, the shrine's intricate carving, the Nepalese costume, and of course the child's preoccupation with her task.*

A small member of an isolated Nepalese village forages for a local delicacy—a kind of termite that is eaten like popcorn by the Nepalese. When the insects swarm in the evening air, the villagers turn out en masse to gather them into baskets. This boy, like children everywhere when they are confronted with something good to eat, manages to sneak a hand-to-mouth snack for himself.

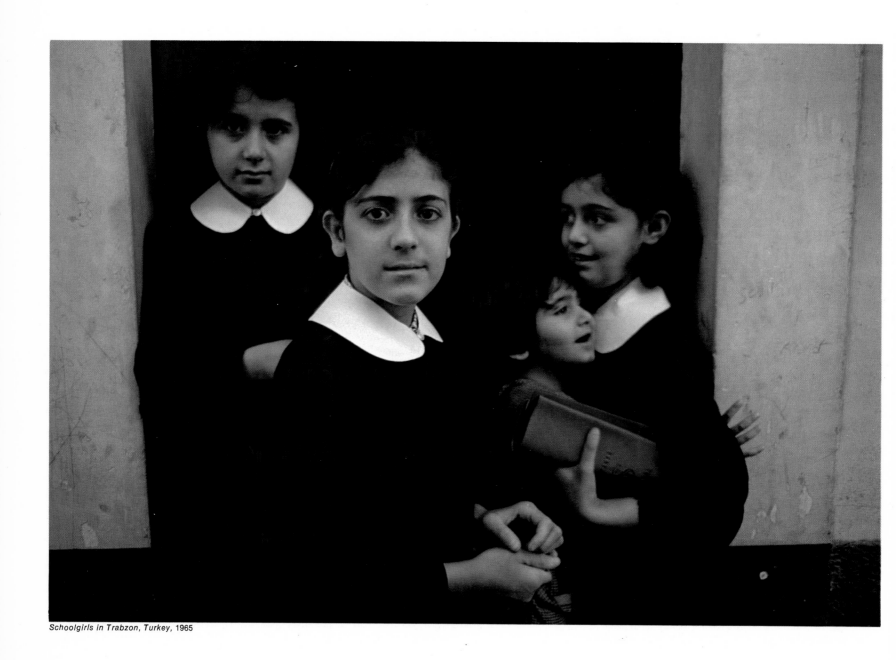

Schoolgirls in Trabzon, Turkey, 1965

◀ On a visit to Turkey early in her career, Mary Ellen Mark photographed many subjects, including hundreds of children such as these schoolgirls. Like many other beginning photographers, she simply found children less intimidating than adults. She spotted these girls, dressed in their prim school uniforms, standing in a doorway after class. Two turned to face the camera, providing the photographer with the moment she sought—in which gestures, facial expressions, composition and color all come into perfect balance.

Irony—"a kind of sad humor"—is one of the qualities Miss Mark likes to show in her pictures; and here she has found it in a peasant girl hired as an extra for the movie Fiddler on the Roof, which was being shot on location in Yugoslavia. The day had been long and extremely hot, and the little girl was crying with exhaustion. But she rallied sufficiently to dry her tears and try a slight curtsey, though her face still reflects her disquiet. In the background an older extra provides a contrasting note of venerable serenity.

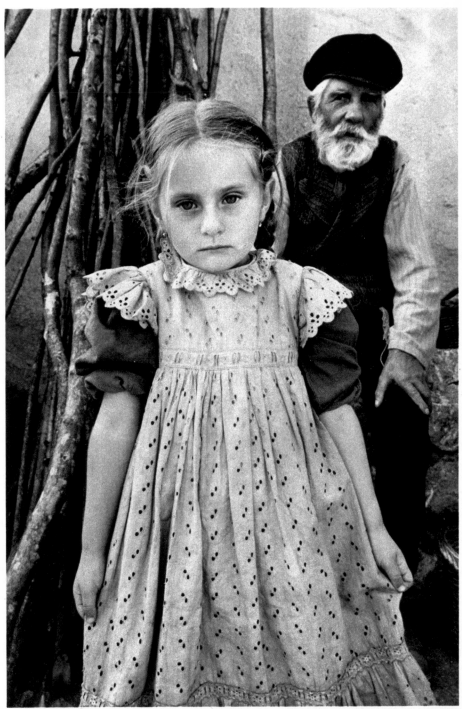

Movie Extras near Zagreb, Yugoslavia, 1970

201

A. Doren

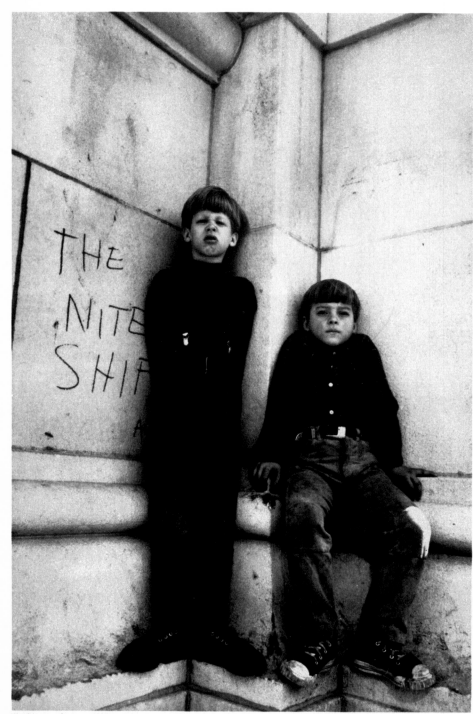

Washington Square, 1967

Virtually every child photograph by A. Doren represents a head-on, person-to-person encounter between the subject and the photographer. "I try to show children at the moment they assert their identity," says Doren. That moment usually occurs while the child is looking into the camera, saying in effect: "I am me."

Doren's pictures of them are made for children themselves to look at, and he has found that children feel a kinship with subjects that look straight out from the pictures, into their eyes. Doren finds that getting children to face his camera is easy. "A camera is like magic to kids," he says. "They love to be photographed." Occasionally, when a child seems reluctant, Doren tells him that there is a man inside the lens; the child looks, and sees his own reflection in the glass. But Doren seldom needs such gambits, for he finds no difficulty in relating directly to children. "There are times when I feel more at ease with them than I do with most grownups," he says. Indeed, he approaches all subjects—children, adults, or the nature scenes that first led him to photography —with a childlike curiosity and respect.

Doren's photographs are anything but child's work. To obtain his perfectly balanced, carefully detailed negatives he uses a 2¼ x 2¼ single-lens reflex camera. He then makes prints of astonishing richness, with vibrant blacks, lush highlights and a power that expresses the hand of a mature artist.

A pair of beguiling young ragamuffins stare coolly into the camera from a corner of Washington Square Arch in New York City's Greenwich Village. The boys were playing follow-the-leader on the stonework when the photographer interrupted the game for a pose.

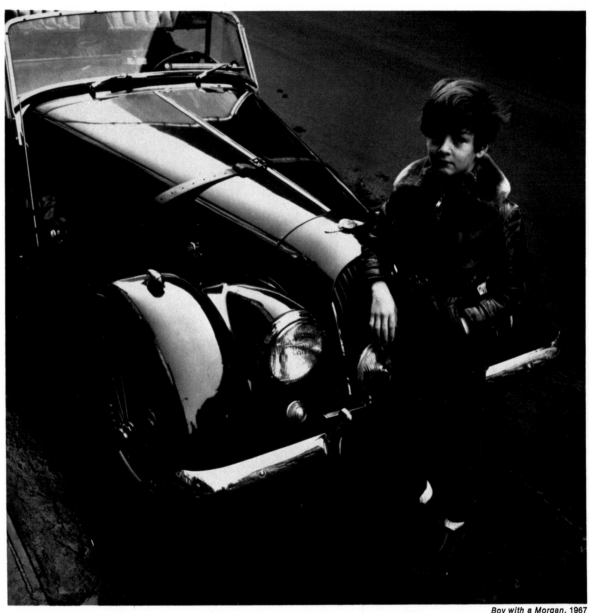

Boy with a Morgan, 1967

*Leaning against the grille of a gleaming sports car
as though he owned it, a pensive nine-year-old
regards the photographer with a self-confident
gaze. Doren had asked the child to pose on a
whim, only to discover later that he was the son of
a friend, fellow photographer Arthur Freed.*

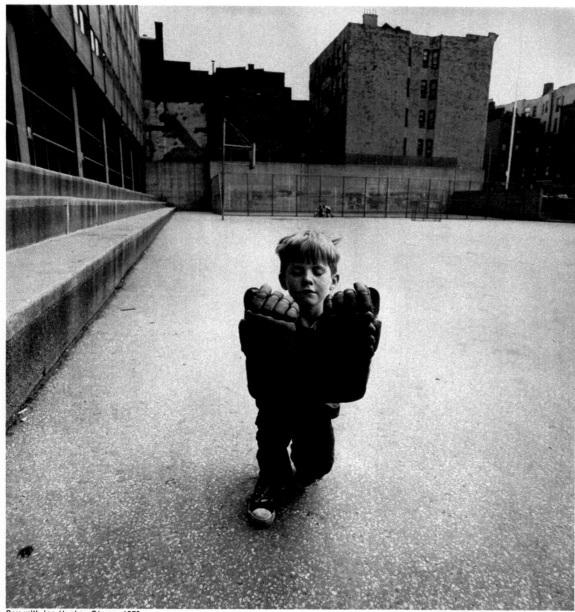

Boy with Ice Hockey Gloves, 1970

Encased to the elbows in his older brother's hockey gloves, this young New Yorker wears a soft and almost beatific expression that contrasts with the stark lines of the playground and tenements. The scene is in Hell's Kitchen, long one of the tough neighborhoods of Manhattan.

Arthur Tress is a documentary photographer whose major themes are social conditions, problems of poverty and regional folkways. The pictures shown here, for example, were taken in tenement neighborhoods in the New York area. But each one goes beyond the usual straightforward portrayal of slum children and penetrates into a realm of fantasy. For the reality that Tress documents in the city is not simply the physical reality of littered asphalt streets and run-down buildings, but a state of mind. "My photographs," he says, "exist in that strange borderland quietly hovering between the real and the unreal." He has called the approach "social surrealism."

Children fit perfectly into the surrealistic landscape of his pictures, Tress feels. Often they seem to sense intuitively the mood that he is trying to capture with his camera and will fall into an appropriate pose without being directed to do so, as did the boy at left. Tress felt that the monstrous leather hands, so out of scale with the young subject, should somehow convey a feeling of prayerful meditation—which is exactly the attitude the boy struck. "The image just happened between the two of us," Tress explained.

In some of his photographs of children; Tress abandons the idea of direct social comment in order to give fantasy full play. The results, as illustrated on the following two pages, are unadulterated flights of surrealism.

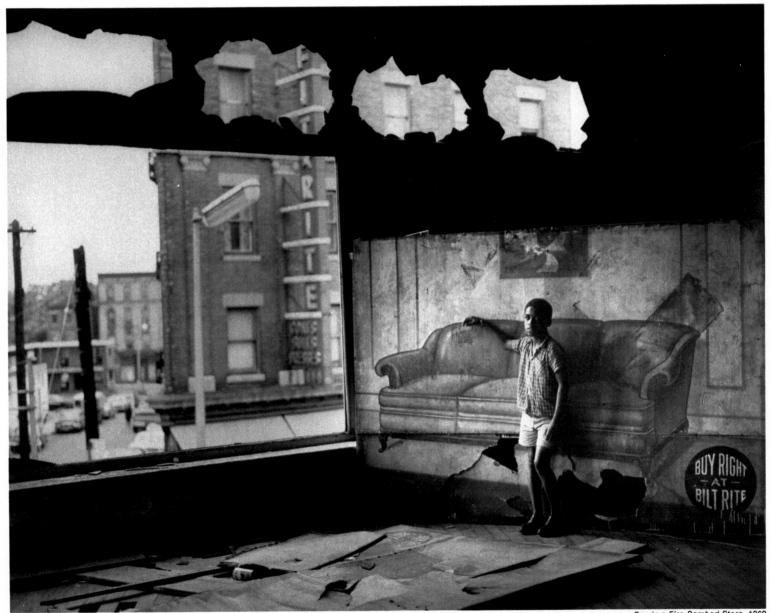

Boy in a Fire-Bombed Store, 1969

In a burned-out store in the black section of
Newark, New Jersey, a youth pretends to rest
against a sofa depicted on an advertising poster.
The picture was taken two years after the area had
been devastated by riots; local children were still
using the unrepaired shops as playgrounds.

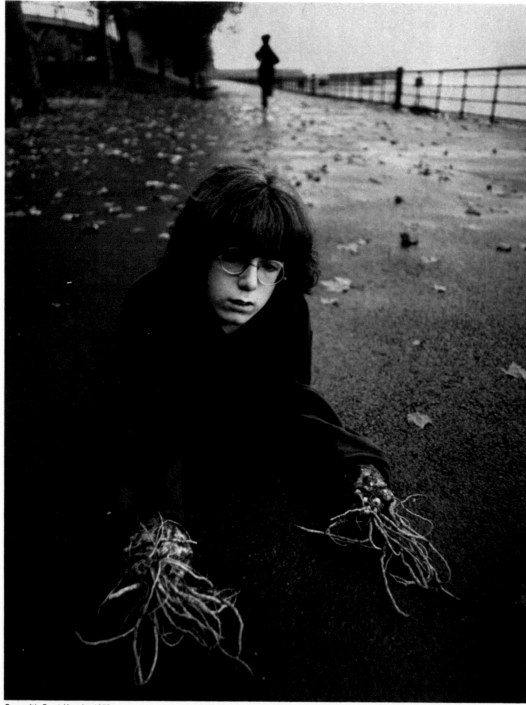

Tress was making outdoor studies of rutabagas, a vegetable with bizarrely tangled roots, when a group of schoolboys stopped to watch. They became intrigued, joined in, and the result was this nightmarish hybrid. "The idea of the hands becoming grotesque roots, the body being cut off, and even the runner in the background having only one leg—a visual accident—amused the boys no end," the photographer remarked.

A foggy day, an abandoned pier, and a child ► running into the waves at a beach near San Francisco unite in a scene that seems half real, half imaginary. The photographer came upon the combination of elements by chance, and was immediately caught by its evocative power. "I was struck by a quality of infinity," he said, "as if the decaying piers were some kind of dreamland gate disappearing into another world."

Boy with Root Hands, 1970

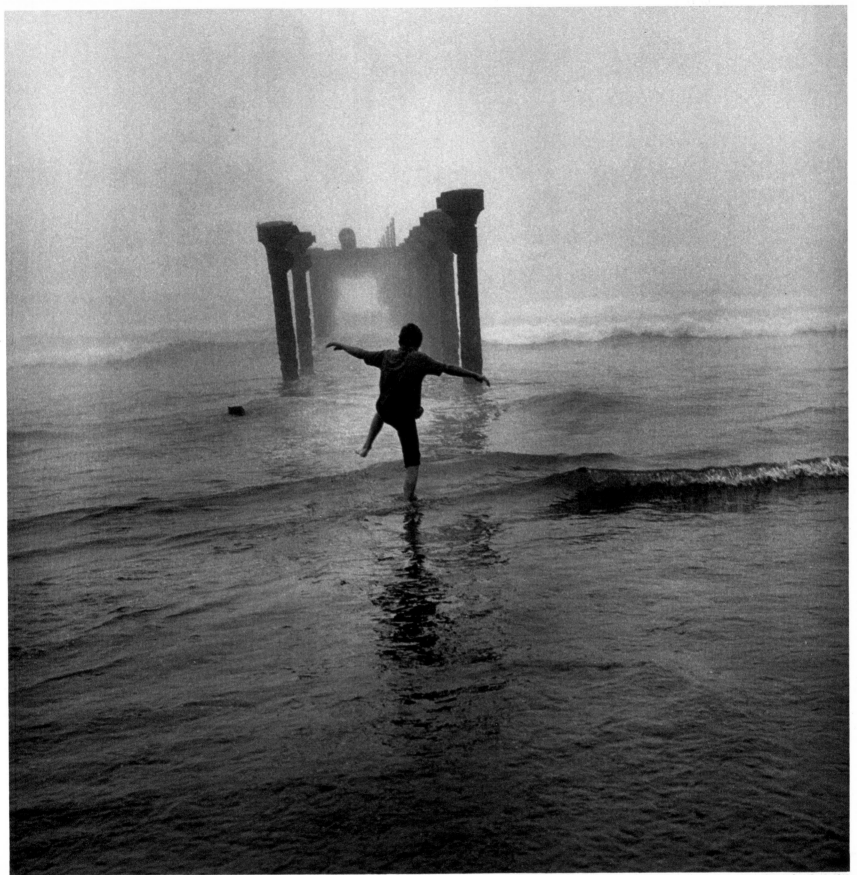

Boy at Sea Gate, 1968

Emmet Gowin

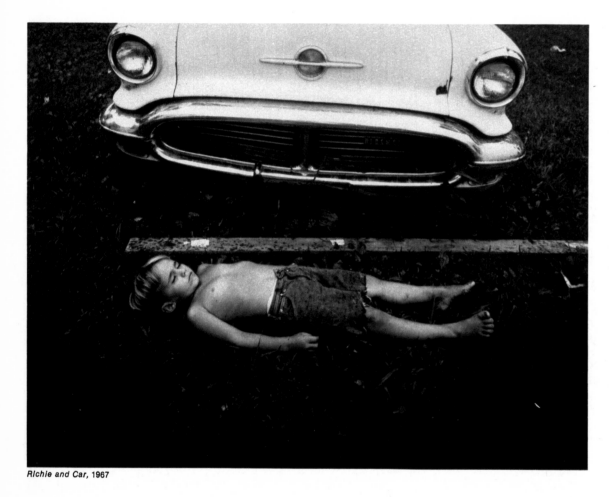

Richie and Car, 1967

Emmet Gowin photographs the things that are closest to him—his family and friends, his children and their playmates. These are everyday subjects, seemingly rendered in an everyday, almost casual manner. Yet there is something disquieting about a Gowin photograph, a sharp edge of incongruity suggesting that his situations are not as ordinary as they seem. "I like a photograph to show something unexpected," Gowin says, "to reveal the ominous potential in the ordinary moment."

When taking pictures of children, Gowin turns photography into a game. He sets up his 8 x 10 view camera on a tripod, gives the children a little direction and then lets them improvise.

Not surprisingly, Gowin does not always know how his photographs will turn out. "What really excites me is when I get more than I thought was there," he says. Sometimes the extra ingredient is an unexpected incident as in the picture at right. Sometimes, as in the picture at left, it is a quality of suspense that forces itself into the record of a commonplace moment.

Two perfectly innocent images—the front end of a parked automobile and a child lying on the grass —when seen together—conjure up a distinctly ominous set of circumstances. The photographer had been taking pictures of children in various positions around the car, and on a whim asked one of them, his nephew, to lie down in front of it.

A strange visual coincidence makes this picture ▶ interesting at the outset: everything comes in pairs. There are two boys, two turkeys and two inverted buckets. The boys had asked the photographer, a neighbor, to take their picture with the turkeys. The buckets were for the boys to sit on. Then one turkey scratched one boy on the face, and his companion rushed to console him —thereby providing an immediate, slightly puzzling relationship between birds and boys.

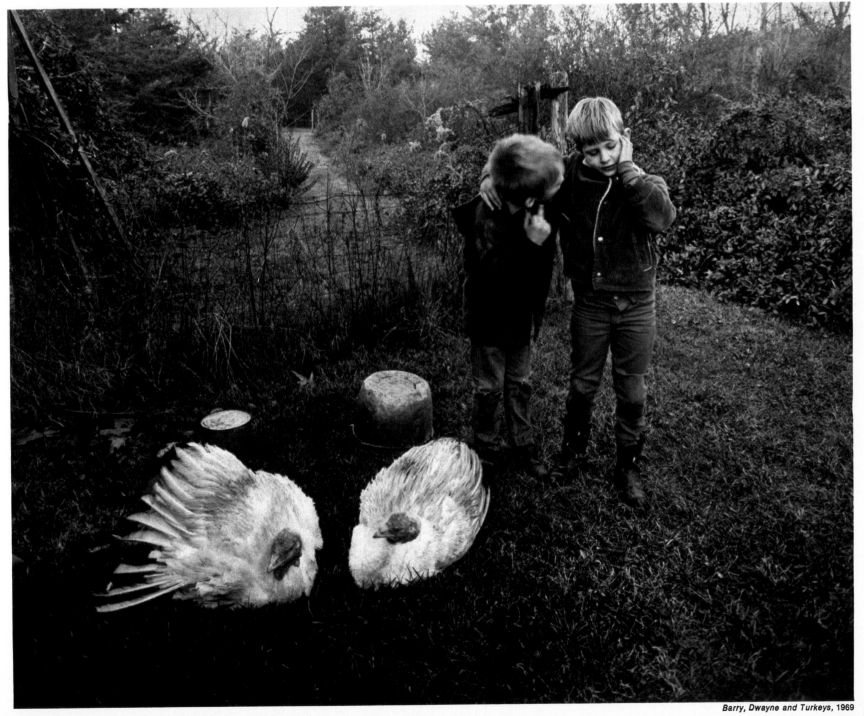

Barry, Dwayne and Turkeys, 1969

George Krause

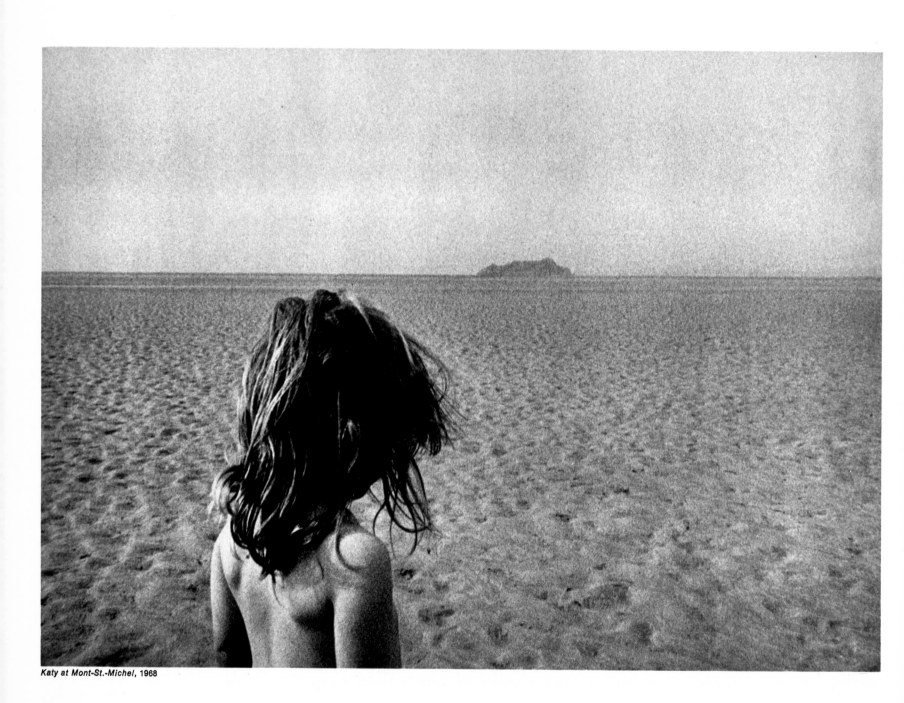

Katy at Mont-St.-Michel, 1968

Like many other contemporary photographers who often work with children, George Krause treads close to the edge of fantasy. Yet he never steps completely over. No matter how moody or evocative his pictures, or how deeply they stir the imagination, they are always too firmly rooted in the real world to seem unnatural or contrived. "Fantasy is like a tightrope," he says. "It can't look forced." Instead, Krause relies on a feeling of atmosphere, a sensuous play of light and shadow, to free the viewer's imagination.

The natural look of Krause's pictures comes, paradoxically, from the photographer's gentle but deliberate control over every step of the picture-making process. Many of his photographs, like the two shown here, are discreetly posed. Then, in developing and printing, Krause employs a full arsenal of darkroom techniques to balance contrast, deepen shadows and emphasize forms or obliterate shapes in order to bring out the mood—half real, half fantasy—that he seeks. "I want to leave an after-image," he says, "something that you can't quite get out of your mind."

◄ *The seemingly limitless expanse of sand flats off Mont-St.-Michel on the French coast provides an otherworldly backdrop for the photographer's daughter, who silently gazes into the eerie distance. The vastness of the scene and the cryptic back-of-the-head view of the little girl inspire a sense of fantasy, Krause believes, "an ambiguous feeling of being real and then unreal."*

By carefully posing this boy in a spot where the light struck his features only from the sides, the photographer made the face swim mysteriously out of the picture's shadowy depths. The effect was intensified by a printing technique that darkened the background to eliminate all detail.

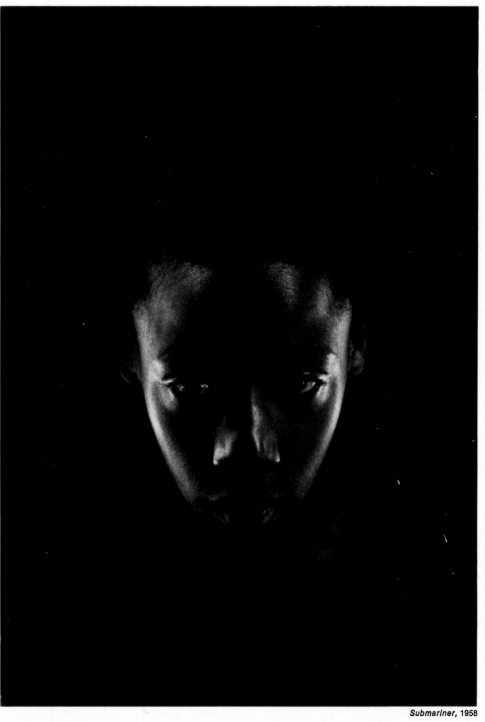

Submariner, 1958

Comedy and Tragedy, 1964

Krause noted these two child portraits—one laughing, one sobbing—as he walked past the display window of a dilapidated photography shop in Spain. By taking his own photograph of the faces in the ornate double frame and darkening the background when making his print, he invested the two pictures with a special meaning, transforming them into diminutive masks of comedy and tragedy in a kind of infant's theater —the very earliest of all fantasy worlds.

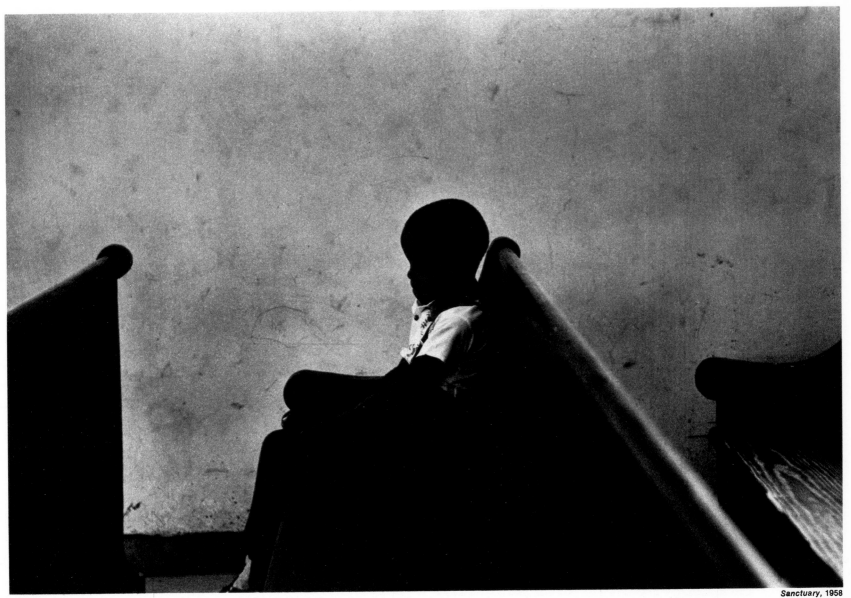

Sanctuary, 1958

Most of Krause's early pictures, like this quiet
portrait of a boy in a rural South Carolina church,
show the photographer's growing preoccupation
with composition and design. He posed the boy
so the shape of the head contrasted with the
severe lines of the pews. But the picture's impact
exceeds its formal values, capturing some of
the profound calm of the simple country church.

David Heath

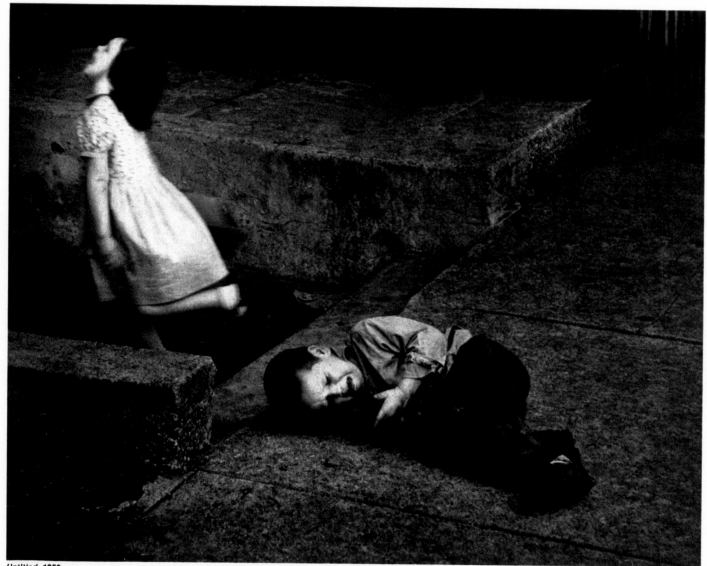

Untitled, 1956

All the torment of unhappy childhood moments seems condensed in this stark little drama between brother and sister on a Chicago street. The girl was taunting the boy, who tried to hit her, but tripped and fell. As he doubles up in fury and pain, she runs off a gleeful victor. "So the boy was doubly defeated," said the photographer, but "his hurt was more psychological than physical."

There is an intensity about a David Heath photograph that sets it apart. Some of the intensity is visual: the shadows that seem blacker than black, the highlights that glow with an almost unnatural radiance, both the result of printing techniques that amplify contrast. But Heath's darkroom methods only bring out a more basic, deeply personal intensity of feeling.

His photographs of children stir uneasy emotional echoes from his own childhood. An orphan, Heath felt alienated from the warmth of family life. Thus the anguish of the boy at left recalled unhappy moments in his relationship with his own foster sister.

In all his photographs of people Heath seems to catch human relationships at their emotional peak. And often the emotions express themselves in grim, violent ways. "Disenchantment, strife and anxiety enshroud our times in stygian darkness," he wrote in the preface to a book of his photographs, *A Dialogue with Solitude,* which included the two pictures shown here. And many of his brooding, restless pictures are charged with such qualities.

But out of the shadows, a gleam from the brighter side of life may appear. Nothing could be more tender and compassionate than the current of feeling passing between the mother and her daughter *(right),* learning to skate.

Venturing forth on a single roller skate, a little girl looks trustfully to her mother for reassurance. "She is deliciously intimidated," said the photographer, who came upon the scene in a New York City park. "She wants her mother to hold her hand, but she also wants to skate alone. Her mother is telling her, 'Don't be afraid, I'll be here to help'—an ideal mother and child relationship."

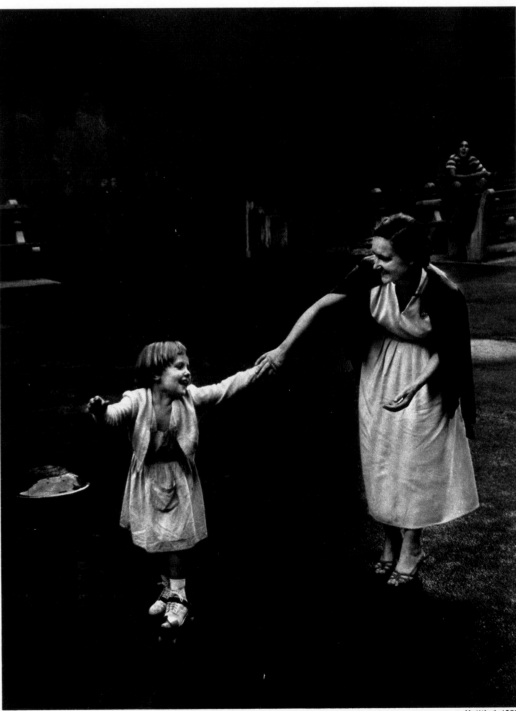

Untitled, 1958

215

Ralph Eugene Meatyard

Most viewers, looking for the first time at the deeply symbolic works of the late Ralph Eugene Meatyard, are totally mystified by them, or at least made uncomfortable. Who are these shadowy people who seem to materialize, like ghosts, from the dark recesses of his photographs? After looking at some of Meatyard's work, the poet Wendell Berry exclaimed, "My basic assumptions about reality are being tampered with!"

Behind each of Meatyard's photographic puzzles there is a form of reality, deliberately tampered with by the photographer's use of his own private set of symbols. Each picture is a carefully thought-out vignette that illustrates a universal theme, whether it be the recurring cycle of birth, growth and decay, man's place in the natural world or man's faith in God.

Meatyard's initial inspiration was usually a setting, almost always one near his home in Lexington, Kentucky. Meatyard then assembled ideas, props, costumes and characters, often using his own children as models.

Like many photographers who deal in fantasy, Meatyard found that children have a special passport to the world of the imagination. Also, because they are more malleable than adults, less camera-shy and easier to direct, they allowed him more control. And control was essential to his approach. In fact, he once declared, "I never will make an accidental photograph!"

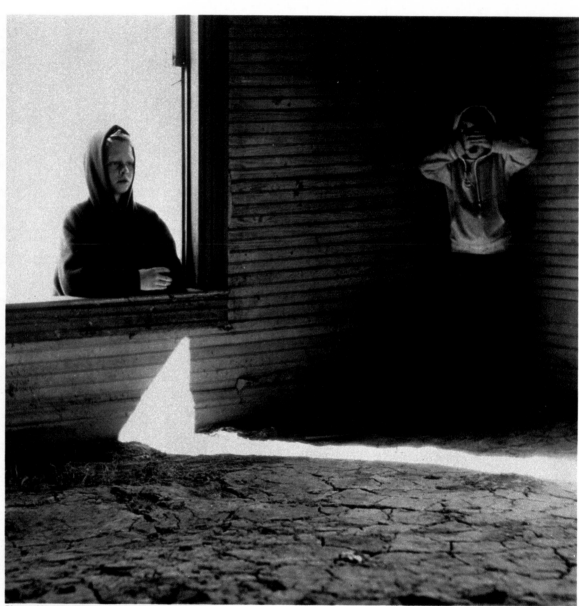

Rimose Meeting, 1962

Faith and despair are the themes of this picture of the photographer's sons in an abandoned house. The boy at the window, in monk's habit, represents faith; a shaft of light points at him. But the light slips past the boy in the shadows, who covers his eyes in fear and trembling. The title is not entirely cryptic; "rimose" refers to something with many cracks and fissures.

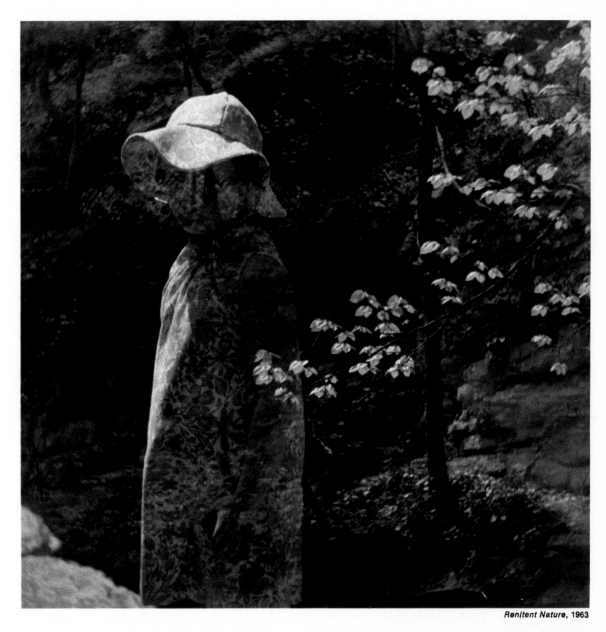

Renitent Nature, 1963

Child and nature merge in ghostly union in this deliberately calculated double exposure of the photographer's daughter and a woodland scene. Assuming that modern man, with his aggressive technology, has set himself at war with nature, Meatyard is expressing his belief that nature will win, since man is subject as is everything else, to the natural laws of birth, growth, decay and death.

Bruce Davidson

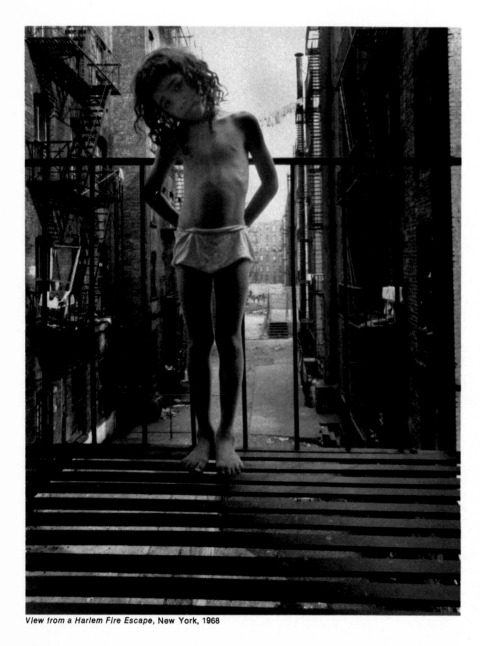

View from a Harlem Fire Escape, New York, 1968

"Talk to anyone who knows Bruce Davidson," says a friend, "and you're apt to find as many Davidsons as people you've talked to." He is a man who eludes pinning down, yet like many another artist, he sees one thread running through his own works. "On the surface they may look different, but they are unquestionably my style," he says. "I try to catch an instant."

The instant may be plucked from life in the East Harlem tenements, where Davidson spent two years photographing, or it may be a glimpse of childish emotion. The rendering is as varied as the subject matter; some scenes are unfocused, others sharp.

Through all this variety Davidson maintains a deep concern with the interrelationships of humans and their environments. And no subject better helps him express that concern than a child. "Looking at children is a way of seeing ourselves," he says. "In their innocence they teach the profound . . . and if you can see their truth you can see your own."

With unconscious inquisitiveness an East Harlem child ignores the bleak alley behind her to study the photographer confronting her —becoming one element in his juxtaposition of human emotion and urban environment. "The fire escape is her playground," he remarks. "Her mother wouldn't allow her to play in the rat-infested alley behind."

Another little girl, unaware of the camera, runs across a Sicilian meadow, as timeless and dream-shrouded as the temple in the rear.

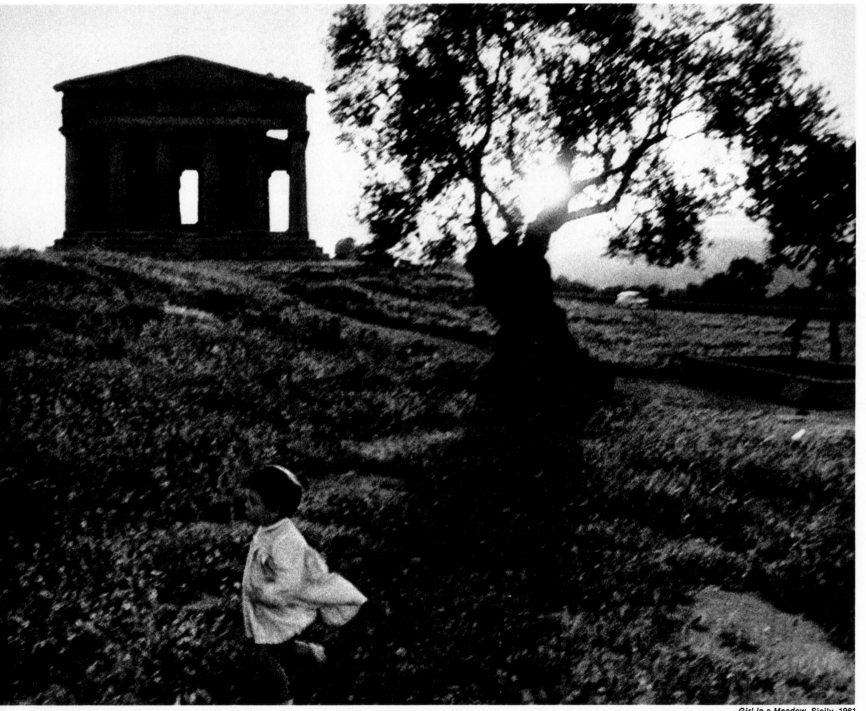

Girl in a Meadow, Sicily, 1961

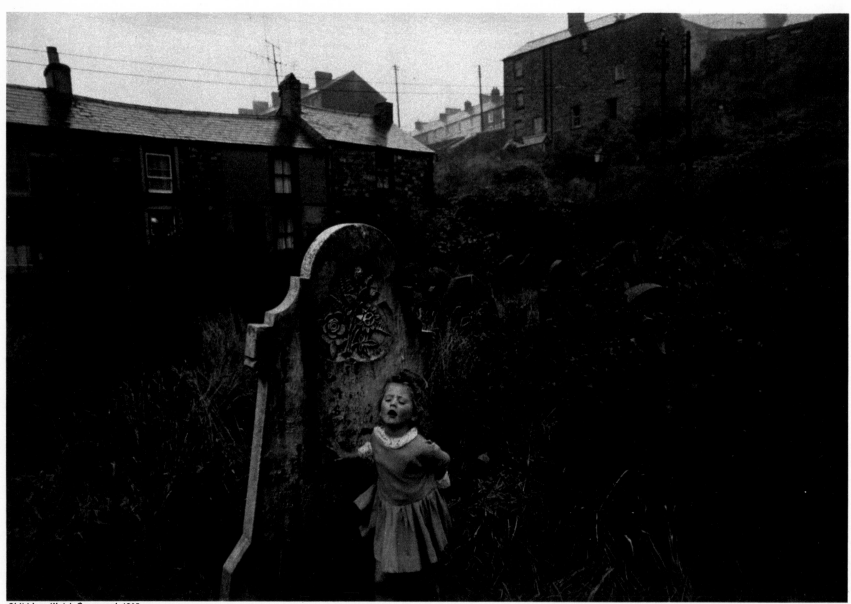

Child in a Welsh Graveyard, 1965

In a somber graveyard in a Welsh mining town the photographer found a child singing to herself among the tombstones; out of the scene he constructed an illustration of a favorite theme: a child absorbed in her own dream. This particular child appears to be as remote from the real world—and from the grimy houses behind her—as are the bodies that lie beneath the soil.

At the other extreme, the picture at right deals with rigid control and discipline. On an assignment in the U.S.S.R. the photographer visited the Leningrad Ballet School, where children begin their rigorous training at the age of nine. There he found these young girls hard at work, their supple young bodies already being forced from awkwardness into grace and their poses forming a pattern of curves against the straight lines of the ballet bar and the window behind it.

Ballet Class, Leningrad, 1963

221

Paula Nude, 1966

With Marie Cosindas, photography of children comes full circle—back to the ethereal visions reminiscent of an earlier era. But Miss Cosindas does it with a modern invention, instant Polaroid film, the same film that millions of families use for their snapshots.

The camera she uses is a 30-year-old view camera. She adds no artificial lighting and carries no more accessories than can be packed in an overnight bag. "I find Polacolor works well for children," she says, "because we can look at the pictures together and talk about what is happening. They feel very much a part of it all."

Marie Cosindas' hallmark is her use of muted colors. She came upon her method quite by accident one afternoon when, to compensate for the fading light, she extended the exposure time and the film developing time by several seconds. This affected the colors just enough to make them soft, without losing subtle shadings, and in portraiture the longer exposure gave her subjects a look of ease.

But more important than the technical aspect of her pictures is the spirit. "The best photographs," she says, "are the ones with rapport between the subject and the photographer. I find the more time we spend doing other things, like having tea parties or playing games, the better the rapport."

With a sweet shyness that is all her own and the unwitting look of a turn-of-the-century cherub, the daughter of a friend of the photographer sits for her portrait on a faded velvet bench. The photographer handed the child the roses to give her something to think about besides her body, and the child struck this pose on her own.

Paula, 1966

This photograph was taken on the morning of the
same day as the picture opposite. "Usually I am
satisfied to have one great photograph
at the end of a day," says the photographer,
"but these are two that I feel are important." An
easel left over from Miss Cosindas' days
as a painter stands behind the child.

223

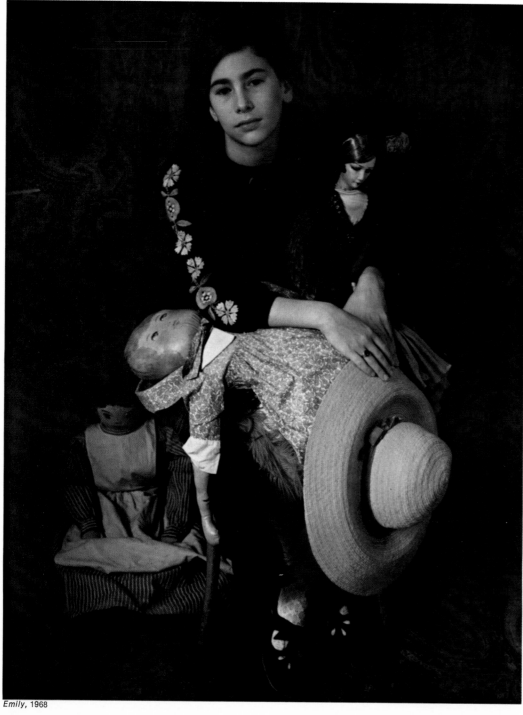

Like a figure from a quieter, less complicated time, a young sitter is revealed with all the gentle warmth of Marie Cosindas' fin-de-siècle style. The picture itself, a commissioned portrait, took two days to make. Props were assembled from the girl's collection of antique dolls; her dress was selected, and a brown paisley shawl was hung as a backdrop. Beyond all that, time was needed for photographer and sitter to develop the rapport essential for a fine portrait. It was these leisured preparations—combined with the rich, muted colors—that created the deep autumnal mood that distinguishes a Cosindas photograph.

Emily, 1968

Bibliography

History

Braive, Michel F., *The Era of the Photograph.* Thames and Hudson, London, 1966.
†*The Concerned Photographer.* Grossman, 1968.
Five Photographers. University of Nebraska, 1968.
Focal Press Ltd., *Focal Encyclopedia of Photography.* McGraw-Hill, 1969.
Gernsheim, Helmut:
 Creative Photography: Aesthetic Trends 1839-1960. Faber & Faber, 1962.
 History of Photography. Oxford University Press, 1955.
Gernsheim, Helmut and Alison:
 Creative Photography: 1826 to the Present. Wayne State University Press, 1963.
 The History of Photography: from the Camera Obscura to the Beginning of the Modern Era. McGraw-Hill, 1969.
Newhall, Beaumont:
 The Daguerreotype in America. Duell, Sloan & Pearce, 1961.
 The History of Photography: from 1839 to the Present Day: The Museum of Modern Art, Doubleday, 1964.
 Latent Image: The Discovery of Photography. Doubleday, 1967.
Newhall, Beaumont and Nancy, *Masters of Photography.* Harry N. Abrams, 1969.
Pollack, Peter, *The Picture History of Photography.* Harry N. Abrams, 1969.

Photographic Art

*Carson, Rachel, *The Sense of Wonder.* Harper & Row, 1956.
Cartier-Bresson, Henri:
 Cartier-Bresson's France. Viking, 1971.
 The Decisive Moment. Simon & Schuster, 1952.
 The Europeans. Simon & Schuster, 1955.
 †*The World of Cartier-Bresson.* Viking, 1968.
Children At Play. School of Visual Arts, 1964.
David Seymour—"Chim". Paragraphic, Grossman, 1966.
Davidson, Bruce, *East 100th Street.* Harvard University Press, 1970.
†*Dorothea Lange.* The Museum of Modern Art, 1966.
Dorr, Nell:
 In A Blue Moon. G. P. Putnam's Sons, 1939.
 Mother and Child. Harper & Brothers, 1954.
Gasser, Manuel, *The World of Werner Bischof.* E. P. Dutton, 1959.
Gernsheim, Helmut:
 Julia Margaret Cameron. Fountain Press, 1948.
 Lewis Carroll. Dover, 1969.
Gutman, Judith Mara, *Lewis W. Hine and the American Social Conscience.* Walker and Company, 1967.
Heath, Dave, *A Dialogue with Solitude.* Community Press Publication, 1965.
Heyman, Ken, and Michael Mason. *Willie.* Ridge Press, 1964.
Hine, Lewis W., *Men at Work.* Macmillan, 1932.
Kertész, André, *Enfants.*

Librairie Plon, Paris, 1933.
Kirstein, Lincoln, and Beaumont Newhall:
 †*Photographs by Cartier-Bresson.* Grossman, 1963.
 The Photographs of Henri Cartier-Bresson. The Museum of Modern Art, 1947.
Lange, Dorothea, and Paul S. Taylor, *An American Exodus.* Renal & Hitchcock, 1939.
Lartigue, Jacques-Henri:
 Boyhood Photos of J.-H. Lartigue. Ami Guichard, 1966.
 Diary of a Century. Viking, 1970.
Levitt, Helen, and James Agee, *A Way of Seeing.* Viking, 1965.
Mallet-Joris, Françoise, *Enfance, ton regard . . .* Librairie Hachette, 1966.
Martin, Paul, *Victorian Snapshots.* Country Limited, London, 1939.
†Miller, Wayne, *The World Is Young.* Ridge Press, 1958.
*Mitchell, Margaretta, *Gift of Place.* Scrimshaw Press, 1969.
Morgan, Barbara, *Summer's Children.* Morgan & Morgan, 1951.
Muybridge, Eadweard, *The Human Figure in Motion.* Dover Publications, 1955.
Penn, Irving, *Moments Preserved.* Simon & Schuster, 1960.
Ralph Eugene Meatyard. Gnomon Press, 1970.
Reich, Hanns:
 Children and Their Fathers. Hill and Wang, 1962.
 Children and Their Mothers. Hill and Wang, 1964.
 Children of Many Lands. Hill and Wang, 1958.
†Steichen, Edward, *The Family of Man.* The Museum of Modern Art, 1955.
Werner Bischof. Paragraphic, Grossman, 1966.
Wolf, Bernard:
 Jamaica Boy. Cowles Book Company, 1971.
 The Little Weaver of Agato. Cowles Book Company, 1969.

Special Subjects

†Ariès, Philippe, *Centuries of Childhood.* Vintage Books, 1965.
Better Homes and Gardens, *Baby Book.* Better Homes and Gardens Books, 1969.
†Clark, Kenneth, *The Nude.* Doubleday, 1956.
†Friedländer, Max J., *Landscape Portrait Still-Life.* Schocken Books, 1963.
Gesell, Arnold, M.D., *Studies in Child Development.* Harper & Brothers, 1948.
Ginott, Dr. Haim G., *Between Parent and Child.* Macmillan, 1965.
Homan, William E., M.D., *Child Sense.* Basic Books, 1969.
†Longford, Elizabeth, *Queen Victoria.* Pyramid Books, 1966.
Maas, Jeremy, *Victorian Painters.* G. P. Putnam's Sons, 1969.
†Mead, Margaret, and Ken Heyman, *Family.* Ridge Press, 1965.
†Mead, Margaret, and Martha Wolfenstein,

Childhood in Contemporary Cultures. The University of Chicago Press, 1955.
Opie, Iona and Peter, *Children's Games in Street and Playground.* Clarendon Press, Oxford, 1969.
*Palfi, Marion, *Suffer Little Children.* Oceana Publications, 1952.
Piaget, Jean, *The Child's Conception of the World.* Littlefield, Adams, 1963.
Queen, Stuart A., and Robert W. Habenstein, *The Family in Various Cultures.* J. B. Lippincott, 1967.
*Spock, Dr. Benjamin, *Baby and Child Care.* Pocket Books, 1971.
Stevenson, Robert Louis, *A Child's Garden of Verses.* Heritage Press, 1944.
*Walmsley, John, *Neill & Summerhill: A Man and His Work.* Penguin Books, 1969.
The World of Children. Paul Hamlyn Ltd., London, 1966.

Techniques

Croy, O. R., *The Photographic Portrait.* Focal Press, 1968.
Falk, Edwin A., and Charles Abel, *Practical Portrait Photography.* Amphoto, 1967.
Gross, Józef, *Child Photography.* Fountain Press, London, 1965.
Nurnberg, Walter, *Lighting for Portraiture.* Amphoto, 1969.
Schneider, Josef A., *Child Photography Made Easy . . .* American Photographic Book Publishing Co., 1957.
Szasz, Suzanne, *How I Photograph Children.* Amphoto, 1966.

Periodicals

Album, Aldan Ellis and Tristram Powell, London.
Aperture, Aperture Inc., New York City.
Art News, Newsweek, Inc., New York City.
British Journal of Photography, Henry Greenwood and Co., London.
Camera, C. J. Bucher Ltd., Lucerne, Switzerland.
Camera 35, U.S. Camera Publishing Co., New York City.
Camera Work (1903-1917), Alfred Stieglitz, New York City.
Color Photography Annual, Ziff-Davis Publishing Co., New York City.
Creative Camera, International Federation of Amateur Photographers, London.
Infinity, American Society of Magazine Photographers, New York City.
Modern Photography, The Billboard Publishing Co., New York City.
Popular Photography, Ziff-Davis Publishing Co., New York City.
Travel & Camera, U.S. Camera Publishing Corp., New York City.
U.S. Camera World Annual, U.S. Camera Publishing Corp., New York City.

*Available only in paperback.
†Also available in paperback.

Acknowledgments

For help with this book, the editors are indebted to Sven Andersson, Director of Tiofoto Bildbyrå, Stockholm; Thomas Barrow, Assistant Director, George Eastman House, Rochester, N.Y.; Roloff Beny, Rome; Paul Bonner, The Condé Nast Publications Inc., New York City; Peter C. Bunnell, Curator, Department of Photography, The Museum of Modern Art, New York City; Mary S. Calderone, M.D., Glen Head, Long Island; Albert Delacorte, New York City; Dena, New York City; Susanne Goldstein, Rapho Guillumette, New York City; Martus Granirer, New City, N.Y.; L. Fritz Gruber, Photokina, Cologne; Christine Hofmann, Bayerische Staatsgemaeldesammlungen, Munich; Philip B. Kunhardt Jr., New York City; Tom Lovcik, Curatorial Assistant, Department of Photography, The Museum of Modern Art, New York City; Grace Mayer, Curator, The Edward Steichen Archive, The Museum of Modern Art, New York City; Julie Pool, Curatorial Secretary, Department of Photography, The Museum of Modern Art, New York City; Christiane Roger, Secrétaire Administrative, Société Française de Photographie, Paris; Jerry Rosencrantz, Magnum, New York City; Robert Sobieszek, Assistant Curator, George Eastman House, Rochester, N.Y.; John Szarkowski, Director of Photography, Department of Photography, The Museum of Modern Art, New York City; Catherine Whitworth, Research Assistant in the Photography Collection, Humanities Research Center, University of Texas at Austin; Anthony Wolff, New York City.

Picture Credits *Credits from left to right are separated by semicolons, from top to bottom by dashes.*

COVER: Eadweard Muybridge, courtesy George Eastman House.

Chapter 1: 11—John Minshall. 14—Dorothea Lange, courtesy The Oakland Museum. 15,16—Anthony Wolff. 17—Ken Josephson. 18—George Krause. 19—Ron James. 20—Paul Schutzer for LIFE. 21—Gordon Parks for LIFE. 22—John Yang. 23—Henri Cartier-Bresson from Magnum. 24—Dena. 25—Henri Cartier-Bresson from Magnum. 26—Cornell Capa from Magnum. 27—John Yang. 28—James Carroll. 29—© Ulf Simonsson. 30—Charles Pratt. 31—Charles Harbutt from Magnum. 32—Danny Lyon from Magnum. 33—William Gale Gedney. 34—Paul Schutzer for LIFE.

Chapter 2: 37—Roger Fenton, courtesy Gernsheim Collection, Humanities Research Center, The University of Texas at Austin. 40—Courtesy The Museum of the City of New York. 41—Courtesy Deutsches Museum, Munich, copied by Eric Schaal. 42—Julia Margaret Cameron, courtesy Gernsheim Collection, Humanities Research Center, The University of Texas at Austin. 43—Julia Margaret Cameron, courtesy George Eastman House. 44—Ludwig Silberstein, courtesy George Eastman House, copied by Paulus Leeser. 45—Antoine Claudet, courtesy Gernsheim Collection, Humanities Research Center, The University of Texas at Austin. 46,47—Edward Steichen, courtesy The Museum of Modern Art, New York. 48—Lewis Carroll, courtesy Gernsheim Collection, Humanities Research Center, The University of Texas at Austin. 49—Clarence H. White, courtesy The Museum of Modern Art, New York. 50,51—Lewis Carroll, courtesy Gernsheim Collection, Humanities Research Center, The University of Texas at Austin. 52—Culver Pictures. 53—Courtesy Richard L. Williams. 54—De Meyer photograph for *Vogue*, © 1920, 1948 The Condé Nast Publications Inc. 55—Bachrach Studios, courtesy Anthony Wolff. 56—Imogen Cunningham. 57—Nell Dorr. 58—Will Connell, copied by Paulus Leeser. 59—Courtesy Ione Wollenzein. 60,61—Constance Bannister. 62—Marie Cosindas. 63—Toni Frissell for LIFE, courtesy Library of Congress. 65—Mayer and Pierson from *Editions M.D.*, 1953, courtesy Madame Christiane Roger, copied by Jacques André and Louis Molinier. 66,67—Frank M. Sutcliffe, courtesy Gernsheim Collection, Humanities Research Center, The University of Texas at Austin. 68,69—Arnold Genthe, courtesy the M. H. de Young Memorial Museum—California Palace of the Legion of Honor; Frank M. Sutcliffe, courtesy The Royal Photographic Society of Great Britain, copied by R. Smith. 70,71—Lewis W. Hine, courtesy George Eastman House. 72,73—André Kertész; Jacques-Henri Lartigue from Rapho Guillumette. 74,75—Dorothea Lange, courtesy Library of Congress; Henri Cartier-Bresson from Magnum. 76—© Cecil Beaton. 77,78—David Seymour from Magnum. 79—© Barbara Morgan. 80—George W. Gardner. 81—Charles Harbutt from Magnum. 82—Suzanne Szasz. 83—Arthur Tress. 84—Bill Brandt from Rapho Guillumette. 85—Ronald Mesaros. 86—Irving Penn, © 1960 The Condé Nast Publications Inc. 87,88—Arthur Tress.

Chapter 3: 91—Wolf von dem Bussche. 94-97—Sebastian Milito at New York University Medical Center. 98-109—Wolf von dem Bussche. 111—Bradley Hindson. 112—Bill Binzen. 113—Dena. 114,115—George Krause; Bradley Hindson. 116—Bill Binzen. 117—Jay Maisel. 118,119—Bill Binzen. 120—Ronald Mesaros. 121—Charles Pratt. 122—Arthur Tress.

Chapter 4: 125—A. Doren. 128,129—Henri Cartier-Bresson from Magnum. 130—Emmet Gowin. 131—John P. Aikins. 132—Ken Josephson. 133—Alen MacWeeney. 134—Charles Traub. 135—Norman Snyder. 136,137—Jack Schrier. 139—© Raimondo Borea. 140—Terry Bisbee. 141—Max Dellacher, courtesy Hanns Reich Verlag. 142,143—Ken Josephson. 144—Arthur Freed. 145—Laurence Fink. 146—Burk Uzzle from Magnum. 147—Emmet Gowin. 148,149—Armen Kachaturian. 150—Charles Traub. 151—Suzanne Szasz. 152,153—Bill Binzen; Philip Jones Griffiths from Magnum. 154—Bill Binzen. 155—Ronald Mesaros. 156—© Raimondo Borea.

Chapter 5: 159—Alen MacWeeney. 162—Ralph Eugene Meatyard. 163—Sabine Weiss from Rapho Guillumette. 164—Rae Russel Gescheidt. 165—John Loengard for LIFE. 166—Bill Ray. 167—Louise Dahl-Wolf, courtesy *Harper's Bazaar*. 168—© André A. Lopez. 169—Dan Weiner. 170—Danny Lyon from Magnum. 171—Arthur Tress. 173—Ernst Haas. 174—Arthur Freed. 175—Werner Bischof from Magnum. 176—Diane Arbus. 177—Toni Frissell for LIFE. 178—Ron Benvenisti from Magnum. 179—Jay Maisel. 180—Leonard Freed from Magnum. 181—Dominik Burckhardt-Nicolas Bossard-Lilo Nido. 182,183—Lilo Raymond. 184—Charles Pratt. 185—John Benson. 186—Danny Lyon from Magnum. 187—Alen MacWeeney. 188—Danny Lyon from Magnum. 189—Wayne Miller from Magnum. 190—Dick Swanson.

Chapter 6: 193-197—Bernard Wolf. 198-201—Mary Ellen Mark. 202,203—A. Doren. 204-207—Arthur Tress. 208,209—Emmet Gowin. 210-213—George Krause. 214,215—Dave Heath. 216,217—Ralph Eugene Meatyard. 218-221—Bruce Davidson from Magnum. 222,223,224—Marie Cosindas.

Index

Numerals in italics indicate a photograph, painting or drawing of the subject mentioned.

Printed in U.S.A.

XXX